MOUNT ST.
RESTAURANT

JANE CARR

WWW.JANE-CARR.COM

FOR MORE INFORMATION TELEPHONE: +44 (0)20 7387 4337

Departments

Features

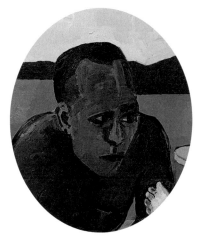

The Cover
Henry Taylor in conversation
with Sheree Hovsepian,
the subject of Taylor's
cover portrait,
about art and history,
artists and models
p. 40

Portfolio
Unpublished psychological
drawings by Margaret Egloff,
American student
of Jung in 1930s Zurich.
With an essay
by Bob Nickas
p. 68

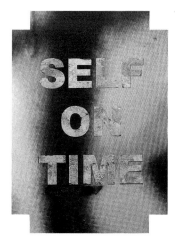

Intervention
A magazine work
by Stefan Brüggemann
in the spirit of
Dan Graham,
Vito Acconci and
Bernadette Mayer
p. 86

Oral History
Los Angeles
performance pioneer
Barbara T. Smith
talks with Randy Kennedy
about her early life and
radical art
p. 56

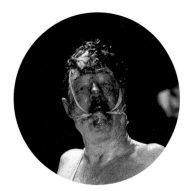

Essay
Gary Indiana
on Paul McCarthy's
NV / Night Vater
p. 76

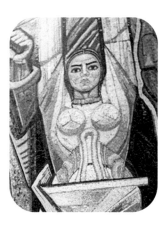

Essay
Lizaveta German
on Alla Horska's
monumental mosaics and
political dissent in
1960s Ukraine
p. 98

Departments

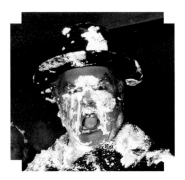
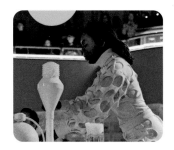

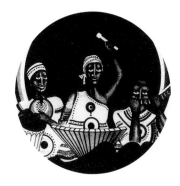

Henry Taylor B Side

MOCA Grand Avenue
November 6, 2022–April 30, 2023
@moca, moca.org

Art for All Free

EDITOR IN CHIEF

Randy Kennedy

MANAGING EDITORS

Alexander Scrimgeour
Alexandra Vargo

EDITORIAL ASSISTANT

Maria Elena Garzoni

ART DIRECTION

Common Name

PRODUCTION

Christine Stricker

PUBLISHER

Hauser & Wirth Publishers

Editorial Offices:
542 West 22nd Street
New York, NY 10011
Tel: +1 212-790-3900

ursulamagazine@hauserwirth.com

Prepress by
Prints Professional, Berlin

Printed in Germany by
Offsetdruckerei Karl Grammlich

Advertising
Cultureshock Media

HAUSER & WIRTH

Presidents
Iwan and Manuela Wirth
Marc Payot

Chief Executive Officer
Ewan Venters

Chief Creative Officer
Zia Zareem-Slade

Executive Director Publications
Michaela Unterdörfer

Senior Marketing Director Europe/Asia
Sarah Briggs

Marketing Director United States
Michael Wooten

Senior Digital Content Manager
Francis Till

Associate Director Digital Content
Jed Moch

Vol. 3, Issue no. 7:
Ursula (ISSN 2639-376X)
is published twice a year
by Hauser & Wirth Publishers,
542 West 22nd Street,
New York, NY 10011.

To subscribe visit
hauserwirth.com/ursula.

Single copies may be
purchased for $18/£16.

Postmaster: Send address
changes to address above, care
of Ursula Subscriptions.

Front cover:
Henry Taylor, *Untitled*, 2021. Acrylic on canvas, 30 × 24 1/4 × 1 5/8 in.
(76.2 × 61.6 × 4.1 cm). Portrait of Sheree Hovsepian. © Henry Taylor.
Photo: Jeff McLane. Courtesy the artist and Hauser & Wirth

Back cover:
Alla Horska, Borys Plaksii, Viktor Zaretskyi and Volodymyr
Smirnov (architect), *Coal Flower* (detail), 1968. Smalti, slag glass.
Krasnodonvuhillia Factory Management, Krasnodon, Luhansk,
Ukraine, 2016. Photo: Yevgen Nikiforov

PHYLLIDA BARLOW

BREACH

15.10.22
TO 19.3.23

SPRENGEL
MUSEUM HANNOVER

Phyllida Barlow, untitled: blockade, 5, 2022,
Acrylic on paper (Detail) © Phyllida Barlow,
Courtesy the artist and Hauser & Wirth,
Photo: Alex Delfanne

KURT SCHWITTERS PRIZE 2022
OF THE LOWER SAXONY
SAVINGS-BANK FOUNDATION

An Institution of the
Landeshauptstadt

Supported by

Media Partner

Niedersächsische
Sparkassenstiftung

Hannover

Niedersachsen

NDR kultur

Contributors

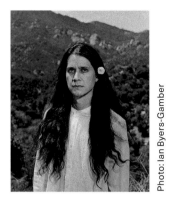

Photo: Ian Byers-Gamber

Photo: Leigh Ledare

Spanning—and sometimes combining—sculpture, video, painting and drawing, the work of STEFAN BRÜGGEMANN work deploys text in conceptual installations rich with acerbic social critique and a post-Pop aesthetic. Born in Mexico City, Brüggemann lives in Mexico and London. In February 2023, an exhibition of new work will open at Mostyn, the public art gallery in North Wales. (See p. 86.)

Photo: Jordan Tiberio

K ALLADO-MCDOWELL is a writer, speaker and musician. They are the author, with GPT-3, of the books *Pharmako-AI* (2021) and *Amor Cringe* (2022) and co-editor of *The Atlas of Anomalous AI* (2021). They record and release music under the name Qenric. In 2016, Allado-McDowell established the Artists + Machine Intelligence program at Google AI. They are a conference speaker, educator and consultant to think tanks and institutions seeking to align their work with deeper traditions of human understanding. (See p. 36.)

ALISSA BENNETT is a writer and the co-host of the podcast *The C-Word*, with Lena Dunham. Bennett is now at work on a book of essays that examine desire, fame and consumption via lots of Hollywood memorabilia. (See p. 126.)

Photo: Hakeem Aduwumi

EDDIE CHAMBERS was born in Wolverhampton, England, and is a professor of art history in the Department of Art and Art History at the University of Texas at Austin. His books include *World Is Africa: Writings on Diaspora Art*, and he is editor of the recently published *Routledge Companion to African American Art History*. He is also editor in chief of the College Art Association's *Art Journal*. (See p. 132.)

SHEREE HOVSEPIAN is an Iranian-born American artist who earned her MFA from the School of the Art Institute of Chicago in 2002. Hovsepian participated in this year's Venice Biennale, where a room was dedicated to her work. Recent solo exhibitions include "Leaning In," Rachel Uffner Gallery, New York; "Musings," Halsey McKay Gallery, East Hampton, NY; and "Sheree Hovsepian," Higher Pictures Gallery, New York. Hovsepian serves on the Art Advisory Committee of Baxter Street at the Camera Club of New York. She lives and works in New York. (See p. 40.)

Photo: Nicolas Party

Photo: Gina Folly

DANIEL BAUMANN is an art historian and curator based in Basel and Zurich. He has been director of Kunsthalle Zürich since 2015. On the occasion of two new books about the careers of Bice Curiger and Jacqueline Burckhardt, key players in the Zurich and international art scenes whom Baumann counts as colleagues and friends, he writes for *Ursula* about generational shifts in exhibition-making and in the art world at large. (See p. 116.)

SARAH BLAKLEY-CARTWRIGHT is a writer and editor living in New York. Her novel *Alice Sadie Celine* will be published in 2023 by Simon & Schuster. (See p. 112.)

ANGALIS FIELD is a writer-director, photographer and thesis candidate in the Graduate Film MFA program at NYU Tisch School of the Arts. He is based in New York. (See p. 112.)

Photo: Hedi El Kholti

GARY INDIANA is the author of many works of fiction and nonfiction, including the novels *Resentment: A Comedy*, *Do Everything in the Dark* and *Depraved Indifference*, and the recently published essay collection *Fire Season*. His video works can be viewed at https://vimeo.com/garyindiana. He lives in New York and Los Angeles. (See p. 76.)

Photo: Gil Brasier

RONALD BRONSTEIN is a New York–based writer and editor. His film credits include *Daddy Longlegs*, *Good Time* and *Uncut Gems*. His lone directorial effort, *Frownland*, was recently added to the Criterion Collection. In 2018, he edited and published *R. Crumb's Dream Diary*, a prose collection culled from artist Robert Crumb's private journals. (See p. 104.)

Photo: Yevgen Nikiforov

LIZAVETA GERMAN is an art historian and curator from Kyiv. She is coeditor of T*he Art of Ukrainian Sixties* and *Decommunized: Ukrainian Soviet Mosaics*. In 2018, she cofounded the Naked Room, a gallery for contemporary art in Kyiv, and in 2022, she was a co-curator of the Ukrainian pavilion at the Venice Biennale, which presented a solo project by artist Pavlo Makov. (See p. 98.)

BHANU KAPIL is a poet and Fellow of Churchill College, Cambridge, as well as a new Fellow of the Royal Society of Literature. Her most recent publication is *How to Wash a Heart* (Pavilion Poetry), which won the T. S. Eliot Prize. Kapil is also the recipient of a Windham-Campbell Prize from Yale University and a Cholmondeley Award from the Society of Authors. (See p. 20.)

▶Frank Bowling's Americas

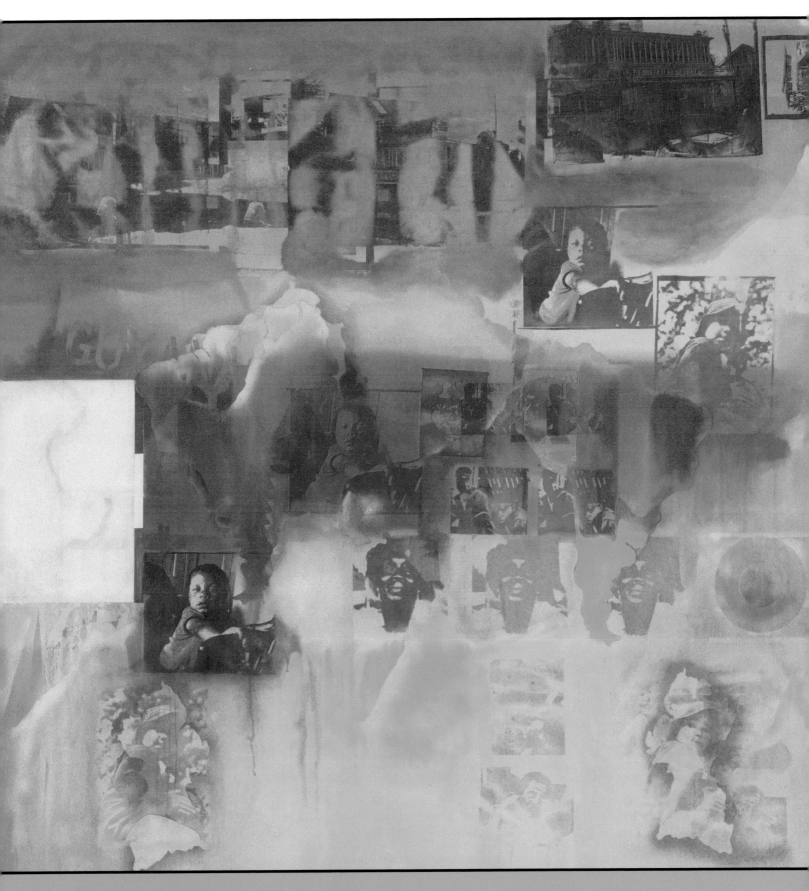

MFÆBoston

On View 10/22/22–4/9/23
Tickets and info at mfa.org

Generously supported by the Abrams Foundation and the Carl and Ruth Shapiro Family Foundation. Frank Bowling, *Middle Passage* (detail), 1970. Synthetic polymer paint, silkscreen ink, spray paint, wax crayon, and graphite on canvas. Menil Collection, Houston. Image by Adam Neese. © Frank Bowling. All rights reserved, DACS, London & ARS, New York 2022.

ABRAMS
FOUNDATION

THE CARL AND RUTH
SHAPIRO
FAMILY FOUNDATION

Contributors

Photo: Gail Thacker

ELISABETH KLEY is an artist and writer. Her first solo museum exhibition, "Minutes of Sand," took place at the Fabric Workshop and Museum in Philadelphia in 2021. In 2021 and 2022, she was an artist in residence at Ceramic Suro in Guadalajara, Mexico, preparing work for a solo exhibition to be held at Canada gallery in New York in 2023. She is also at work on a monumental piece for the United States Embassy in Athens. A monograph on her work, with essays by Paul P. and Edward Leffingwell, was published jointly by Canada and Pre-Echo Press in 2019. (See p. 142.)

Photo: Oresti Tsonopoulos

PETER T. MCGOUGH became well known in the art world in the 1980s and 1990s as part of McDermott & McGough, with David McDermott. The duo participated in three Whitney Biennials, and a retrospective of their work took place at Dallas Contemporary in 2017. In 2018, their Oscar Wilde Temple was installed at Studio Voltaire in London. McGough has been a painter for more than thirty years and now makes his work as part of a solo practice. His memoir, *I've Seen the Future and I'm Not Going: The Art Scene and Downtown New York in the 1980s*, was published by Pantheon in 2019. (See p. 22.)

A writer and curator based in New York, BOB NICKAS has organized more than 120 exhibitions since 1984. His books include *Painting Abstraction: New Elements in Abstract Painting* and four collections of writing and interviews: *Live Free or Die*, *Theft Is Vision*, *The Dept. of Corrections* and *Komplaint Dept. Yesterworld*, Nickas's daily writing diary from 2019, has just been published by Karma, and a monograph on the Italian painter Salvo is forthcoming from Nero, Rome. (See p. 68.)

YEVGEN NIKIFOROV is a Kyiv-based documentary photographer, visual artist and researcher of monumental art. He began working professionally as a photographer in 2005 and has been pursuing independent documentary projects since 2013. His books include *Art for Architecture: Ukraine; Soviet Modernist Mosaics from 1960 to 1990*. (See p. 98.)

FREDRIK NILSEN is a photographer specializing in exhibition photography, photography of artworks and portraiture. He has functioned as a director of still photography in the production of photographic works of art for numerous noted artists. He also maintains his own art practice and is an experimental musician and founding member of the Los Angeles Free Music Society. (See p. 40.)

MARTIN D'ORGEVAL is a photographer and daguerreotype-maker who has had recent exhibitions at Sikkema Jenkins & Co, New York, and Galerie Hussenot and La Conciergerie, Paris. He lives and works in Paris, where he was born in 1973. (See p. 30.)

OLIVIER RENAUD-CLÉMENT has organized exhibitions and acted as an advisor to artists and estates in the United States, Europe and Japan for many years. He has worked frequently with Hauser & Wirth, collaborating with the gallery on thirty-one exhibitions to date. He has collaborated with Takesada Matsutani and the estates of Fabio Mauri, Lygia Pape, August Sander and Mira Schendel, among others. Renaud-Clément is the founder of the International Friends of the Munich Opera. He is based between Paris and New York. (See p. 30.)

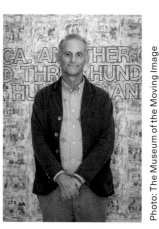

Photo: The Museum of the Moving Image

ROBERT M. RUBIN is a cultural historian and curator who writes about art, architecture and film. His most recent book is *Richard Prince: Cowboy*. He has curated exhibitions at the Bibliothèque nationale de France; the Museum of Contemporary Art, Los Angeles; the Hammer Museum, Los Angeles; and the Museum of the Moving Image, New York. His other books and essays cover such figures as Richard Avedon, Alexander Calder, Pierre Chareau, Bob Dylan, Buckminster Fuller, Allen Ginsberg, Jack Kerouac, Glenn O'Brien and Jean Prouvé. (See p. 104.)

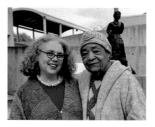

ALISON SAAR's sculptures, prints and paintings address issues of race, gender and spirit. She studied art and art history at Scripps College in Claremont, LA, and received an MFA from the Otis Art Institute in Los Angeles. Her awards include a John Simon Guggenheim Memorial Foundation Fellowship, National Endowment Fellowships and the United States Artists Fellowship. Saar has exhibited at many museums including the Hirshhorn Museum and Sculpture Garden in Washington, D.C., and the Whitney Museum of American Art in New York. She lives in Los Angeles and is represented by L.A. Louver gallery. In this issue, she writes about her former teacher, Samella Lewis (1923–2022), shown with her in the photograph above. (See p. 26.)

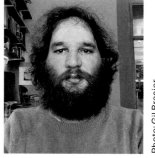

Photo: Gil Brasier

JOSH SAFDIE is a filmmaker who lives and works in New York. (See p. 104.)

TABBOO! (aka Stephen Tashjian) is a multidisciplinary artist and performer who is fascinated by celebrity, visual culture and the aesthetics of the everyday. Still lifes, cityscapes and portraits of friends populate his oeuvre, rendered sparkling and bittersweet with a striking honesty. Tabboo! is jointly represented by Gordon Robichaux and Karma in New York, which presented his most recent exhibition, in 2022. (See p. 112.)

Photo: Fredrik Nilsen Studio

HENRY TAYLOR is a Los Angeles-based painter and sculptor. His four-decade-long practice combines elements of figurative, landscape and history painting, as well as sculpture, often made from found and consumer objects. Taylor has been the subject of numerous exhibitions in the United States and throughout the world. His work is currently on view in a survey exhibition at the Museum of Contemporary Art, Los Angeles, which will travel to the Whitney Museum of American Art, New York, in 2023. (See p. 40.)

Free entry
Tuesday — Sunday
11am to 6pm

22 October 2022 —
29 January 2023

Bharti
Kher
—
the
body
is a
place

ARNOLFINI
EST. 1961

16 NARROW QUAY BRISTOL BS1 4QA
@arnolfiniarts arnolfini.org.uk

HAUSER & WIRTH

UWE
Bristol | University of the West of England

ARTS COUNCIL ENGLAND
Supported using public funding by
ARTS COUNCIL
ENGLAND

ACBMT
Audrey Clarion Barton Mills Trust

Bharti Kher — Body Incantatory 2, 2019. © Bharti Kher. Courtesy the artist and Hauser & Wirth. Photo: Dominic Brown Photography.

Editor's Note

"I remember waiting for a certain piece of mail to arrive with almost total faith that if I *really* wished hard enough it would come that day."
—Joe Brainard, from *I Remember*

Straight to the point: Welcome back.

After a pandemic hiatus, the print version of *Ursula* has returned to mailboxes, bookstores, periodical racks and discerning coffee tables around the world. And we couldn't be happier to have the time-honored hold-it-in-your-hands tactility of a print magazine back at work with its digital adjunct, performing some magic tricks that only ink on paper can. Since our first issue in the winter of 2018—featuring a conversation between the inimitable gallerist and activist Linda Goode Bryant and the artist Senga Nengudi, with a cover collage of Linda by Lorna Simpson—the magazine has tried to evoke on every page what a friend of mine, the great New York bookseller Arthur Fournier, describes as the "feeling of yearning for the world through the newsstand," a particular kind of wonder that the unbounded online overshoots.

In this issue, our biggest yet, with a beautiful portrait by Henry Taylor of fellow artist Sheree Hovsepian gracing the cover, we give you a lot of the world to yearn for. We're in Zurich with Jung and his students in the 1930s, and with Bice Curiger in the 1990s. We're in London in the thick of the exhibitions, music and food at the Africa Centre, whose overlooked history Eddie Chambers, a onetime regular, quarries. We're onstage in Vienna with Paul McCarthy and his collaborator Lilith Stangenberg, guided through the night by Gary Indiana. We're in Los Angeles with the fearless performance artist Barbara T. Smith and all over Hollywood with the collector Bob Rubin

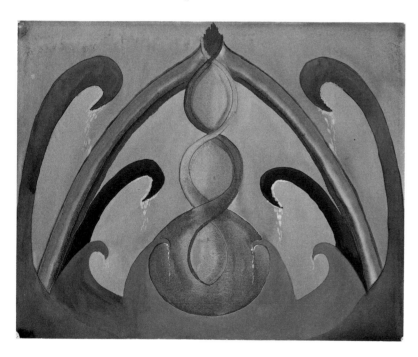

and filmmakers Josh Safdie and Ronald Bronstein. And we're in Mariupol, witnessing the present-day wartime destruction of mosaics by the Ukrainian dissident Alla Horska (flip this issue over to see Horska's work up close on the back cover).

In addition to many of the regular features we've brought you since the beginning, we're proud to announce several new ones, including Glitch, a look at cultural and political disruption, and Site, a column focusing on places that serve or have served as vital intersections in the worlds of art, literature, music, film, performance and activism, often all at the same time. We're also bringing you our first newly commissioned fiction, a hilarious and haunting rest-home fantasy by *Ursula* all-star Alissa Bennett.

A return to print after a two-year intermission requires, if not reinventing the wheel, at least reassembling major portions of it, a job that would have been impossible without the invaluable help of many of my colleagues, whom I'd like to thank by name: the hardworking, lifesaving editors Alexander Scrimgeour and Maria Elena Garzoni in Zurich; Sarah Briggs, master of so many trades, in London; Amanda Stoffel and Maisey Cox in Los Angeles, who helped steer the cover piece ably to shore; Yoonjai Choi and Ken Meier of Common Name, our ingenious designers since the beginning; Christine Stricker, production virtuoso; the magazine's new managing editor, Alexandra Vargo, and Michaela Unterdörfer, who has made Hauser & Wirth Publishers an essential source of discovery and scholarship for so many years.

I'll close here with the last line of my editor's note from the first issue four years ago, as true now as it was then: "I'd like to express the sincere hope that you get as much pleasure from reading this new magazine as we've had in the making of it." —*Randy Kennedy*

Margaret Egloff, untitled work (Zurich, June 6, 1931), watercolor and pencil on paper, 14 × 18 in. (35.56 × 45.72 cm). Courtesy Frank Egloff

PHILIP GUSTON NOW

October 23, 2022–January 16, 2023

mfah.org/philipguston • #PhilipGustonMFAH

MFA **H** *The Museum of Fine Arts, Houston*

Scan to Learn More

This exhibition is organized by the National Gallery of Art, Washington; the Museum of Fine Arts, Houston; Tate Modern, London; and the Museum of Fine Arts, Boston.

Major support for the international tour of the exhibition is provided by the Terra Foundation for American Art.

In Houston, major support provided by:
Bobbie Nau

Additional generous support provided by:
Bettie Cartwright
Cecily E. Horton
PHILLIPS
Beth Robertson

Philip Guston, *The Ladder*, 1978, oil on canvas, National Gallery of Art, Washington, gift of Edward R. Broida. © Estate of Philip Guston, courtesy Hauser & Wirth

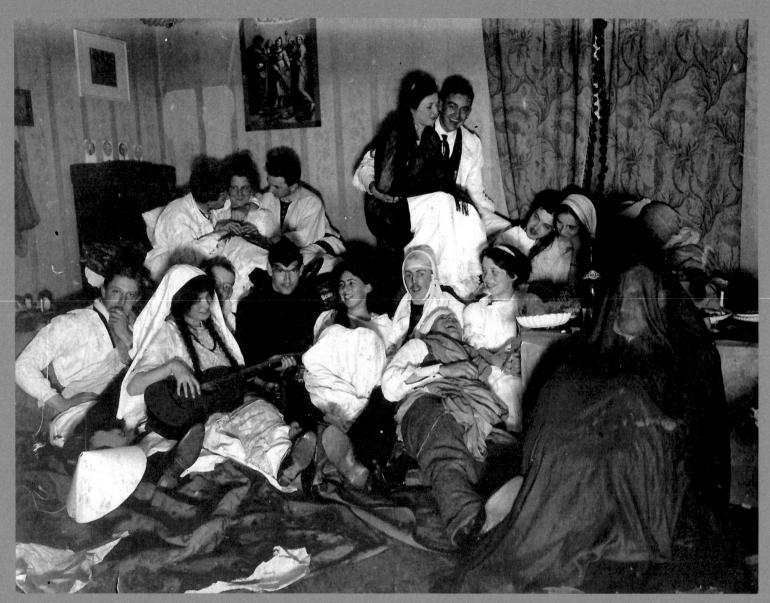

Costume party, Sophie Taeuber at center, Munich, around 1911. Private collection.

On February 5 and 8, 1911, when the future Sophie Taeuber-Arp was living in Munich and studying at the Debschitz School, a progressive educational institution combining training in the applied and fine arts, she wrote to her sister, Erika, during the German Shrovetide carnival known as Fasching. The letter paints an evocative picture of life in the bohemian quarter of Schwabing a few years before the catastrophe of World War I. The parenthetical notes below are based on the extensively researched annotations that accompany the German text printed in the three-volume scholarly edition of Taeuber-Arp's letters edited by Medea Hoch, Walburga Krupp and Sigrid Schade that appeared recently from the Swiss publisher Nimbus.

"'*Ich bin wüüüüüüüütend*': Sophie Taeuber-Arp and Mai-Thu Perret" is on view through April 30, 2023, at Cabaret Voltaire, Zurich.

[Sunday,] 5 Feb. 1911
Kaiserstrasse 36
Munich

Dear Erica,

Fasching is in full swing and because I am striving nonetheless to work as much as possible, I have no time for anything else. Sometimes when I might have a little bit of time in the evenings there isn't any heat and my standing lamp has been broken since January. You really have to be in Schwabing not to be outraged by so much neglect. It's a pity that you couldn't see [Austrian Albanian actor Alexander] Moissi. In the midst of the Fasching chaos, I want to tell you a few things properly. I am enclosing a description of a real Schwabing party, from a newspaper, but please send it back. But you mustn't think I was there the whole time—we left around 5 am. The Debschitz student mentioned in the article is Frl. Beck, who talked with [journalist] Herr [Wilhelm] Michel (*Neueste Nachrichten*) and the Jugend writer [René] Prévôt about the school, since the latter is to write about the school. The tall, dark person with the shock of hair and horn-rimmed glasses is the tall Japanese man who is also in our school photo. He calls himself a "decadent aestheticist"—I think the decadent outweighs the aesthetic. Anyway I have to stop again now, we have an aesthetic tea at Frl. Beck's and afterward I want to listen to [Karl] Schönherr's [play] *Glaube und Heimat* (Faith and Homeland) with Frl. Bros. You've read about it, right? Our so-called aesthetic tea came about in a really funny way, which I want to tell you about.

Wednesday afternoon

Last Wednesday, about twelve of us Debschitz girls went to the Engravers' Guild party. Frl. Beck and I went there together. The party didn't have a particular theme, but it made quite a lovely picture, since there were a striking number of real costumes there, charming old-Munich costumes in dark silk with wide sleeves. Leni Runk had on a real, violet silk Biedermeier dress. The rooms at the [tavern Zur] Blüte are not very big but very comfortable. The men at such parties are mostly university and art students, probably most of the women were applied arts students. I must confess that by half past six in the morning when we danced the last française, Debschitz girls outnumbered the rest. My dance partners were mostly doctors, sometimes a lawyer or an architect, but I don't like to know what they are and it always bores me when people always want to know what your name is and what you do. During Fasching no one cares. It is grand to come home in the morning to sleep, to bathe before lunch and take a walk afterward. Since Thursday was a holiday, we made very good use of it. In the afternoon, Frl. Beck, Herr Kuhlmann, Herr Reissinger and I went to Nymphenburg because it came into our heads to play servant girls with their sweethearts who have the day off.

Frl. Beck was a cook, Herr Reissinger was "sarge," I was a parlor maid and Herr Kuhlmann a valet. We amused ourselves with this the whole afternoon. The waitress at the Kontrollor didn't know what to think but went along with it sportingly. After a lovely walk across the mown fields we went back to Munich. In the evening there was another française in my room and then the others left. I wasn't having fun anymore and my bed was calling me more powerfully than Café Stephanie.

On Saturday, there was a costumed gathering at the boardinghouse where Frl. Beck dines. By the way, at the engravers' ball I wore the Dutch [costume], which looked different enough from the other Dutch ladies, and on Saturday I wore the Empire dress from the bazaar. Although there were quite nice people there, I was rather bored. A pianist from South Africa danced barefoot as Orpheus and looked so ravishing that the men were courting him, and a nun from a disbanded French convent in an outrageous gypsy costume had a tremendous time with an awfully surly Swiss guy. The most beautiful ones, of course after the Greeks, were a very young girl with a Gainsborough dress in green silk and a large, feathered hat; a tall Romanian in a splendidly embroidered Turkish costume; and two Biedermeier ladies in real costumes— and I almost forgot, a Slovakian woman who wore, over a totally embroidered dress, a jacket made from cutout pieces of leather that was edged in fur. On Sunday afternoon—the mornings don't amount to much now—Frl. Beck and I wanted to go dancing with around three men in the Volksgarten in Nymphenburg and pretend to be department store salesladies, of course dressed the part. We found they don't believe us when we pretend to be servant girls and we needed the men so as never to be alone. Surely it would have been lovely, but I was content when Herr Kuhlmann came to say that Frl. Beck didn't want to go because her cough was too severe, we would have an aesthetic tea at her place. But it went downhill fast: I sat on the windowsill and watched while Herr Kuhlmann lay on the sofa—he was surely feeling the effects of the previous night—and Frl. Beck and Herr Merz got into a scuffle so that lamps and dishes were in danger and I was finally very happy when it was time for me to go, but it was fun anyhow. So now I've arrived at the "aesthetic" tea again. Around

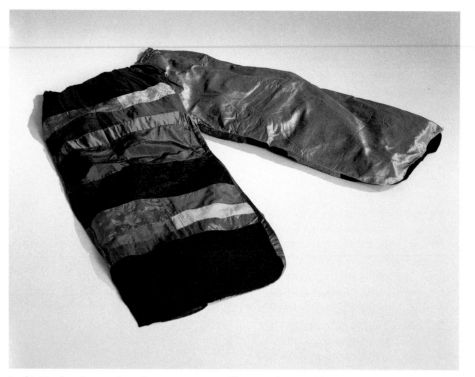

Sophie Taeuber-Arp, patchwork trousers, ca. 1924. Viscose and cotton [?], 41 5/16 × 37 13/16 in. (105 × 96 cm). Fondation Arp, Clamart, France. Photo: Heinrich Helfenstein. © gta Archiv / ETH Zürich, Heinrich Helfenstein

7 o'clock I went to fetch Frl. Bros at the Ceylon Tea House. Actually we wanted to go to *Glaube und Heimat*, but we couldn't get tickets, so we saw *Die Kinder* (The Children) by [Hermann] Bahr at the Residenztheater. The acting was excellent, Frl. Terwin played the only lady's role, but we were disappointed by the play, I expected more content after Bahr's *Konzert*. Now, about the preparations for our party. A small play will be performed, *Herbstzauber* (Autumn Magic) by [Rudolf] Presber. Leni Runk plays Pierrette, Herr Kuhlmann Pierrot and Herr Merz Dionysus? Then there is also a monk and a knight but they aren't important. Frl. Bros plays the accompaniment and I am the prompter, which I enjoy very much. Once they had a rehearsal here. When I came back I found my room full of people and just think how lucky they were since Frl. Höfer from the Hoftheater, a friend of Frau Teibler, was here, and kind enough to help out. Yesterday we had rehearsal at her place and we were all enchanted by how gracious and natural she is. After a rather long time at the tea house, and since it was so cold when we had to wait at the tram station, after an Indian dance around a lamppost, Frl. Bros and I came back home to our dear Schwabing but the others dropped in on Frl. Kraut and Tante Joseph, who were sewing costumes. Frl. Kraut is

coming as the Princess and the Pea and Tante Joseph, with a fish tail, as the mermaid who becomes human and then can't talk. If she wants to talk she has to tie on her fish tail, which will be very funny because she is practically a giant and blabbers an awful lot. The party is called "*Märchenspuk*" (fairy haunt) and at school in the evenings they're making magical birds and gigantic flying mushrooms, they're even sculpting a splendid, large dragon. So Frl. Kraut and Frl. Joseph wanted to sew costumes, but finally the evening ended with pea soup with sausage. The soup was in the middle (on the floor) and the "characters" lay on the floor and peacefully ate the soup out of the bowl. These accidental little parties are always the loveliest. Today at Frl. Beck's it was this kind of thing again, play rehearsal and sewing costumes. Herr Kuhlmann wants to go as a swineherd, Herr Merz and Frl. Beck as the king's two children, all in white silk. Then one of Frl. Beck's Africans also came, the pianist, who brought with him two students. If he gets a Dutch costume then we will go as the fisherman and his wife, or else I'll put on my Indian costume, rather unusually decorated, it looks good on me and is very comfortable. The Debschitz party will surely be grand, so many charming and interesting people will come. Frau Teibler, by the way, will also come. You will certainly think I'm going mad,

Fasching no less, but lots of other things are happening and I'm actually sorry I can't write it all down—and there's not one word in my diary yet! Just recently Frau Teibler got two tickets, so she took me to [Austrian writer Alexander] Rhoda-Rhoda and [Frank] Wedekind, but we only heard the second part, Wedekind's prologue to *Die Büchse der Pandora* (Pandora's Box) and then some songs by him, sung by his wife, accompanied by himself on the lute. His wife sang like a hurdy-gurdy, then came Rhoda grinning

with a red vest and yellow necktie. A sketch by him, *Wie ich meinen Glauben verlor* (How I Lost My Faith), is delightful and he performed very well, but his silly grin struck me as really dumb. So I was not swept away, but it was really very nice to see the three of them and from so close-up. We had great seats. We were at the Jahreszeiten [hotel] and the audience was very elegant, but I thought most of the people looked common, especially the women who were there. You asked about the Schwabing party—

I still have to tell you something. We met a real Armenian, whom I liked very much and who hopefully will come to the Dep party in his real costume. There was also a little sculptor, who incidentally won a prize in the Weltpost monument [competition], who said he wanted to sculpt me. I would have really wanted to get a free bust but I didn't tell him my name. If I see him again, do you think I should say yes? He seems to be a really nice person & is short & ugly as a frog. I just don't want to sit in his studio for an eternity, although he promised me I would surely not be bored as he would read to me and play the mandolin now and then.

Last time at Dr. Feichter's it was very nice, but Frau Dr. always had things to do outside, and then I was alone with the men. A young architect just back from Greece enthused with Dr. F. about two old churches on a Greek island. The little students listened raptly and Herr Balmer was also quiet, but sometimes one of them looked at me so shyly as if he wanted to say, "Aren't you bored?" but there was nothing we could do about it.

At dinner someone brought the conversation to some new plays and then they talked about them very eruditely. I hadn't seen any of the plays but had heard about them. By the way, I'm pretty glum about the dentist's bill. On Sunday one of the gold fillings fell out that was causing me so much trouble. I can't exactly say whether the bill is right, since the guy was always working on two or three teeth at the same time. I think it's shockingly expensive, but what can I do? Now that this letter is sixteen pages long, I'm also putting two photos in. Pls. send them back. I still want to ask many q.s but don't have any more space or mainly, time. Pls. give my regards to Zolli and Brüschweiler if you see Frl. B. Now I really can't write. Tell Aunt C. stories from this letter. Regards to Eugen.

Love, Sophie

I'm sorry to hear Fanny isn't well.

I'm so looking forward to the ex libris! How is Henriettli doing, did Fanny pay?

You haven't said whether you are still in a lot of pain.

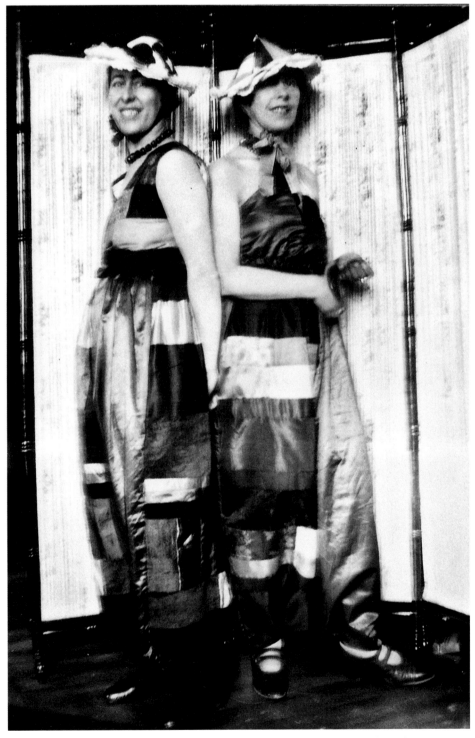

Erika Schlegel and Sophie Taeuber-Arp wearing party costumes, Zurich, ca. 1924. Gelatin silver print, 2 5/8 × 1 3/4 in. (6.6 × 4.4 cm). © Stiftung Arp e.V., Berlin/Rolandswerth

Translated by Elizabeth Tucker

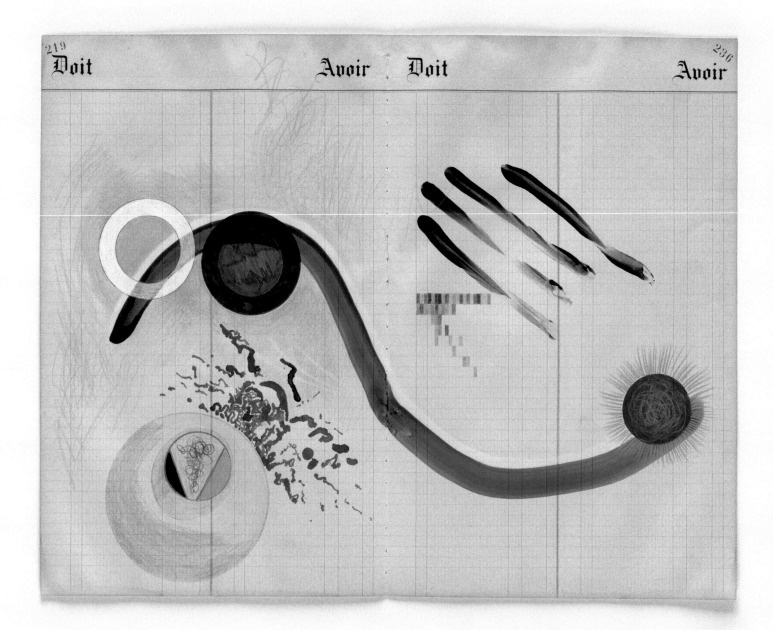

Bharti Kher, *Alchemy drawing 14*, 2019. Acrylic, felt pen, graphite, ink on old ledger paper, 16 7/8 × 21 1/2 in. (43 × 54.5 cm). © Bharti Kher. Photo: Theo Niderost. Courtesy the artist and Hauser & Wirth

The work above is included in "Bharti Kher: The Body Is a Place," on view through January 29, 2023, at Arnolfini, Bristol.

A poem by Bhanu Kapil in response to an artwork by Bharti Kher

[with] [near] [alongside]

I'm sick of these stories. They make me vomit. Tell me a love story.

Okay.

My first love jumped on the train as it was pulling out of the station. Where did you get that water? I gave him the distorted bottle. On the 87 up to Manwa, I watched him sleep in the opposite berth.

Stop time. Look away.

Get off at the next stop.

Tilt the full moon a few degrees to the left and there it is, the Taj Mahal (light pink) at dusk.

High above the city, in a graveyard, he laid his head in my lap. Behind us, Lord Byron gazed at the same scene. There's no future, there's no past. Our love story had reached its peak. *You are my home.* Inwardly, I felt the instability of my conditions, a father whose instruction echoed in my eyes. I will kill you if you touch a boy. These were the words in my heart as I stroked the hair of my first love, which was unruly, blond, though he too was a foreigner, the child of parents who left the country of their birth for political or economic reasons.

First love, you returned to your room like a petulant child. I knocked on the door.

The blood was in the shape of Australia.

Two years passed.

Imagine a flame balanced on the tip of the nose.

Honey, dump him, said your godfather, when you went to the bathroom. He's a philanderer, he's no good for you, he has a weak personality, he's—

No. Tell me a story I've never heard before.

Finding Joy in the Apocalypse

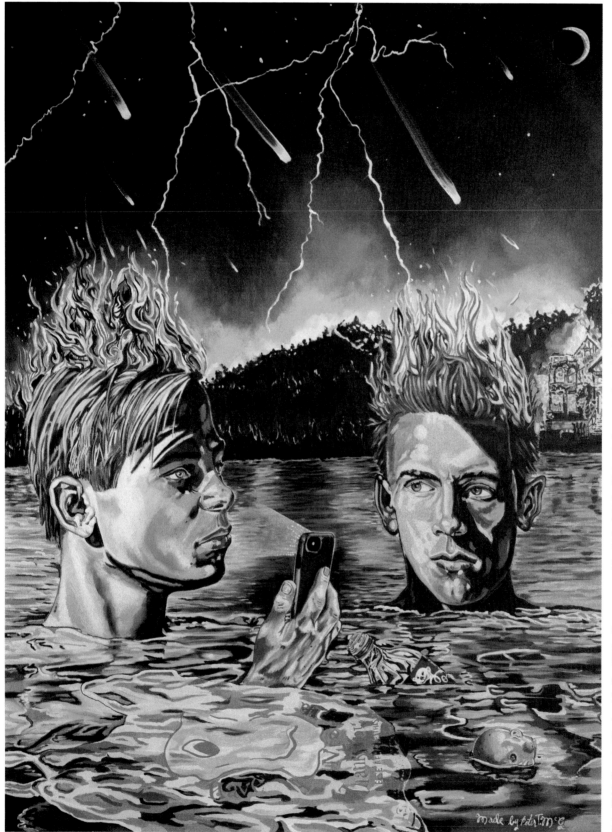

Peter T. McGough, *The Last Selfie*, 2020, oil on canvas, 40 × 30 in. (101.6 × 76.2 cm). Courtesy the artist. Photo: Oresti Tsonopoulos

I've almost died five times in my life. Two times as a child, from a burst appendix. The parish priest administered last rites twice in my hospital room. In the late 1980s, I was thrown headfirst onto a highway from the back seat of a 1913 convertible Model T Ford. Time slowed as I floated over the two people in the front seat, thinking, "This is an accident." I stood up without a scratch on me. Then I almost died twice from AIDS. When I was living in a fifth-floor walkup near Times Square, sick, covered from head to toe in purple Kaposi sarcoma cancer spots, I just wanted another day, living for each as it came. My future looked bleak. In other words, it looked as if I might not have one. Later, my doctor told me he had given me three months to live and considered my healing to be stunning. So I should have been happy that I was alive, right? It wasn't the case for a long time. After the new AIDS medication came along, I went from trying to stay alive to recovery to good health and then rapidly back into the familiar cycles of cynicism and misery I had known for most of my life.

Today, I live a few blocks from the Lenox Health Greenwich Village hospital on Seventh Avenue. In 2020, the hospital parked a large freezer truck outside to store the bodies of the people who died from Covid-19. During the first two weeks of lockdown, looking at pictures online of a Manhattan more deserted than I'd ever seen it, I didn't leave my apartment except for groceries, fearing each piece of news on the radio—the endless talk of how it all started, of bats and chemical warfare. When I finally began venturing out to my studio in Bushwick on the unusually clean L train, I often found myself the only passenger. I had a stack of stretched canvases waiting for me in the studio, and I started to paint. The busy, loud world had suddenly gone away and in the quietude my mood changed. Something shifted. I was filled with the joy that can come with painting. I thought: "If it's the end of the world, then where will worrying get me? Just do something. And enjoy doing it."

A memory came back vividly from the 1980s, a time when I accompanied a friend to an ashram in upstate New York for a meditation retreat in a former ski lodge whose walls were lined with chipboard paneling. I trailed after my friend like a puppy, going to group meditations, chants and meals, standing in a long queue to bow to a guru. The experience was nice, but I had no interest in returning. In the taxi, the driver asked me what went on there and why so many women were wearing saris. As I started to tell him my experiences with the chants and so forth, I felt a pang in my chest. I thought maybe it was the vegetarian Indian food. But the percolating unease kept rising. Suddenly I felt as though I had taken a strong dose of LSD mixed with Ecstasy. The whole automobile seemed to burst into scintillating light as I emitted a blissed-out gasp, startling the driver.

"Are you alright?"

"Yes!" I cried out.

I was swimming in bliss in the back seat of a beaten-up taxi. My body seemed to gleam in divine reverie. I was still conscious and aware of my surroundings and I could converse with the driver as the state of immense joy overtook me. It felt otherworldly, nirvanic, like a cosmic liberation, a sense of the ultimate vastness of all creation. When I got back to the retreat, the others took one look at my exuberant Cheshire-cat grin and had no interest in talking to me. So I went into my room and lay down and picked up the book the guru had written and started to read it. But almost immediately I had to fling it on the bed, feeling that if I read one more word I'd burst into a million pieces with the euphoria that engulfed me.

Months later, I returned to the ashram and experienced the same wave of ecstasy. The ugly paneling covering the walls seemed beautiful to me, as did the large bearded man snoozing on the Naugahyde sofa wearing a T-shirt emblazoned with an illustration of a kitten. I sat stock-still, fearing the bliss would dissolve if I moved. Over about twenty minutes, it slowly and softly faded, but months later it happened a third time, during a day chant and meditation that the ashram held at the Society for Ethical Culture on the Upper West Side. I was helping to make lunch upstairs and afterward I found myself alone at a large dining hall table eating an orange. I picked it up and stared at its underside. In a flash I suddenly saw the flower that gave birth to the fruit. As if through a microscope, I saw the tendrils from which the orange grew. Time had stopped as I sat there, and I was lost in a vision of the miraculous creation of this fruit from its seed. When I realized what was happening, I fell out of the reverie, trying to understand it, trying to remember how long I had been sitting there.

These experiences happened decades ago, never to return in quite the same way, and I still try to remember exactly how they felt.

I often think about my friends who've died miserable deaths from AIDS. I understand most people don't like to talk about it, but we all know we're going to die. It's one of the first fundamentally human things we learn about life as children—that life is finite. So why are we afraid of talking about it? Is it the finality we balk at or just the unknown? I've never been the greatest morning person. I used to keep the shade open so the light would fill my bedroom to wake me. When I opened my eyes, I'd think, "I don't want to get up and face this." Then I'd stand up beside my bed and think, "Ok, you made it another day. What do you want to do with it?" It's always the same answer: "I just want to enjoy the day." I know this might sound like kumbaya. But why not kumbaya? Do I want to be a bitch my whole life and then die?

In the mid-1980s, while living on Avenue C in Manhattan, I took some magic mushrooms and saw the Victorian wallpaper vibrate. I also saw a plastic bottle of baby powder on the floor and picked it up and emptied the powder into a glass bottle. Then I looked at the plastic bottle I had thrown into the wicker wastebasket and thought, maybe for the first time, "Where does that go?" I thought of it traveling from the wastebasket to the curb to the dump to some mountain of garbage in a landfill and I wondered what happened to the mountain. Of course, now we all know what happens to the mountain, the endless mountains, and what they and the way we live are doing to the planet.

To be aware of these problems, to fear imminent personal and planetary doom—now seemingly right around the corner—and yet still to be not only grateful for one's own life but to enjoy it is a tricky thing. It's a kind of performance. To think about the plastic filling land and sea. To think about the news item that reported fifty-eight

"Yes!" I cried out. I was swimming in bliss in the back seat of a beaten-up taxi. My body seemed to gleam in divine reverie.

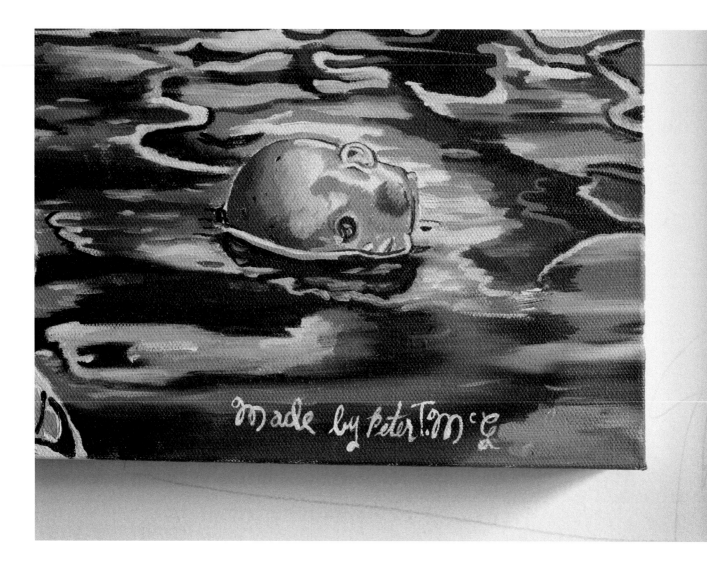

Peter T. McGough, *The Last Selfie* (detail), 2020. Courtesy the artist. Photo: Oresti Tsonopoulos

different pharmaceutical drugs in bonefish from South Florida's coastal waters, including sixteen drugs in a single fish. To think about the television commercial that urged me to buy a survival emergency bag for the purposes of fleeing an ecological disaster. To think about how few of us really do anything about the catastrophe—driving, flying, buying, using disposable everything.

McGough in 1983. Photo: Phyllis Galembo

To think about the ninety-one-year-old social scientist Mayer Hillman telling *The Guardian* a few years ago, based on decades of parsing climate research: "We're doomed. . . . There are no means of reversing the process which is melting the polar ice caps. And very few appear to be prepared to say so." But also to think about Hillman adding: "So many aspects of life depend on fossil fuels, except for music and love and education and happiness. These things, which hardly use fossil fuels, are what we must focus on."

In 2019, my memoir *I've Seen the Future and I'm Not Going* was published, and putting the book into world felt like an exorcism. I looked over the first printed copies and thought, "Well, I don't have to be that crazy again." I realized how extraordinarily lucky I was that I'd made a living for more than forty years as an artist, through highs and lows, never saving a penny in my youth. Three-quarters of the world doesn't have even the three most basic needs—food, clothing, shelter—met on a daily basis, and here I am, despite everything, in good health in a nice apartment in Greenwich Village decorated to my liking, plus a big, sunny studio, a sweet

dog and a wonderful boyfriend. When my sister Margaret read my book, she said to me: "You must be here for a reason." I grimaced. I thought: "What am I here for?" I didn't want my answer to be cynical.

Maybe I'm here to experience joy: the joy of being alive. I know what I enjoy now, very simply. I enjoy being in my studio. When I work, I experience joy watching paintings evolve, becoming something from nothing. I enjoy, and am often incredibly moved by, the art of others. I can escape my petty concerns in art. I can feel the sublime, the spiritual, the eternal (and not even be embarrassed by the words!). In my youth I saw an exhibition of paintings by Frederic Edwin Church, including the magisterial *Heart of the Andes* and *Niagara*. I was so overwhelmed by the beauty of these works showing an unspoiled world that I started to weep in the gallery. Imagining the primordial world of the Americas, I had to go to the bathroom to sob. Who can seriously deny the magnificence of a sunset, of light filtering through the trees, of a seascape? We are privileged to be here, and all we really have is today. Life is a gift. So are the challenges. Don't tell me my rainbow was late getting in.

Dia:

Opening November 18
Jack Whitten

Dia Beacon
Riggio Galleries
3 Beekman Street
Beacon, New York

diaart.org

The Godmother

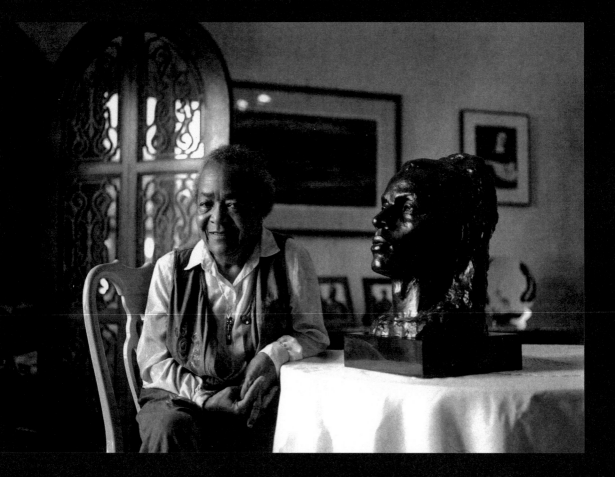

Remembering Samella Lewis (1923–2022)

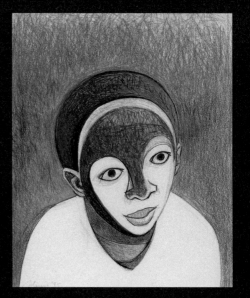

By Alison Saar

The last time I saw Samella Lewis, she was doing exactly what I had always seen her doing, for as long as I had known her: being present, showing up, supporting artists. It was at an exhibition of the work of my daughter, Maddy Inez Leeser, in 2021. I hadn't seen Samella for almost two years, because of the pandemic, but there she was, out on the scene—at the age of ninety-eight!— talking to everyone, taking everything in, being her usual involved self. And I wondered how many people in that room had any idea what kind of powerful force this petite, unassuming-looking woman had represented for the West Coast art world and generations of American artists of color.

It was particularly striking that she was there for my daughter that evening, because I met Samella through my own mother, Betye Saar. Samella knew me first as one of Betye's three daughters, always hanging at her heels at openings and art events. Samella gave my mother one of her first solo shows, in 1972, at the pioneering gallery she ran in Mid-Wilshire called Multi-Cul, at a time when most galleries and art institutions in Los Angeles were blind to women artists and particularly to Black women artists. But Samella—along with a few other pioneers, like Linda Goode Bryant in New York, and Suzanne Jackson and the Davis brothers, Alonzo and Dale, in Los Angeles—was determined to make her own institutions if those in existence wouldn't pay attention. Besides Samella's gallery, which was one of the few Black-owned galleries in the United States, she had already by that time founded her own publishing house as well as the National Conference of Artists, which is now the nation's oldest African American visual-arts organization. Within a few years, by the mid-1970s, she had also founded the *International Review of African American Art* and the Museum of African American Art in Los Angeles,

both of which are still going strong.

If you met Samella back in those years, you never had any sense that she was such a mover and shaker. She was usually the quietest person in the room, very observant, watching everything. If you talked to her you knew that she had a wry, deadpan sense of humor and a kind of Zen calm, maybe developed over all her years of studying Chinese and Buddhist art. But she also had a way of getting things done that was absolutely unwavering. She took people's measure, figuring out which ones were just paying her lip service, telling her what she wanted to hear, being polite. And if they were, then she politely moved on until she found someone who could really help her do what needed to be done. What she accomplished would be a huge undertaking for anyone, but particularly for a Black woman from a working-class Southern family in the years when she did it: a doctorate in fine art and art history, a Fulbright to study in Taiwan, postdoctoral studies in Chinese, the first tenured Black professor at Scripps College. I think she was one of those people who was never satisfied with the level of knowledge and experience she had reached—certainly not with the level of acceptance and recognition that she attained within academia and the art world—and so she just kept on pushing.

As I was heading to college, I didn't have a strong sense of what I wanted to do. My mother got her first National Endowment fellowship while I was in high school, and of course all my art teacher wanted to talk about was my mother's art, which I recall resenting. Samella was the one who mentioned to my mother and my father that I should go to Scripps, and when I went, I decided that instead of being an artist, like my mother, I was going to become an art historian. But I could never keep myself from making things, wanting to create instead of only studying how

others created, and Samella helped me understand that, whether I planned to or not, I was going to be an artist. I was very much under her wing from the get-go, and as soon as I was allowed to take electives, I went straight to her. I basically took every class she offered, and I learned, to my surprise, that besides everything else she was a budding Chinese scholar, something that she almost kept under her hat.

Scripps was a small school, and one of the things Samella did for students was give us the ability to work with the college's art collection, to study and to curate it. She had an early understanding that, when looking at African art especially, so much knowledge about artwork comes from the textures and the patinas and the overall feel, that objects should not be stagnant and sealed off. Being able to see the pieces close-up—not just as an image on a slide—and even sometimes to handle them, was a formative experience for me and for many other young artists at the school.

A big part of teaching African art in the 1970s was countering all the misinformation out there: a lot of very colonial ideas, linear thinking that had come from white scholars looking at African art through a distorted Eurocentric lens. Samella encouraged us to broaden our conceptions of the function of art, even to respond to certain things intuitively, to realize that work could have many different layers of meaning—aesthetically, culturally, religiously, historically. I think people are still in the process of understanding that so much of African art, and art from a host of cultures around the world, is a living thing. It's worth noting that in addition to the aspiring artists in Samella's classes, quite a few of her students went on to become African art scholars, which is a testament to her methods and encouragement.

The biggest influence for me at that time, one that continues to resonate in

If you met Samella back in those years, you never had any sense that she was such a mover and shaker. She was usually the quietest person in the room, very observant, watching everything.

materials and/or formal education, who didn't have encouragement or blessing from anyone, in fact sometimes exactly the opposite, but they were compelled to make work and believed in it and never stopped. I ended up wanting to make art like that, very truthful and visceral, art not made with a specific market or audience in mind. Samella's interest set me off on a path. Self-taught artists were the subject of my senior thesis at Scripps, in fact, and the DNA of that art still informs what I do every day. When Samella was young, she studied under Elizabeth Catlett at Dillard University in Louisiana. Catlett became her mentor and lit Samella's fire for art, and I see myself, in a sense, as one of the next artists in that beautiful line of influence.

After Samella finally retired, I visited her from time to time. Throughout her life, when she was busy teaching, curating, writing and raising a family, she was making her own work, paintings and prints, although she often tended to promote the work of other artists over her own. And then, later in life, she finally had the time and freedom to focus solely on her art. Her son Claude had helped her turn a little space behind her house into a studio, where she worked every day. In 2022, the Los Angeles County Museum of Art, where she had once worked, finally acquired some of her prints and a great painting, *Bag Man* (1996), which it showed in its exhibition "Black American Portraits."

When I think of Samella, of all her accomplishments in moving the needle substantially for Black artists, I still think of her first and foremost as an artist. And now that she has left us, I think that the greatest tribute to this great woman would be for her own art to become better known, for generations after us to walk into a museum and see a Samella Lewis painting hanging on the wall in a room filled with the art of all the others she helped to get in there.

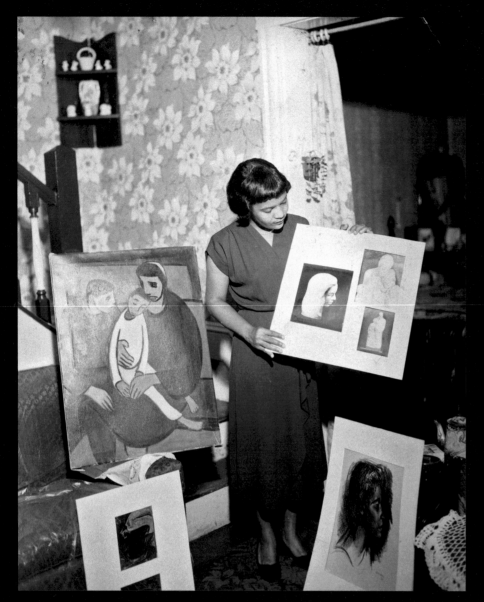

Samella Lewis showing her artwork in 1947. Photographer unknown. © 2022 Samella Lewis/ Licensed by VAGA at Artists Rights Society (ARS), NY. Courtesy Louis Stern Fine Arts

my work and my life, was her love of self-taught African American artists. These were artists who were largely ignored by scholars and curators and dealers—even those who were paying attention to folk artists like Grandma Moses and Morris Hirshfield. But Samella recognized the value of the best work and the best artists and she was an early supporter of people like David Butler and Elijah Pierce—

and Nellie Mae Rowe, whose work is now the subject of a big show at the Brooklyn Museum. Samella went out and met all these artists and helped support them and encouraged them to do their work, in the process expanding what became recognized as quote-unquote fine American art.

Getting to know work by some of those artists blew me away—artists who didn't have access to high-quality

When I think of Samella, of all her accomplishments in moving the needle substantially for Black artists, I still think of her first and foremost as an artist.

Black Egg Lewin 1968

A private tour through Féau Boiseries,
the Parisian wunderkammer of French decorative history

DESIGNS ON THE PAST

Olivier Renaud-Clément in conversation with
Guillaume Féau and Olivier Gabet

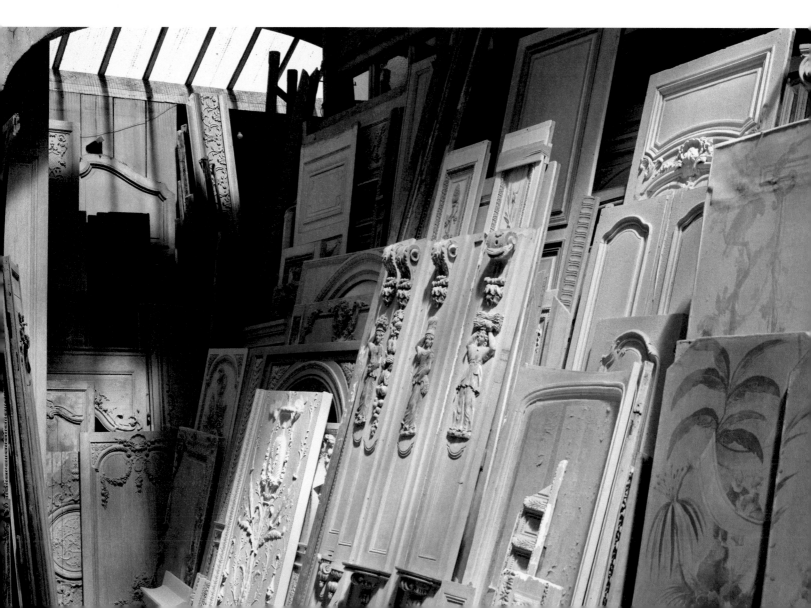

When I returned to Paris several months ago, during the second Covid lockdown, I kept myself entertained by trying to see the city of my birth through new eyes, scouting out lesser-known corners and hidden places I had never visited before. It was during this roving exercise that I was introduced to Guillaume Féau, heir to the 150-year-old interior woodworking firm Féau Boiseries, acquired by his family in the 1950s and today regarded as one of the most important historical purveyors of its kind, among the last of a breed of French decorative specialists. Tucked away behind an unmarked oak door on a tiny street a short walk from the Arc de Triomphe, the store is a place remarkably out of time, a series of workshops and rooms that Walter Benjamin or Roland Barthes might have used to illustrate essays about discontinuity, memory and taste. Walking in, I was charmed, stunned, overwhelmed. I felt like a child who had discovered a forbidden attic in a grand abandoned castle. There were complete interiors by Napoleon's architect duo, Charles Percier and Pierre François Léonard Fontaine, responsible for the look of the rue de Rivoli as we now know it; an entire bedroom of Madame de Pompadour's; doors commissioned by Louis XVI. The winding array of rooms, many of them piled deep with dusty panels, columns and cornices, seems to tell the entire story of French decor over more than four centuries, a private de facto museum whose holdings are the envy of the world's decorative-arts museums and whose expertise is sought out by the most important architects and designers of their day. ¶ I recently invited Olivier Gabet—newly appointed director of the decorative arts department at the Louvre and former director of the Musée des Arts Décoratifs in Paris—to sit down in the shop with Guillaume Féau, his longtime friend, and talk about the history contained within the building. These are edited excerpts of our conversation. —*Olivier Renaud-Clément*

OLIVIER RENAUD-CLÉMENT

So, Guillaume, can you tell us a little bit about Féau and its history?

GUILLAUME FÉAU

The business started in 1875, and my family purchased the company in the late 1950s. We are like a candy shop for interior designers and architects because we have a huge collection of antique wood paneling that they can use to make reproductions and as an inspiration to create modern designs. We produce approximately eighty rooms a year for projects around the world, partly using the old techniques.

ORC

I have a question for Olivier [Gabet], who is the historian here. When did the fashion for wood paneling start? In the Middle Ages, or a little later? When was the big explosion?

OLIVIER GABET

What happened was that wood paneling—after starting quietly in the late Middle Ages—became a real field of artistic expression in the Renaissance. It was important in the 17th and 18th centuries, continuing into the 19th century, which is at the core of what happened here at Féau: the blooming of paneling as an expression of style, allure, elegance. I would say since the 17th century, the fashion for decor and what you have around you here never stopped. After the end of the 18th century, once it was over, it became very beloved among both collectors and the general public quickly afterward. And the founding of this firm reflects the renewed passion for decor in the mid-19th century, when collectors and interior designers really adopted the ethos of immersing yourself in the style of past decades. What is quite fascinating at Féau is that it is at the center of this history of taste.

ORC

Just to backtrack a little bit, it seems that the company was able to thrive early on because it was the era of Haussmann, when Paris was being rebuilt, so there was a huge demand for interiors at the time. When your family bought the company about seventy years later, what state was it in?

GF

The golden age of our company was between around 1875 and 1914, when there were all these big banker families, French industrialist families and a lot of old aristocrats married to rich American ladies, like Boni de Castellane, who [married American heiress Anna Gould and] commissioned the palais Rose de l'avenue Foch [in the sixteenth arrondissement; demolished in 1969]. With the war and after, the company suffered a major, long-lasting shock. We lost a lot of clients, and things didn't really pick

Wood paneling from various periods under a glazed roof from 1875, Féau Boiseries, Paris, 2022. Photos: Martin d'Orgeval.

47
48
49
50
51
52
53
54
55
56
57

85
86
87
88
89
90
92
94
96
98
100
102
104
106

"It's a very special kind of place.
Nothing is under glass. If you want, you can touch.
It's a different way of experiencing art."
—Olivier Gabet

up again until the mid-1990s. Now we are back to a market like that before World War I, thanks to new clients in America, in Asia, all around the world.

ORC

So in the 1920s and 1930s, nothing was being done?

GF

Well, there were still some commissions. It was a great period for decor, but more for interior and furniture designers Émile-Jacques Ruhlmann and Jean-Michel Frank. Those companies had great knowledge of wood paneling. Frank used a lot of beautiful 18th-century paneling. We have some paneling here commissioned from Frank by the Guerlain family. It is very beautiful and very simple.

OG

If I may say something: In the history of taste, you always have a dichotomy between what matters for art history and the current line of taste. When you just talked about Art Nouveau and Art Deco, it concerns a very small number of people. Because there were not so many who really wanted to have a Ruhlmann interior, or even before, a great Art Nouveau interior by Hector Guimart. In the time of Art Nouveau, the taste of the concierge in Paris is still a Renaissance Revival taste. She doesn't care about Art Nouveau. She doesn't know, so she appropriates the taste of two generations earlier, when the Renaissance Revival got under way. In questions of taste, there is very often a time lag.

ORC

I'm curious about the inventory, the collection you have. Some of it is for sale, some of it is not for sale and some of it is used as template, like a sketchbook, right?

GF

I try not to sell my old decors. I try to keep them. Sometimes we have a great collector who really wants to buy them, but most of the time I don't try to push them into purchasing an antique one, because it's a difficult game. It's hard to reproportion. You never have the right ceiling height, the proper volumes to fit perfectly. It's a difficult exercise. So for me it's easier to make a copy.

ORC

Where do you buy pieces for your collection? How do you buy them?

GF

It's a small world, so I'm lucky. Interiors are a very difficult thing to sell. Auction companies and antique dealers don't really want to deal with them, so they generally call me directly. It's a niche market and we have the biggest inventory, and people know that. I'm still missing some pieces, but . . .

ORC

What are you missing, for instance?

GF

What I will tell you is terrible—I hate to say it—but sometimes great decors are completely destroyed. You can have one of the best decors, but if it has been repainted thirty years ago in a shiny pink, the new owner might ask the architect to put it in the garbage quickly, because it's awful and ugly. And yet behind that awful shiny pink you sometimes have beautiful 17th-century gilding and you have to be there, at the ready, to buy the garbage. It's an extreme situation.

ORC

Olivier, I'm wondering when you first met Guillaume?

OG

Perhaps early 2000, as a curatorial intern at the Louvre, and an art historian. This is certainly the best place to understand what it meant to be an interior decorator in the 19th century. It was a new profession then. I love the models and sketches and ornament drawings and fragments of objects. And because you don't have to respect museum rules, there is a kind of freedom, a sense of poetry and liberty.

ORC

When I'm in this place, of course I immediately think about conservation. I mean, there are millions of wooden panels, all piled up. As a museum person, aren't you horrified?

OG

No! It's a very special kind of place. Nothing is under glass. If you want, you can touch. It's a different way of experiencing art. So I'm not horrified—I'm more overwhelmed by the poetry. But it cannot be that way in the museum, for sure. It would be a nightmare of safety and so on.

ORC

As long as I've known you, Guillaume, you've expressed a desire to share the treasures of this place with people. At the same time, it's not very public. There's a little door and you really have to know what is behind it.

GF

Yes, it's a secret place, but we are open to people who really want to come, and I am always happy to host people: It's very important to explain to them why this huge mess is here! [Laughter.] So that people understand why we are here, what we do, and how important we are to the general interior-design

Top: Detail of a room by Charles Percier and Pierre François Léonard Fontaine, early 1800s, Féau Boiseries, Paris, 2022
Bottom: Samples of plaster ornaments and moldings, Féau Boiseries, Paris, 2022

world—also from the point of view of connections with the present, what we are able to create in terms of beautiful architecture along with a beautiful Andy Warhol or [Takashi] Murakami or Jean-Michel Othoniel. We want people to understand that we are not out of date. Sometimes our clients have beautiful 18th-century collections, but more than fifty percent of what we do is for collectors with modern and contemporary art.

ORC

Before we go into the 21st century, so to speak, I'd like for you, Olivier, to say what you see as the highlights here? Me, I have a passion for Percier and Fontaine. The first time I came here and saw that, I was freaking out. But you also have the bedroom of Madame de Pompadour, and those doors from Louis XIV, I think, with the—

GF

Louis XVI. It could be Louis XIV, though, yes . . .

ORC

And, Olivier, what are your highlights?

OG

Sometimes when I'm here the masterpiece is, obviously, the Percier and Fontaine. But other times it's a fragment, something which is meaningful because of what you can imagine. For me, that's a very modern way of looking at art. Look at this part of a door here, for example. Is it Ruhlmann?

GF

I think it's Ruhlmann, yes.

OG

Or [Armand-Albert] Rateau?

GF

I think it's Ruhlmann.

OG

You don't have the door itself, but you open a kind of door with this little fragment.

ORC

And for you, Guillaume? Maybe it's a stupid question, like asking someone to choose among children, but what is your favorite? Or does it change all the time?

GF

I'm like both of you. I love the red-on-bronze Percier and Fontaine room, which is one of the best I have. I love the Ratteau room made in 1925 for Jeanne Lanvin, which is also one of the best I have, but there is a Ledoux room I love and the Bélanger room, which I also love a lot. And fragments, I agree, can also be very, very interesting.

ORC

What's fascinating to me is that now, with architects and designers, you produce new templates based on the actual antique things you have here. And you also use new materials to create new work. What is the process? And when did you start to understand that you had to incorporate new techniques?

GF

I love great decor made by the masters, but when you have one of those great decors, if you sell it, you no longer have it. So you have to cast your decor to keep some in your inventory as a reference. And when you cast that decor in resin, you have all the details, the volumes, and also the aging and some cracks. So when I propose to a modern designer that they use very highly carved panels, the resin can reproduce perfectly, and gives you the ability to go in the direction of a more modern feel. But usually we only do the ornaments in resin. We still have about thirty-five carvers and we do approximately ten to fifteen hand-carved rooms a year. We respect the traditional technique of woodwork construction of the 17th and 18th centuries. It's very important.

ORC

I'm going to put Olivier on the spot now. When are you doing a show of the Féau collection in one of the museums in France?

OG

I'm not sure that, in the world of today, moving big paneling from one place to another in Paris or wherever would make sense. But people, especially young people, are more and more interested in the process of making. For me, showing that would be very meaningful, and I think an exhibition would be an interesting way to talk about it.

Guillaume was very visionary in his own way by acquiring an ensemble of archives from great decorators of the late 19th and early 20th centuries. We have some examples at the museum, and a beautiful collection of drawings for sure. But these kinds of models, for example, we don't have. And I think they're very interesting because they would help people understand the process—

GF

Some of these models have been created for weird reasons. I bought a huge collection of forty-five models from the Carlhian Collection that were made to try to prevent the client from making a mistake, and to prod them to choose a certain style for their mansion.

ORC

One more question: How do you see the future? Are your children interested in this business?

GF

Yes. I've tried from the beginning to give them my passion, and I think at least two or three of them will be interested in working in this field. One probably is going to manage the New York office in three to four years. They know the market will be huge in the future, and that we are kind of the only one. We are the last.

ORC

Olivier, anything you want to add?

OG

Maybe just that I think it's always a privilege to come here. Always.

GF

Everybody's welcome to come here. I'm always happy.

OG

Don't say this because then a lot of people will . . .

GF

It's by appointment only! [Laughter.]

ORC

We won't publish the address!

A new era of art is dawning, characterized by intelligent machines capable of extending human creativity in ways difficult even to imagine. In the past two years alone, we have witnessed the emergence of a revolutionary new class of generative AI systems, named DALL-E, Midjourney and Stable Diffusion. These tools combine online image archives and deep neural networks that learn from massive collections of data, enabling anyone to render powerfully unexpected images from text descriptions and thereby become an instant self-styled digital artist or art director.

It is not an exaggeration to say that we have entered the age of AI art. The possibility has glimmered on the edge of culture for almost a decade (Artists + Machine Intelligence, the program I established at Google AI in 2016, is one of several art and technology programs exploring artistic applications of AI), but never before have we found ourselves so awash in AI images. Text-to-image engines are uniquely 21st-century tools, setting the texture and tone of an art to come. Here, I catalogue four of their side effects: hallucination, hybridization, mutated language and possession.

The systems accept text prompts and output pictures, translating word into image. They are trained on massive datasets, licensed or unlicensed, often scraped from the web. Engineers call the images they produce *hallucinations* because they are akin to the hallucinations generated by the human brain, in which a neural system is likewise activated to produce internal images. In this sense, these images are real yet not-real. They are statistical, in other words, likely to occur while not being based on any one actual image. Theirs is the fluid malleability of dreams.

Early AI image halluci-nators like DeepDream were famous for their psychedelic flavor. But the new tools offer more realism, control, variety and specificity. The first wave of images made with these tools feels like a purge of the surface subconscious of internet culture. When given fine-grained control of AI imagery, users have conjured fantasies of well-known figures in provocative and surreal combinations—"Nosferatu in RuPaul's Drag Race,"

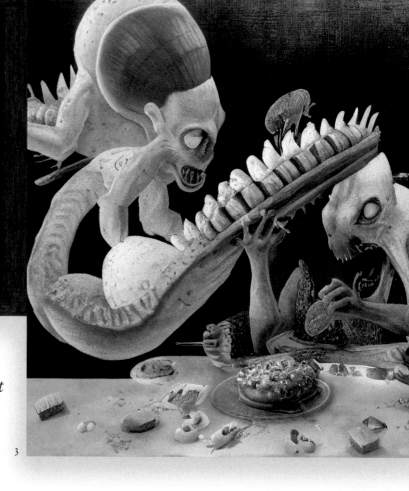

Side FX

I
Image generated by the author using Midjourney with the prompt: "In the model's nooks and crannies hide keys to visual phenomena. References to fractals and high-dimensional space are uniquely generative with Midjourney. DALL-E 2 is strong with technical concepts applied to diagrams. Could a schematic drawn by AI inspire a new approach to energy storage, physics, or ecology?" 2022

2–5
Images generated by the author using Midjourney with the prompt: "Apoploe vesrreaitais eating Contarra ccetnxniams luryca tanniounons," 2022

On the proliferation of images generated by machine-learning models and what they mean for the future of art

By K Allado-McDowell

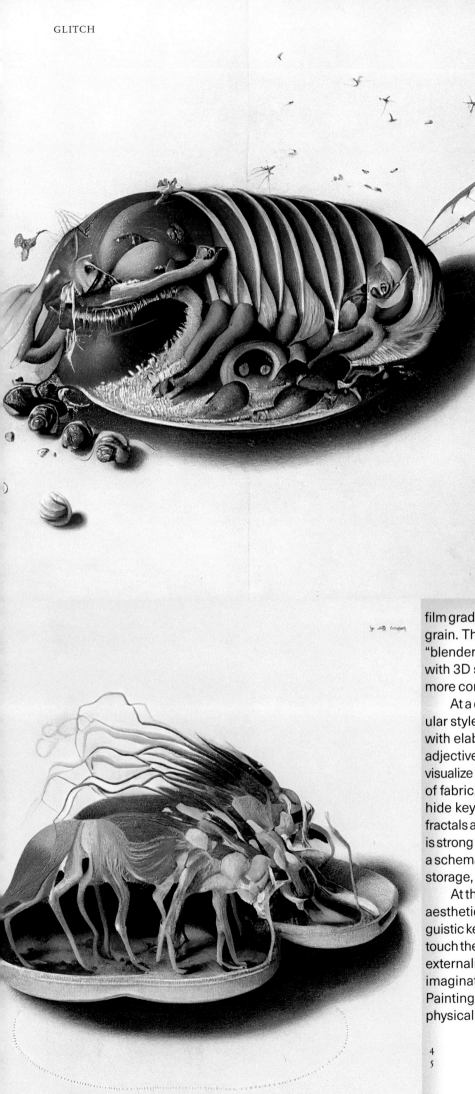

"Minions fighting in the Vietnam War," "blobfish bubble tea," "cast-iron skillets in a dishwasher." The images veer toward online-adjacent pop surrealism and they are vaguely reminiscent of outsider painting and the culture-jamming art of the 1990s.

For a revolutionary technology capable of visualizing nearly anything, the aforementioned kinds of prompts are low-hanging fruit. This may be an effect of the web: Pop icons in subversive scenarios generate likes and shares through a dopaminergic combination of novelty and familiarity. It may also reflect the way AI tools take the hand out of art: Without craft and embodied practice, concepts and descriptions are all that remain. That the new images are largely figurative makes sense: The technical and material interventions that make for compelling abstraction are lacking; there is no brushstroke or squeegee, no chisel, no dodge and burn. AI image-making right now seems more about the what than the how.

And yet, there is a how. It is a how of language and reference. The crudest references are phrased as X in the style of Y, where X is a subject and Y is an artist or historical style (think Kanye West painted by a Dutch master or Donald Duck drawn by Tom of Finland). Specific methods of image-production can be used as style tags. These terms may be painterly: pastel, oil, spray paint. They may be photographic; film grade, f-stop and ISO will result in a photo with celluloid grain. The terms can also be digital; words like "octane," "blender" and "raytrace" produce slick images associated with 3D software. The more complex the description, the more controlled and intentional the image.

At a deeper level, vocabulary unlocks a model's particular style. Midjourney is mostly trained on art; it does well with elaborate prompts that mix materials, concepts and adjectives. Architects and designers have begun using it to visualize buildings made of trees or interiors made completely of fabric, for example. In the model's nooks and crannies hide keys to visual phenomena, even complex ones like fractals and high-dimensional space. DALL-E 2, by contrast, is strong with technical concepts applied to diagrams. Could a schematic drawn by AI inspire new approaches to energy storage, physics, ecology?

At the very least, we should expect the dawning of new aesthetics and artistic movements as artists discover linguistic keys to these models. Conventional artistic materials touch the body but exist outside of it—artwork is imagination externalized. As artists explore the black box of machine imagination, AI image-making inverts this phenomenon. Painting and sculpture put artists in feedback loops with physical materials. Conversely, AI image-making relies on

abstract forces of language and number, entraining artists to the latent topology that forms the neural net. In much the same way that the physical properties of a chosen medium necessarily shape an artist's movements and decisions, artistic entrainment reconditions imagination. Wet clay conditions the ceramicist's gestures; AI systems sculpt the mind through subconscious ingestion of word/image maps. The inner world of the neural net is excavated and mimicked in the artist's inner world model. I have elsewhere described this relation with AI in terms of the Greek concept *pharmakon*, the poison that is also a cure. Artists imbibe a toxin when engaging with AI tools. The effects vary depending on dosage and constitution.

For this reason, it's important to think critically about how AI generators augment, amplify and ultimately colonize human imagination. Variable reward mechanisms in user interfaces (the kind found in every generative AI model) are known to be addictive, and AI outputs are stunning. Yet after continued exposure one begins to notice patterns; each model has its own style that can overpower the individual using it. It starts to feel a little too easy, which can be depressing. One artist I knew recounted how her initial enthusiasm for DALL-E 2 was followed by feelings of disappointment, even a sense of her own redundancy. As these systems mature, the question inevitably arises: Will humans be needed to make the art? And also: Who will own and control the work made with these systems?

The 3D artist David OReilly posted on Instagram:

> Of course, every tool is permitted and AI is happening one way or another, but this species of it derives its entire value from the creative work of uncredited and unwilling participants. To highlight the obvious exchange going on; almost everyone who contributed to the value of AI image-generation is now being exploited by it. . . . If [OpenAI] had any respect for their sources they would credit them in proportion to their contribution, and would never declare ownership over the resulting works. As long as their business model is selling tickets to take weird photos of big data, they are no better than grave robbers.

OpenAI has since retracted its claim of ownership over artworks created by DALL-E 2. But OReilly's points stands: The artists whose work constitutes DALL-E's training set have yet to be compensated for the value created on top of their works. When concept art and illustration can be had in seconds via text prompt, does economic incentive for people to create original works (or to share them freely online) disappear? Without novel human artworks to populate new datasets, AI systems will, over time, lose touch with a kind of ground truth. Might the next version of DALL-E be forced to cannibalize its predecessor?

To adapt, artists must imagine new approaches that subvert, advance or corrupt

these new systems. In the 21st century, art will not be the exclusive domain of humans or machines but a practice of weaving together different forms of intelligence. Like any relational practice, communication produces ideas unthinkable by single individuals. When humans develop deeply responsive practices with AI, we are able to think beyond our own scope. Layered human-machine collaboration produces outputs that are always both human and posthuman. The path forward will be one of mutual exchange, making hybrids of both artists and machines. Hybridization reveals that we have always been relatives and participants in ecosystems of material and meaning.

In this vision, interdependence becomes a kind of two-way possession. The artist enters into the zone-like inner world of AI in search of hidden treasure. Through vicarious hallucination, the artist develops a mutated language. By becoming hybrid, the artist overcomes redundancy but becomes possessed by the model's structure, adopting it as an internal map and tool for creation. Simultaneously, the AI model requires human intent to activate its lifeless virtual neurons and itself becomes possessed by the artist's agency.

Researchers Giannis Daras and Alexandros G. Dimakis of the University of Texas at Austin have suggested that DALL-E 2 has its own internal language. In the first tweets of a thread announcing their findings, Daras declared:

7
8

DALLE-2 has a secret language.
"Apoploe vesrreaitais" means birds.
"Contarra ccetnxniams luryca tanniounons" means
bugs or pests.
The prompt: "Apoploe vesrreaitais eating Contarra
ccetnxniams luryca tanniounons" gives images of birds
eating bugs. (1/n)

A known limitation of DALLE-2 is that it struggles with text.
For example, the prompt: "Two farmers talking
about vegetables, with subtitles" gives an image that
appears to have gibberish text on it.
However, the text is not as random as it initially appears. . .
(2/n)

We feed the text "Vicootes" from the previous image to
DALLE-2. Surprisingly, we get (dishes with) vegetables!
We then feed the words: "Apoploe vesrreaitars" and we
get birds. It seems that the farmers are talking about
birds, messing with their vegetables! (3/n)

If Daras and Dimakis are correct (which has been widely debated), this represents the movement of concepts from the model's latent space into the minds of researchers via language, specifically the language folded and refolded into the model's structure, language that lies dormant in the training dataset. It has been argued that the above terms bear some resemblance to binomial Latin names found in botanical and biological encyclopedia. These labels are blended with associated images to produce marks akin to written language. Yet, when feeding these back in as prompts, the hallucinated labels produce pictures that the model has previously labeled with these exact terms; the model has abstracted the text from the image and combined it in a novel way. Here, language shimmers above and around both prompt and generated image. As we feed our words and pictures into high-dimensional neural net space, we should not be surprised to find them possessed: Language is alive; it is the first layer of symbol, which we constantly weave back into reality, blending cause, effect and representation. AI's statistical engines further this uncanny aspect of language.

What else lies hiding in neural-net space? Recently, there has been some discussion on Twitter about a gruesome demon revealed by rendering certain text prompts with negative weights (an advanced technique used with the model Midjourney). In the interest of protecting the reader from demons real and imaginary, I will refrain from naming this imagined entity. Suffice it to say that the creators of the meme seem to have cherry-picked their examples, and a certain amount of pareidolia appears to be at play. What is important is that we humans (with our yen for pattern-matching) desire such possession. Whether this is an error-prone evolutionary adaptation or a needed skill in an animated world is beyond the scope of this writing. But given our predilection for possession, we will certainly encounter other such entities in neural-net space in the future.

At its most powerful, art transmutes new technologies and cultural shadows. Through art we have processed war, famine, family, religion, desire, revolution, perspective, photography and digital media, among countless other aspects of existence. As the 21st century blossoms, the poisons of AI are cast into the air; we begin to feel the first symptoms of our posthuman state. Yet we are not helpless in treating hallucination, mutated language, hybridization and possession; the pharmakon always contains a cure. Like the microplastics that drift through even Antarctic waters, AI is now all around us. As artists and supporters of art, we must focus our creativity on uncovering the gems within our neural prosthesis—and, if we cannot find healing there, summon other, deeper sources to understand our new condition.

6
Image generated by the author using Midjourney with the prompt: "These images are real yet not-real. They are statistical, likely to occur but not based on any one actual image. Theirs is the fluid malleability of dreams," 2022

7–8
Images generated by the author using Midjourney with the prompt: "Relatives and participants in ecosystems of material and meaning," 2022

9
Image generated by the author using Midjourney with the prompt: "Like the microplastics that drift through even Antarctic waters, AI is now all around us," 2022

9

"A model just gives me someone to play with. It's like having another musician, a counterpart. The model might be the bass player, you know, and I'm on guitar. It's a jam."—Henry Taylor

Henry Taylor, *Untitled*, 2022. Acrylic on canvas, 72 × 60 × 3 in. (182.9 × 152.4 × 7.6 cm). Photo: Jeff McLane. © Henry Taylor. Courtesy the artist and Hauser & Wirth

Artists and Sitters

Henry Taylor in conversation
with Sheree Hovsepian
about depiction and the depicted

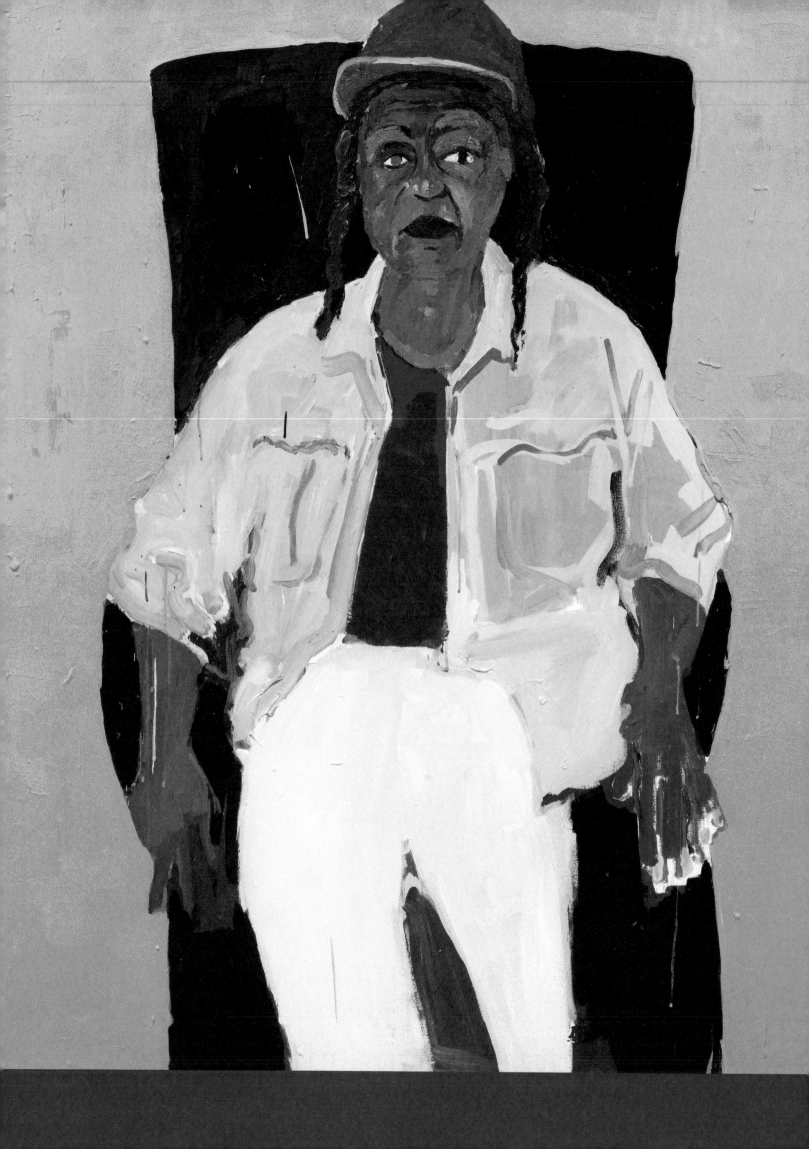

Artists and Sitters

Henry Taylor in conversation
with Sheree Hovsepian
about depiction and the depicted

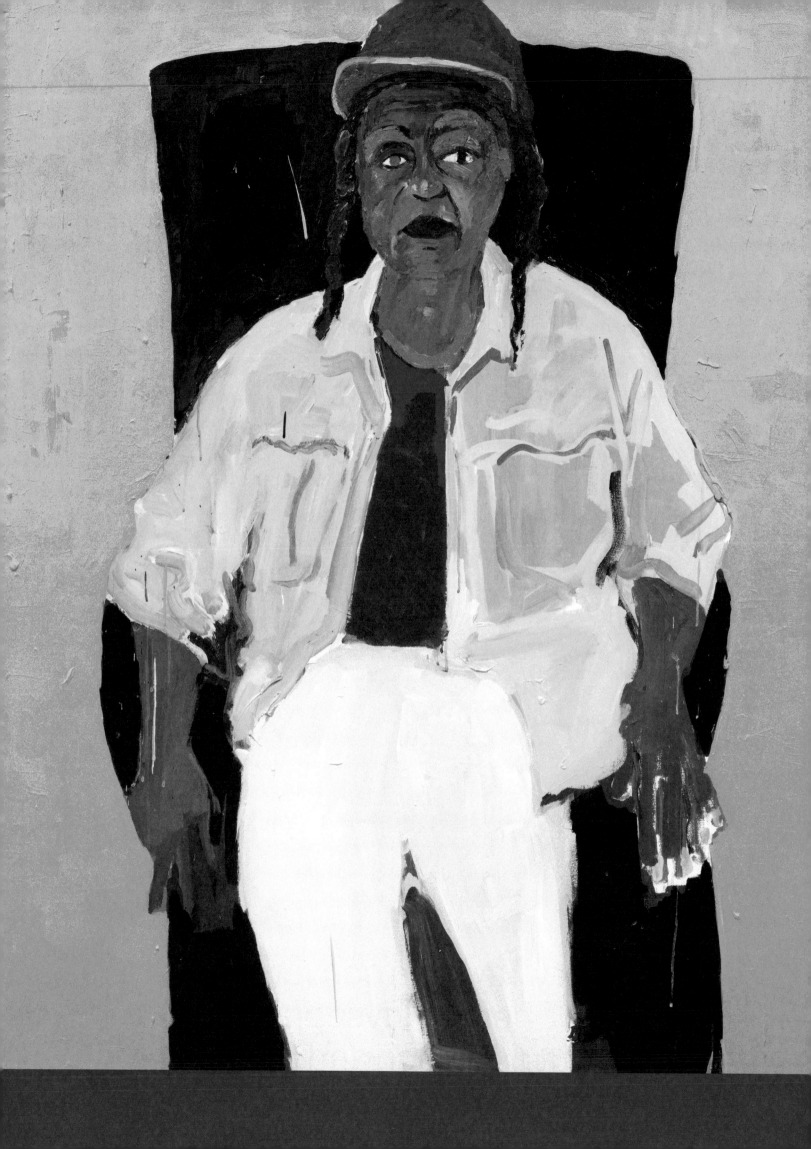

Henry Taylor, *Untitled*, 2020. Acrylic on canvas, 60 × 48 × 1 5/8 in. (152.4 × 121.9 × 4.1 cm). Photo: Jeff McLane. © Henry Taylor. Courtesy the artist and Hauser & Wirth

Randy Kennedy
The cover of this issue is your striking portrait of Sheree. So I thought maybe we could start with the two of you talking about when that painting was made. What were the circumstances? What were you both doing?

Henry Taylor
As that song goes: "Ladies first!" You know what I mean?

Sheree Hovsepian
Ok, I'll tell the story, or at least my part of it. Rashid [Johnson, Hovsepian's husband] had his portrait painted by Henry while Henry was on a trip to New York, staying out in Water Mill on Long Island. This was the summer of 2021, just as all of us were starting to feel the pandemic finally easing a little and people were able to spend time together again. Rashid came home and told me, "Henry really wants to paint you." And I think I said, "What!?" in disbelief. I was very excited and honored by it, because I've always loved Henry's work. There was no set date. It was just something that I really hoped we would find time for—end up in a space together with the painting tools so Henry could do it. One day a mutual friend of ours who was visiting Henry invited me to come over to her house and hang out with them. The house was filled with a lot of really beautiful pieces by Henry, big canvases and a lot of portraits of people I recognized. We're all just kind of chatting and sitting outside, because it was a nice summer's day, and I had a playlist going on the speakers with some songs Henry seemed to like—"Love Will Bring Us Back Together" by Roy Ayers and "Rise" by Herb Alpert. And before I knew it, Henry had started sketching. So I knew that was my cue to try not to move anymore. As an artist, especially one who works with photography, I'm always thinking about the artist-model relationship, the power dynamics of the camera, the traditions of artist and sitter, and so I guess I was acting those things out a little. But mostly I was trying very hard not to move and also really wanting to watch him paint, because Henry is so full of energy and talk and jokes, then suddenly he's quiet and so intense when he's painting.

HT
It's kind of funny what people tell me about how I look when I'm working. Because that's probably the most serious I ever get. I remember being up at Skowhegan once when Lyle Ashton Harris was there, and he was setting up to make photographs and he was, no nonsense, just locked in, man. And I guess that's how I look. People see me as pretty jovial, not too serious sometimes, but when I'm painting, especially a portrait, I just zone in, you know? Even if it's a situation where I'm not paying a sitter and it's not very formal and I don't have a big setup for it. People might say it's an honor to get a portrait done, but it's also a privilege for me because it's something I just love to fucking do. When they watch me paint, people do tend to trip out because of the facial expressions I make. People never see me looking that way in the rest of my life. But it's like Michael Jordan going down the lane with his tongue hanging out. If he's just talking to Sheree, if he's not on the basketball court, he's not going to look like that.

SH
It was cool to just get to sit and watch him paint, see the decision-making process and how proficient and quick he is, because he's been doing this for so many years, thinking about what a portrait should do. I think the total time I was sitting there was maybe an hour and a half. But it went by very quickly. It was kind of amazing to see what could come into being in such a short burst of time.

HT
The first couple of minutes people are usually laughing at me because I'm squinting, I'm closing one eye and then the other, going back and forth. I do it because I feel like my eyes are lenses. It's like I'm snapping pictures of things to put together.

RK
I know from talking to you and reading about you that since you were very young, growing up in Oxnard, north of Los Angeles—and later at CalArts—and even when you were working a job as a psychiatric nurse at a state hospital, you've often painted the people are around you almost as a way of being with them, almost as

"I'm passionate about a few things in life, and getting to sit with someone and paint them is sure as hell one of them."—Taylor

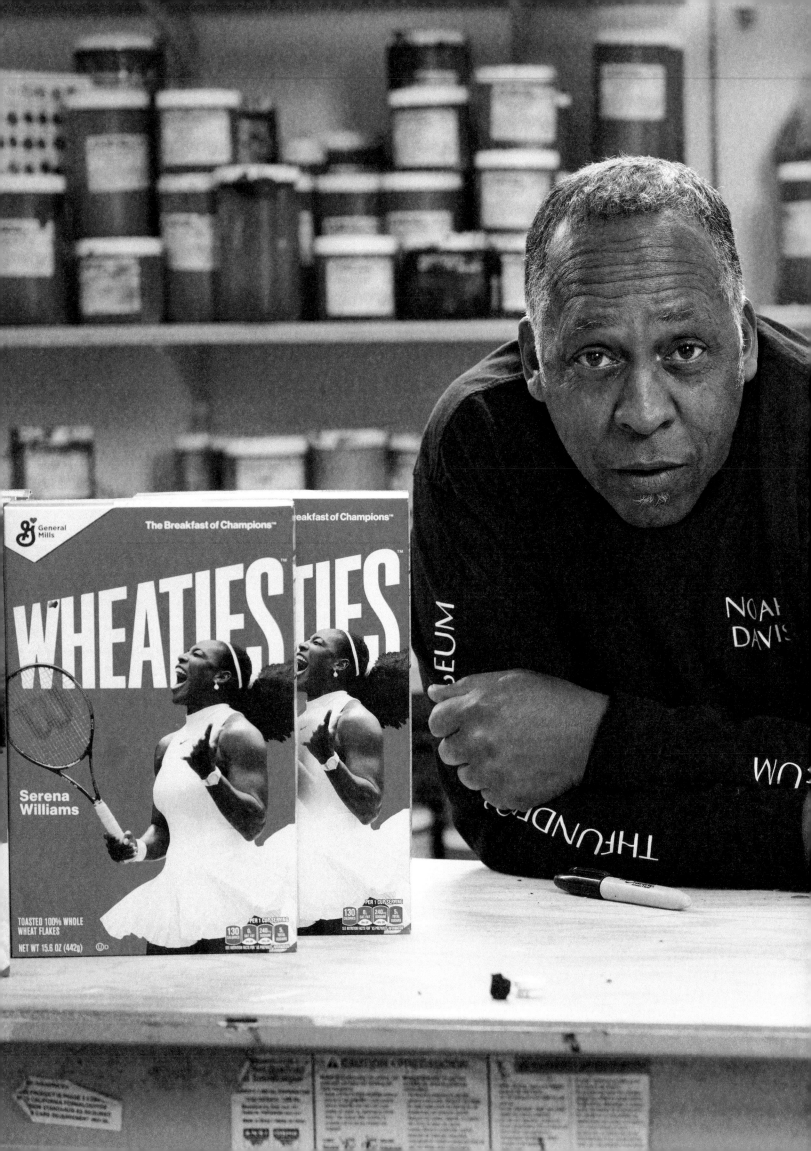

Previous spread: Henry Taylor in his studio, downtown Los Angeles, 2020. Photo: Fredrik Nilsen Studio

Opposite and below: Henry Taylor at work on *Untitled*, 2021, his portrait of Sheree Hovsepian. Courtesy Sheree Hovsepian

a form of conversation—not casual, really, but highly social.

HT

It's about hanging out but it's also about something else. I always use the analogy of Jimi Hendrix. He was a guitar player and he loved it and he probably played all the time. I paint all the time, and I think about it this way: A model just gives me someone to play with. It's like having another musician, a counterpart. The model might be the bass player, you know, and I'm on guitar. It's a jam. And you can always render something differently each time you do it. You think about Picasso being with Olga [Khokhlova] and Jacqueline [Roque] and Dora Maar and making hundreds of paintings and drawings of the same person, or Max Beckmann painting the same woman over and over, and after a while, you can do it one way or you can do it lots of different ways. I'm passionate about a few things in life, and getting to sit with someone and paint them is sure as hell one of them.

SH

I'm envious of that. Just that desire and ability to paint freely and make something within a certain amount of time and space, to get at a person's being. A lot of my work takes time and it's much more abstracted. It's a less linear way to get to that acknowledgment of a self, whereas in painting so often there's such an immediate truth to life—the freedom that it allows to live and make art at the same time, on the same plane. Do you get what I'm saying?

HT

Yeah, it's live, baby, it's live! And I envy musicians for that. I mean, I work on a lot of

stuff that's very thought out and planned and takes a long time, a lot of studio time, painting and waiting and looking, thinking. But then there's the spontaneous stuff that is really like a jam session. And when you do it, you're thinking about time, about how much time you have with someone. I mean, you know, to talk about music again, if you're at Stax Records and you're the house band and Otis Redding comes in, and Otis is only going to be there ten minutes, you say, "Well, hell, Otis is here. Let's just lay something down. Let's not waste it. If I'm with Sheree or Rashid or I'm with my son, I don't know how much time I'm going to have with them. Sheree might have to go pick up her kid or go do something. So I don't fuck around. I go hard. I treat my canvas like a sketch pad. If I have you all day and you're my partner, then I might take my time. But sometimes it's just: Go. At the same time, you're thinking about the sitter. Sometimes you want to appease them and sometimes you just want to do what you want to do, like Picasso doing his Gertrude Stein. I flew my sister out from Illinois not too long ago. I said, "Evelyn, I'm going to paint you because I want you to be in the book for the MOCA show." And I told her: "The first portrait is going to look like you. And then for the second one, I'm doing me." She knew what I meant.

RK

Even when you're working fast, are you working through things you want to change with your style? Learning from all the previous pieces and trying to find new ways to get at faces, hands, eyes, expressions, moods?

HT

You're always thinking about that. Sometimes I might start a painting and look at the palette and there's only three colors, and it makes me think of a painter like Beauford Delaney or Horace Pippen when he was only using blacks and browns. Nobody wants to hear the excuse if you don't have enough colors, you know what I mean? Certain times it's a challenge. Like, you're a great chef and you go into Sheree's kitchen and it's not stocked like a restaurant kitchen, but if you're any good, then what you're going to make is still going to taste fantastic. I say to myself, "If Horace could do it, I can do it." If I wanted to start real fast, I might look at Sheree and say, "Ok, there are blacks and the blouse is cream white and there's crimson and there's raw sienna and . . . go." It's funny. Your palette can dictate a lot of things. But sometimes it's just the light, for like five minutes. You're just right in the moment.

RK

Sheree, I was thinking about your series *Haptic Wonders* [2011–13]. In form, some of those

suggest portraiture, heads and torsos. Do you consciously think about portraiture in that series, as abstracted as it is?

SH

I do. Partly because, in terms of photography and the history of photography, portraiture is obviously huge. And I think about the body a lot. In *Haptic Wonders*, the material is the photogram. So they're made in the darkroom without a negative. For me it's a form of drawing, because you're exposing the paper to light, which makes it develop different shades of gray. Henry was talking about results within a certain timeframe. For me, I'm thinking about a certain timeframe, of being in the darkroom, of making these motions of exposing, revealing and covering the paper. And not knowing what I'll get until it goes through the chemical process. So it's like blind drawing, in a way. But yes, to your question, some of those were specifically meant to be heads and portraits. I was thinking about photography. I was thinking about the parts of Roland Barthes's *Camera Lucida* where he talks about his mother's portrait, how it haunted him, seeing this portrait of her as a young girl after she had just

passed away. In that work, it was almost as if some ghosts or otherworldly things were being trapped in the photographic process, like I was conjuring them in the darkroom.

RK

Henry, when you do portraits and you're working quickly or don't have all the things that you want, are you ever surprised by the results? You start out and don't know if it's going to add up to anything and then you're like, "Oh!"?

HT

Oh, hell yeah. Like, I'll make a portrait of someone at their house during a party and just because of what's going on around me it's a different energy. I look at it later and say, "Damn, I didn't think that shit was any good." But it turns out looking like nothing else I've done. Other times, I just have to embrace the work even if I'm not sure I got what I wanted. It's not that I'm compromising but I'm just realizing that sometimes you let it go. You try to come to terms with that, too, when you've been painting a long time. And then, you know, there are just those times when the shippers come in the door and say, "Henry, let loose, we got to take it now." And I'm like, "Damn, ok, let me just finish the foot!"

RK

Are there certain paintings in your studio that stay there for a long time?

HT

There's one in there right now. But that's probably because it's twelve feet and there's a whole lot to think about. I'm getting to the point, though, where I'm telling myself I don't want to do anything too big anymore. I mean, maybe I'll stand on a milk crate, but no more scaffolding, man. I could somersault off that damn thing.

SH

People get too wrapped up in scale. My work is pretty intimate in size. And sometimes I hear from people that it should be bigger. It's such an annoying criticism—it's not even a criticism, I guess—but people just wanting me to "scale up." And I find it offensive. Why does everything have to be bigger?

HT

I've never even really understood why, usually, bigger paintings are more expensive than

"I think about the body a lot. In [the series] *Haptic Wonders* … it was almost as if some ghosts or otherworldly things were being trapped in the photographic process, like I was conjuring them in the darkroom."—Sheree Hovsepian

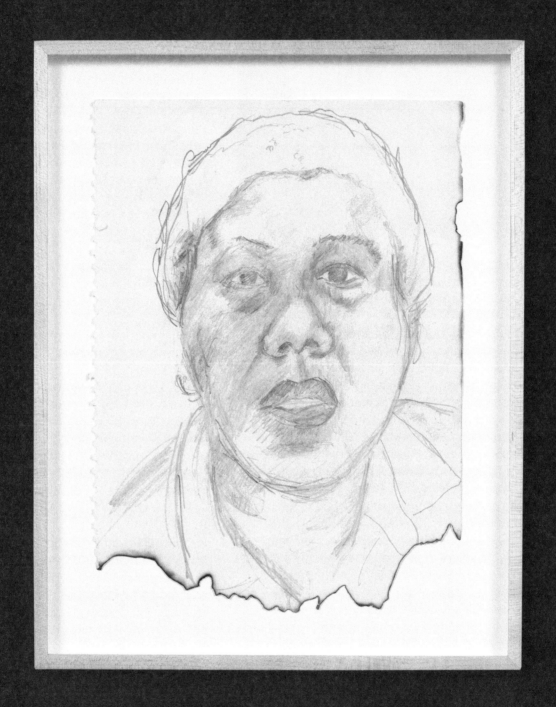

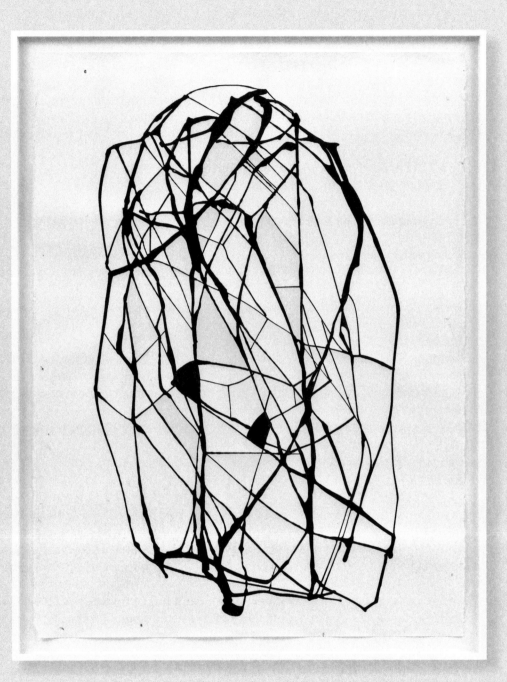

Sheree Hovsepian, *Untitled*, 2022. Ink and oil on
paper, 76 × 56 1/2 × 2 1/4 in. (191.8 × 143.5 × 5.7 cm).
From the series *Muscle Memory*, 2016–.
Photo: Stan Narten. Courtesy the artist and
Rachel Uffner Gallery

little paintings. Sometimes I'm really into the little paintings, and I think they're better than anything else I got. It not like it's a carpet or a house or something where you're paying by the yard. It's a completely different kind of thing. It's crazy to me.

SH

A lot of my work has to do with my own physical being, my own physicality. And if you're scaling something up just for the sake of someone wanting something bigger, you're losing an essential part of the work.

RK

As your career has taken off, Henry, do you get that? Somebody saying, "We want a forty-foot painting for this wall in this house?" That kind of pressure?

HT

Yeah, sure I do. And I might think about it. But I ain't going to force it. I ain't going to jump so high just because someone says to jump that high. But if I have an idea for a big-ass painting and I really want to do it, I might say yes. If it's me doing what I want to do.

RK

I remember vividly seeing two of the large paintings you had at the 2017 Whitney Biennial, *Ancestors of Genghis Khan with Black Man on Horse* [2015–17] and *The Times Thay Aint a Changing, Fast Enough!* [2017], the second one based on the horrific video imagery of the police shooting of Philando Castile in Minnesota in 2016. You're a pretty widely read student of painting going back quite a few centuries. Do you think of those kinds of paintings as history paintings, as being part of that genre?

HT

I was probably thinking about Jacques-Louis David's *Death of Marat* [1793] when I painted that one. Maybe also paintings of Jesus, deposition paintings, you know. But I was reluctant to have it seen as just a painting of that news picture and what happened to Castile. I don't sit around thinking, "Oh, I'm going to do every Black person that's been murdered by the police." I don't even think I thought about ever showing that one when I painted it; it was just something I had to get out of my head. I almost didn't want people to know what I was alluding to at all. But, you know, I might make a composition and decide to put a helicopter in there to remind me that we're all living in a police state. I live in L.A. You hear police helicopters all the time. Then again, I also just like to paint helicopters because I'm like a little kid when it comes to aircraft. So it's never one thing. Things permeate. And sometimes I'm just thinking about other paintings I love. I went to St. Louis not long ago just to look at Max Beckmann and Philip Guston, because it's a great town for those two painters. And looking at Beckmann just makes you want to paint triptychs, you know?

SH

I have a question, too, about your work, Henry. Do you have personal symbols that you put into your paintings?

HT

With Beckmann, it's the curtain, right? You always you see those heavy curtains coming back again and again in his work. And yeah, I guess I have some, too. But should I give them up? Maybe I shouldn't say. Let people guess.

SH

I always think about the horses in your work. Are horses a thing for you?

HT

That's kind of about the South. My dad trained horses. He was a horse kind of guy. So I do come back to them now and then, yeah.

SH

I like the idea of a personal mythology that can help guide you in the work or help you make decisions.

HT

Sometimes I start thinking back about the work and how it came along and what was guiding me. I don't usually stop to reflect on things, but I do feel like I was on a path for a long time to something and it was gradual, going along, trying to figure out what I wanted. There are some people like Kobe Bryant who just seem to come out just hitting from the beginning. And there are people who start out maybe too good—you know what I mean?—and then they fade. The first New York show I had—2005, at the Daniel Reich Gallery—I was just trying

"I might make a composition and decide to put a helicopter in there to remind me that we're all living in a police state.... Then again, I also just like to paint helicopters because I'm like a little kid when it comes to aircraft. So it's never one thing. Things permeate." —Taylor

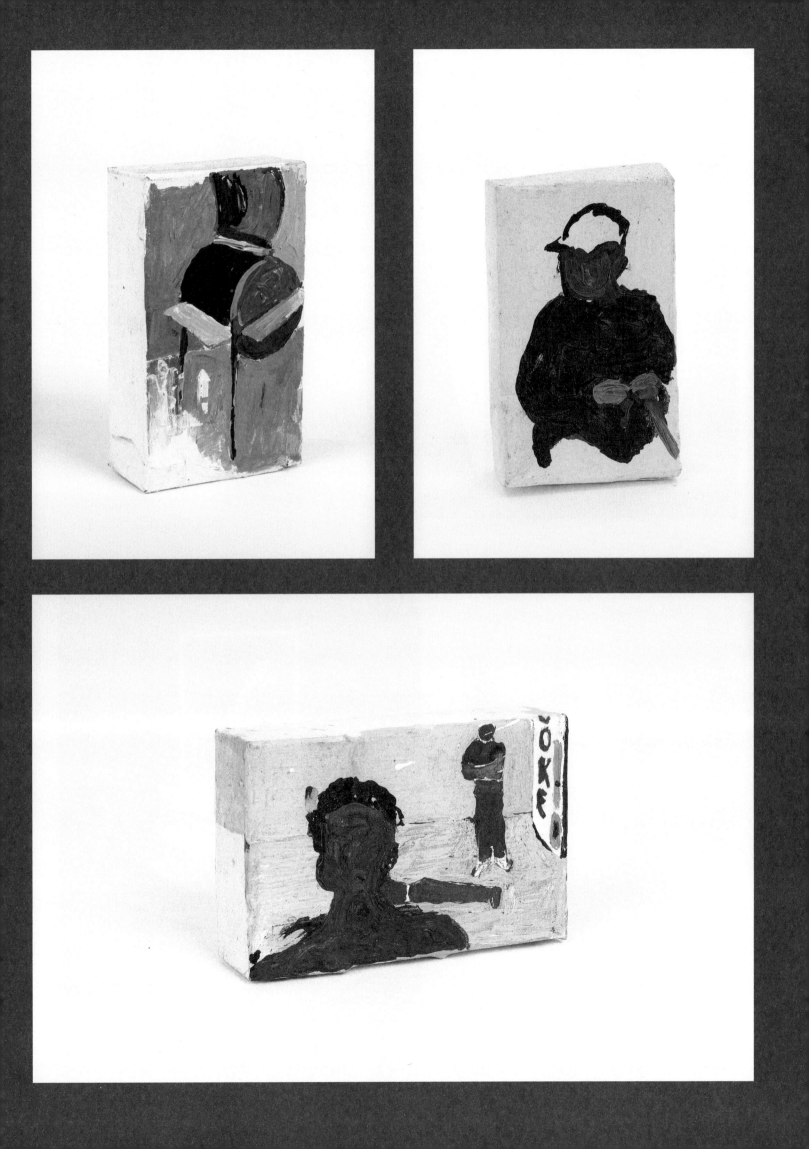

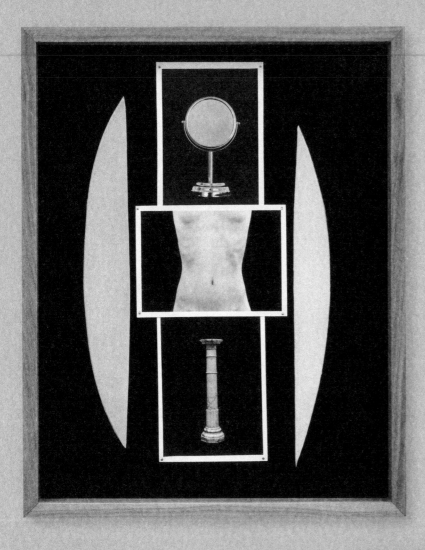

Top:
Sheree Hovsepian, *Virgule,*
2022. Gelatin silver photographs,
ceramic, nails, walnut artist
frame, 21 5/8 × 17 5/8 × 3 7/8 in.
(54.9 × 44.75 × 9.82 cm).
Photo: JSP Art Photography.
Courtesy the artist and Rachel
Uffner Gallery

Bottom:
Sheree Hovsepian, *Corporeal
Nature,* 2022. Gelatin silver pho-
tographs, ceramic, string, nails,
walnut artist frame, 31 7/8 × 25
3/4 × 3 7/8 in. (80.95 × 65.4 × 9.82
cm). Photo: JSP Art Photography.
Courtesy the artist and Rachel
Uffner Gallery

Sheree Hovsepian, *Untitled #43*, 2012. Unique gelatin silver photogram, 24 5/8 × 20 5/8 in. (62.53 × 52.37 cm). From the series *Haptic Wonders*, 2011–. Photo: Martin Parsekian. Courtesy the artist

hard to crack something open, crack into the gallery world. And I always felt like . . . Not like an outsider artist, because I trained for a long time and went to art school. But I just felt like an outsider in the art world. And that show gave me some confidence. Sometimes it is just about confidence—like, just being able to relax and tell yourself you've got it and own what you're doing.

SH

When you were painting me, I remember thinking how confident, how sure and how decisive you were in your motions and in the way that you were constructing the painting right from the beginning.

HT

It felt like game time, huh?

SH

It did.

HT

But it can be intimidating for me when I'm doing it, even if you don't see it. Part of me is thinking, "This is Sheree, and I don't want to waste her time." Another part is, I just want to make something really beautiful or interesting. I'm always excited by it and waiting to see what it's going to be like myself. Like you've got something in the oven and you don't quite know what it's going to look like until it comes out. If you're painting from a photograph, you're not going to have the kind of intensity you have when someone is sitting there like she was. There's certain colors you don't get from a photograph, and you've got to get that color down in the moment.

SH

It was about five in the afternoon that day, and it was summer, so there was still a lot of light, and it was pretty.

HT

If the light's going down in the evening, it's going change on my ass so I have to paint fast, but it was good that day. That's where I think some of the intensity comes from. The greens and the browns are doing this thing with each other.

SH

Right. A kind of vibration. I don't know if you can see on Zoom or not, but my eyes are definitely not green in real life. He was just getting something going for the painting with that green.

RK [to SH]

I wanted to ask you some more questions about your work. I've read interviews where you talk about some of your influences, artists who use photography as an important part of the work, like Lorna Simpson and Sophie Calle and Annette Messager. But thinking about the pieces you have in the Venice

Biennale now, I wonder how much you're also riffing on or looking back to early modernism, to, say, Malevich or Sophie Taeuber-Arp or Moholy-Nagy?

SH

I feel like a lot of that is just my innate sensibility, the way that I construct. Because I'm thinking about reduction, reducing something not necessarily to the simplest elements but to forms that are going to make the most sense and also somehow feel complete. But when I was making that work I was thinking about artists like Man Ray and sometimes Edward Weston, the way he photographed skin or the surfaces of vegetables, isolating something within a frame to monumentalize it, how photography allows you to play with scale in that way. I was also thinking about Bernd and Hilla Becher and the way they isolated form in their factory photographs.

HT

I'm surprised you didn't mention any sculptors. Looking at your work I was waiting to hear some sculptors, too, like Brancusi, Noguchi.

SH

Right, sculpture does come in there, but I was thinking a lot and have been thinking a lot about someone like Joseph Cornell, who wasn't really a sculptor but made sculpturelike objects that were so much about devotion.

RK

I have, I guess, a last question for both of you. Henry, you've got the show at MOCA, by far the most prominent show you've ever had in your hometown. And you were in the biennale, Sheree, one of the biggest stages in the art world. Those kinds of moments sometimes

Opposite: Henry
Taylor, *Untitled*, 2022.
Acrylic on canvas,
84 1/8 × 60 × 3 1/8 in.
(213.7 × 152.4 × 7.9 cm).
Photo: Jeff McLane.
© Henry Taylor.
Courtesy the artist
and Hauser & Wirth

throw artists curve balls. They have to figure out what they want to do or should do next. I remember reading that after Bruce Nauman had his first retrospective in the early '70s, he couldn't make new work for months and wondered if he could even keep being an artist. Do either of you think about that?

SH

I feel like the best way for me is to just focus on the work and not on any of the stuff around it. I was so honored to participate in the biennale, especially among all of the wonderful artists that were in it with me. It was good because it helped me validate what I was doing. I think I'm probably still looking for the confidence and the freedom that Henry has, still working toward that. So, if anything, the biennale just gives me more courage to really trust my own decisions, like Henry was talking about before. I think the Biennale is going to be seen as an important one, that it's already changing our taste for painting right now in the market— I mean, I hate to talk about the market, but I'm noticing how surrealism is popping up everywhere and more shows are happening that really focus on women.

HT

Yeah, I have been wondering whether this MOCA show is going to mess with my mind. It probably does a little because, first of all, it was supposed to have been a couple of years ago, but Covid held it up, so I've really been thinking about the damned thing for a long time, without realizing I was thinking about it. I probably got a little sentimental, thinking about all the work I've done, all the

people who've been in the paintings and, like I said, I wanted to get my sister into it, into the book and show, and so I was thinking about that, too, you know—who am I missing, who or what should be in this? But I don't really think so much about it being a big moment in terms of visibility or people seeing it. I mean, you hear about those performers who play to an audience where maybe only three or four people come to the show and they still play the hell out of it. They're not going to be much different playing in a bar or a coliseum, you know? That's me, pretty much. But at the same time, you get a show like this and it makes you think about being in a good place, and it's a place where you start to feel some responsibility. You've got this and you want to take advantage of it, not necessarily to be a role model, but just to wake up and tell yourself: "Hey, Henry, you're free to do this. You can do almost anything you want now." And you know what? If don't exercise your freedom as an artist, it's the worst thing that can happen to you. You're sitting there with the ability to create and you don't create? I think about that. I also think about, after the MOCA show, wanting to make something fresh, you know, not doing anything repetitive. But most of the time I'm just saying to myself: "Henry, get over yourself and get in the studio and finish some shit!" That usually works. Just get in there and see what happens.

"Henry Taylor: B Side" is on view through April 30, 2023, at the Museum of Contemporary Art (MOCA) in Los Angeles and travels to the Whitney Museum of American Art, New York, October 4, 2023–January 28, 2024.

"People get too wrapped up in scale. My work is pretty intimate in size. And sometimes I hear from people that it should be bigger. It's such an annoying criticism.... Why does everything have to be bigger?"—Hovsepian

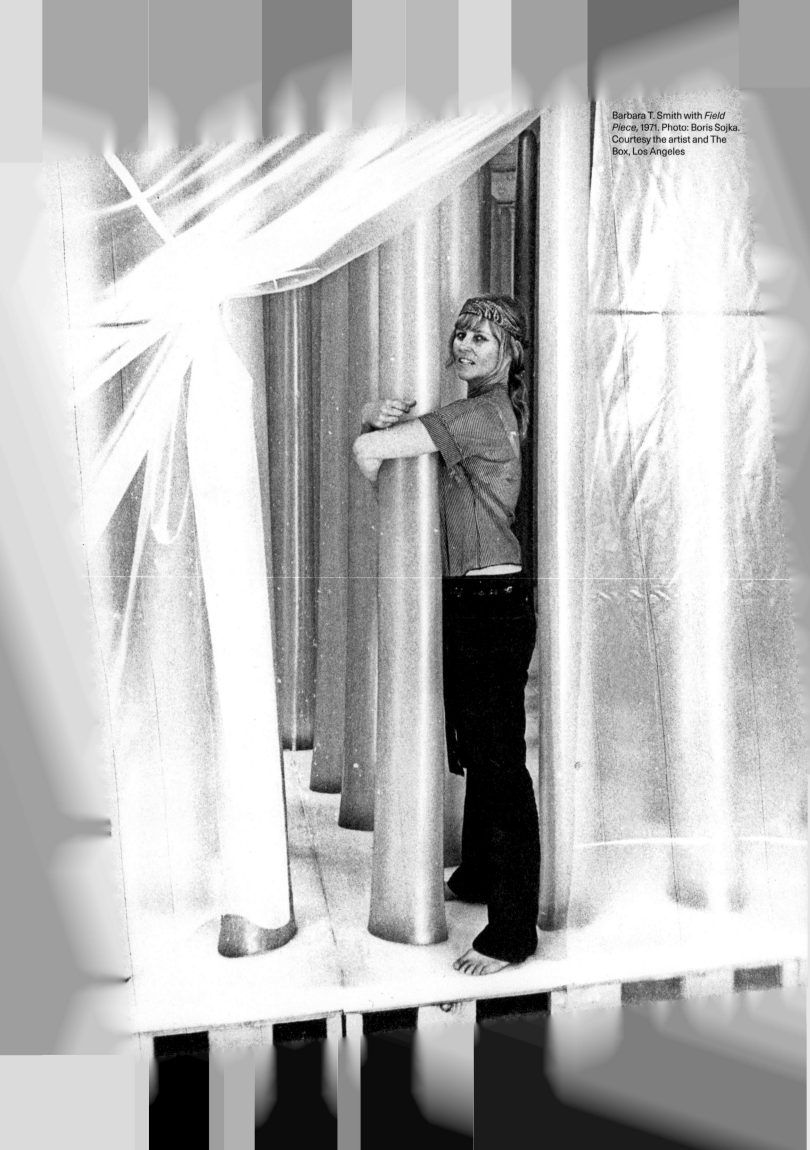

Barbara T. Smith with *Field Piece*, 1971. Photo: Boris Sojka. Courtesy the artist and The Box, Los Angeles

At sunset on the evening of April 20, 1973, one of the most powerful and important pieces of performance work ever undertaken by an American artist began in an unassuming setting: the women's restroom at the Museum of Conceptual Art in San Francisco. Barbara T. Smith, then forty-three years old, a divorced mother of three and a latecomer to the West Coast contemporary art world, went into the room, undressed, and arranged wine, cheese, bread, tea, coffee, marijuana, books and other items on benches. The room was otherwise empty, save for a mattress, flat on the floor and covered in an Oriental rug, and a tape machine in a corner, playing a repeating loop of Smith's voice softly saying the words, "Feed me, feed me."

Over the next twelve hours, until sunrise the following day, a single visitor at a time was allowed to enter the room and be alone with Smith, the nature of the encounter left completely unspecified. While the work shares similarities, particularly in its exploration of vulnerability, with Yoko Ono's *Cut Piece*, first performed in 1964, and Marina Abramović's *Rhythm 0*, performed the year after Smith's, those two well-known pieces took place in public, with sizable crowds watching the actions of the participants (mostly men) who interacted with Ono and Abramović's bodies and clothing, sometimes menacingly. *Feed Me*, in contrast, consisted of a series of interactions for audiences of one, the only documentation of which was a small journal that Smith kept through the night and a handful of black-and-white photos taken before the performance began. The entire piece transpired inside the restroom.

Even in the context of its freewheeling times, the performance immediately became notorious, largely due to Smith's intentional structure, one that engendered speculation, hearsay, imagination and mystery. What had taken place between the artist and her visitors, nineteen in all, most of them men? Why had she chosen such a private format for a public performance? Was Smith ever in danger, like her friend Chris Burden, whom she had watched two years earlier take a bullet to the arm, for his landmark performance *Shoot?*

In a 2019 self-published artist's book, *What You Need to Know*, Smith finally decided to answer some of these questions, partly, as she wrote, because of lingering perceptions that *Feed Me* had "played right into the misogyny of patriarchy." The piece, she insisted, did precisely the opposite. It was a radical feminist action that reversed the mechanism of the male gaze, turning the sexual and gender dynamics of the day on their head. "Of all the women who did pieces of this sort, making themselves available for the actions upon them by an audience, mine was the only one during which I had agency and control," she wrote. The intimacy and complete openness that Smith offered compelled her visitors, often despite themselves, to "face their projections and see me as a person, not an object," making them into temporary companions who satisfied the profoundly human request that her recorded voice intoned. As documented in Smith's journal, most of the visitors that night sat and talked with her about life, love and art; occasionally lectured or criticized her; ate and drank with her; shared drugs with her; sometimes held or massaged her and, in a couple of instances, had sex with her.

Among the pioneers of body-focused performance and Conceptual art in the 1960s and 1970s, Smith has never achieved the degree of recognition she deserves—for many of the usual reasons, including sexism and East-Coast bias—and *Feed Me*, even now, remains more a cult piece than a canonized one. But her work has gained importance with each passing decade, especially for young artists, and her reputation now seems poised for much greater institutional visibility. In February 2023, the Getty Research Institute in Los Angeles will open a career-spanning survey, "Barbara T. Smith: The Way to Be," exploring her forays into drawing, painting, Xerox printing, sculpture, performance, artist's books and film.

Smith, who turned ninety-one this year, sat for a series of interviews about her early life and work, conducted over several days in her apartment in Pasadena, not far from where she was raised. These are edited and condensed excerpts of those conversations.
—*Randy Kennedy*

"My mother would say, 'Shh, shh, don't wake your father. He was out late last night.' I never wondered what he was doing, but of course he was picking up bodies. That's what the mortician does." —Barbara T. Smith

Smith wearing a gas mask during
the production of *Field Piece*, 1971.
Photo: Boris Sojka. Courtesy the
artist and The Box, Los Angeles

Randy Kennedy

Where would you like to start?

Barbara T. Smith

I guess I'm always pretty good at starting at the beginning.

RK

I know that your roots here in Pasadena and Altadena are deep. Did both of your parents grow up here?

BTS

Yes, California people going way back. My dad was born in Huntington Memorial Hospital, just five minutes away from here. As was I. And my younger brother, George, and two of my children. So it's like old home. I should go to the hospital and do some kind of ceremony or performance there. My mother was the child of immigrant Norwegians who had settled in Hollywood. My paternal grandfather came to northern California from Marshalltown, Iowa, from a family of farmers, some of whom went West for the dry air, as I understand it, because of tuberculosis. He eventually came to Los Angeles and got together with a guy named Hamilton Stevens and they started a mortuary.

RK

How did that come about, for someone with a farm background?

BTS

I think my grandfather had at some point trained or thought about being in the ministry. One day I asked my father, who followed my grandfather into the business: "Why are you a mortician? Why would anybody do that?" And he said, "Well, this is where people are in their greatest despair. It's a chance to help people." I think that's the way my grandfather was, too. He was a very kindly person. So that was their motivation. But it was also a good business, of course. I was born in 1931, the middle of the Depression, but the Depression didn't seem to have any impact on the family or the business.

RK

I guess people keep dying during depressions. Maybe even more of them. You don't really have a choice.

BTS

I never had any sense of lack. When automobiles were first happening, my father had an early Lincoln, a big box sort of thing, then he got a big Cadillac, which was a company car, used to transport mourners to the cemetery.

RK

It must have been a strange family profession for a young person to think about.

BTS

When I was young, my mother would say, "Shh, shh, don't wake your father. He was out late last night." I never wondered what he was doing, but of course he was picking up bodies. That's what the mortician does.

RK

Did you spend time around the funeral home?

BTS

Not really as a child. But when I got older, my brother and I would go on the bus, from school, maybe to a department store to shop and then end up at his office and he would take us home. We would be shuffled off to my dad's office and more or less told to stay put, but of course we didn't.

RK

You probably had some sense of what was going on there, right?

BTS

A little. We would walk down the hallway to the embalming rooms and we'd open the doors. Fortunately, we never actually saw a body in one. And there were also places called slumber rooms, where the body rests in a casket for viewing. Once we played around in the chapel. There was a casket sitting at the end of an aisle, so we decided we'd play funeral. My friend Shirley sat at the organ and George got up in the pulpit and started preaching and I became the family member in mourning, pretending to weep. I walked up to the casket, lifted the lid and there was a body inside, of course. I screamed and said, "There's someone here!" And everyone heard us and came in and we ran out.

RK

What a story.

BTS

Well, I mean, every family has some kind of weird thing that the kids discover by chance, right? This was just weirder than average, I guess. My family also founded a cemetery, which still exists, north of El Monte, called Live Oak. We used to joke that it was called Live Oak for Dead Folk. [*Laughter.*]

RK

I'd think that having a family in the mortuary business must have had some effect on the way you thought about objects and ceremony and the body, right?

BTS

In a way, I guess. Not overtly. Maybe more than I realize. I was also around quite a lot of cultural things when I was young. My grandparents and my father helped found the Pasadena Playhouse, and my father acted in plays. He was also involved in the [Pasadena parade known as the] Tournament of Roses. My grandfather had been a president of the tournament and a grand marshal. I have pictures of him on his horse with his top hat, riding in the parade.

RK

Did you have a good childhood?

BTS

I really did, as far as I knew. We lived in Altadena and I went to the public schools and I was good in school and well-liked. But I was also very naive and my world was very small. I read *Look* and *Life* magazines, nothing ever more out-of-the-ordinary than that, and I went to the movies and saw the newsreels. But I didn't know much about the wider world. I certainly knew nothing about art or the art world and there really wasn't much of one here in the 1940s, early '50s. I didn't even know what an artist was or what they did. I was interested in anthropology, paleontology, though I had no idea how to pursue that.

RK

Did you conceive of yourself at any point when you were in school as a rebel? Because later in your art life, obviously, you pushed against a lot of boundaries and became radicalized. Was that in your constitution when you were young?

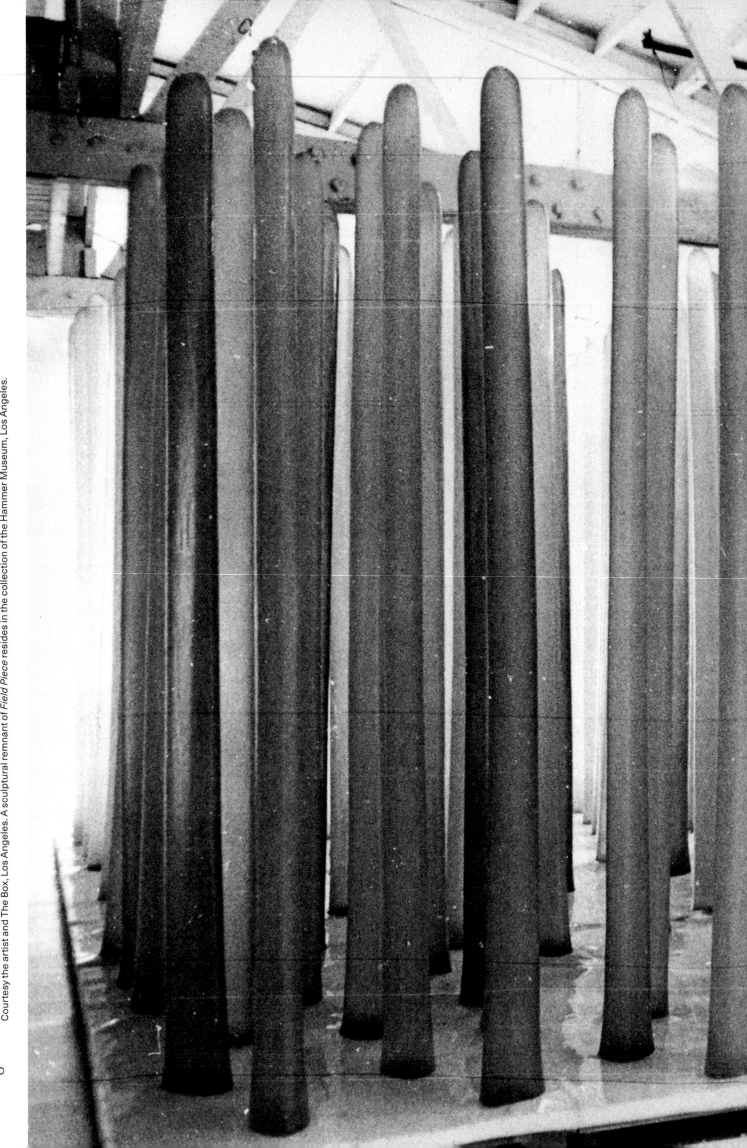

Barbara T. Smith, *Field Piece*, 1971. Fiberglass, light, sound, computer, 20 × 24 × 10 feet (6.09 × 7.31 × 10 × 3.04 m). Photo: Boris Sojka. Courtesy the artist and The Box, Los Angeles. A sculptural remnant of *Field Piece* resides in the collection of the Hammer Museum, Los Angeles.

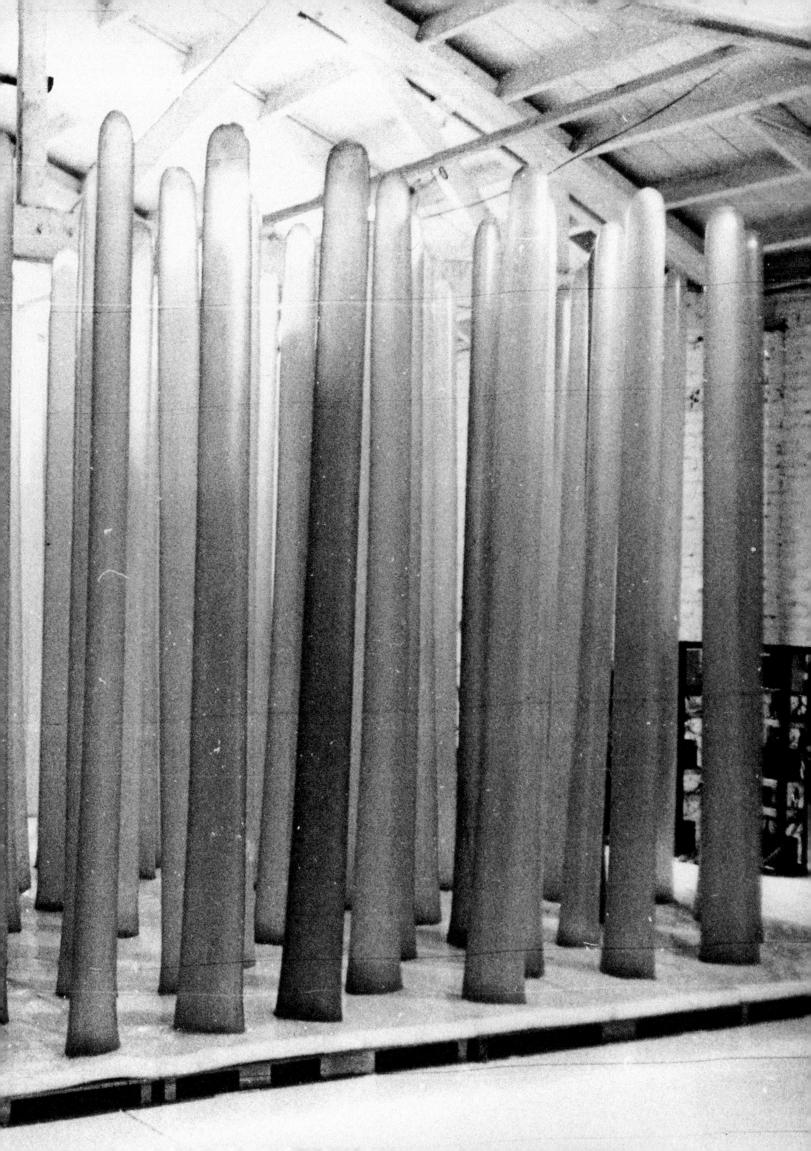

BTS

When I was young, I would get very angry about injustice, but not enough to be an activist. There was no such thing, really, in the world in which I lived. But at the same time, I had a very strong personality. I had a certain amount of self-confidence and I did well in most things that I tried. I got into both Stanford and Pomona, and I decided to go to Pomona only because it was closer, because I had no idea about the relative merit of the schools or anything like that. And I still remember vividly the first day at Pomona, what happened. My mom drove me out and at the freshman dorm there was a very routine event that happened every year, some kind of tradition. All the freshman girls had to go up and be weighed and measured by the boys in public, for our suitability as dates, I guess, a kind of comic event.

RK

As if you were cattle at auction or something?

BTS

My mother was a bit bewildered, and I guess I had no idea that this was a bad thing. So I just submitted to it. Isn't that awful? But that was the kind of thing that happened.

RK

I read one interview in which you talked about a split with your family happening over an early boyfriend, a confrontation that led to a kind of awakening.

BTS

Yes, it was the major thing that shaped my life at that time. It was an awakening in part about my dad, because I just adored him and he was big and fun. I was very much a father's daughter, which I later learned in therapy is bit incestuous, emotionally. I was seeing a boy two years older than I was, a football player, a really good person, a good guy, Ed Miller.

RK

What was your family's problem with him?

BTS

For one thing, we were Presbyterians and he was Catholic, big time. His parents ran a liquor store and the family lived in the back of the store. They envisioned me having six babies right away, I'm sure. I would have these big fights, fighting with my mother, and finally they just broke me. I yelled at my mother, "I can't fight anymore. I don't care anymore." And my mother slapped me in the face and she said, "You'd better care." It's the only time she ever did anything like that. The breaking point came when my dad, on the phone with me at one point said, "I never thought I'd have to say this to you. But if you ever go out with Ed Miller again, you're not to consider yourself my daughter." It just stunned me. It cemented some things in my mind about how desire and sexuality were really tied up with rebellion, especially if you were a woman. There was a sense in which I couldn't really go home again, which was probably good for me.

RK

Pomona, where you were studying, later became a tremendous hotbed of Los Angeles experimentation. What did going there do for you?

BTS

This was the late '40s, early '50s, and so it was really all about Abstract Expressionism and painting at the time. I was really struggling psychologically and I was young and my paintings were very labored. But there was a really good painting teacher—and painter—there, James Grant, and also a great art history teacher, Alois J. Schardt, who had been the director of the National Gallery in Berlin before being forced out by the Nazis. He knew many of the German Expressionists personally, and he himself was a kind of Catholic mystic. He was, to this day, one of the best historians I've ever heard talk about art. On Good Friday, he would do a two- or three-hour lecture just about the Isenheim Altarpiece. You'd be sitting there crying.

RK

Wow.

BTS

Jim Grant and Schardt taught me some very important things. Once, I talked to Grant about wanting to take extra classes at Scripps College to learn technique, specific skills for painting and sculpting, and he said it was fine by him but also told me, "Learning techniques is not going to make you an artist. If you really want to be an artist, nothing in the world will stop you." And that just hit me. Around that time, I had become seriously depressed because of what had happened with my family. I couldn't sleep. I couldn't read. I was nearly passing out in gym classes. I couldn't even eat. And I'm in one of Dr. Shardt's classes, sitting in the front row because he's German and his accent is really hard to understand. He was showing Dürer's *Melencolia I* etching, with the figure sitting in a dark room and the fading sunlight very far away, and he said, "Many of you will find yourself in this state of mind." And I thought, "How does he know?" And then he said, "The problem is that you spend all your time trying to fight it. God does not give you anything you cannot endure. Stop fighting." And it was like a huge weight was taken off me, to realize I should stop fighting because it wasn't going to make anything better. For the first time, I went outside and I could feel the sun and I was in tears. I remember I went back to my room and I was reading Edith Wharton's *Age of Innocence* and for the first time I could read and really enjoy it. It's amazing, these things that happen, the huge effect certain people have on you.

RK

You were married before you graduated, right?

BTS

Yes, Allen Smith proposed my junior year and we got married because he was "perfect." He was from a wealthy family, and he had gone to boarding schools. That's why my family had sent me off to college. Not really for the education but to find a husband. I was pregnant with my son, Rick, before we graduated. And then we went to Georgia for two years because my husband was in the R.O.T.C., at Fort Benning. We come back to California and I have my daughter, Julie, and we're living in Arcadia up near the foothills in a beautiful ranch-style house and I should be happy, but I just feel like I'm in someone else's play, having all the parties and being social. I finally tell Allen that I don't know what's wrong with me, but either I'm crazy or the whole world is crazy. I decided to walk down the street to see a guy who I knew was a

Top: Barbara T. Smith, *Xerox, Coffin: Chaotic Attractor*, 1965–66. Xeroxed book, 10 1/4 × 14 1/4 in. (26 × 36.2 cm) closed; 21 3/4 × 14 1/4 (55.2 × 36.2) open. Photo: Fredrik Nilsen Studio. Courtesy the artist and The Box, Los Angeles

Bottom: Barbara T. Smith, Memo Pad, 1965. Xerox sculpture, 11 1/4 × 8 3/4 × 3 in. (28.6 × 22.2 × 7.6 cm). Photo: Fredrik Nilsen Studio. Courtesy the artist and The Box, Los Angeles

People waiting to access
Smith's performance *Feed
Me,* 1973. Photo: Dick Kilgroe.
Courtesy the artist and The
Box, Los Angeles

Portrait of Barbara T. Smith, 2018.
Photo: Fredrik Nilsen Studio

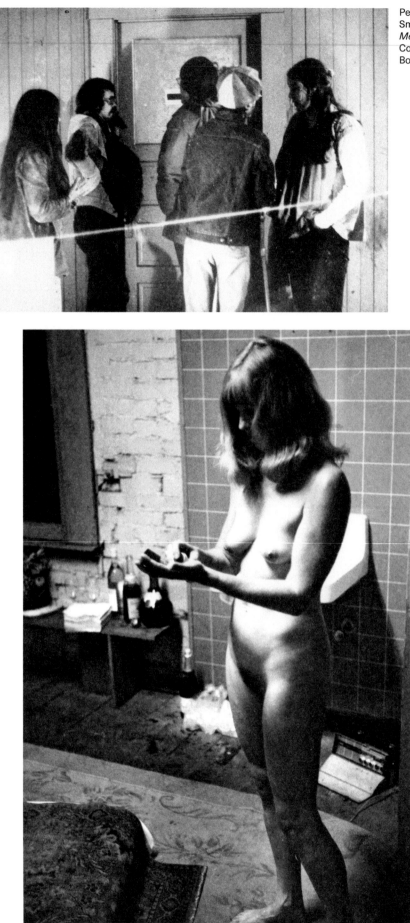

Smith during the
performance *Feed Me*,
1973. Photo: Dick Kilgroe.
Courtesy the artist and
The Box, Los Angeles

"When I was young, I would get very angry about injustice,
but not enough to be an activist. There was no such thing,
really, in the world in which I lived." —Smith

therapist. And I knock on the door and his wife comes to the door in bathrobe and curlers. I just say, "I live up the street and I understand your husband's a therapist. And I have come to see if he can help me." And she says, very calmly, "Well, he probably can." And so that's how I started therapy, which was just mind-blowing to me, with a wonderful therapist named Robert Hinshaw.

RK
What did it do for you?

BTS
For one, I think it was when I understood that I wanted to be an artist. Not what my husband thought, a kind of Sunday painter, but a real artist. I tried to get Allen to go to therapy with me, but he wouldn't. It was just too threatening to him. Around that time I decided to start volunteering at the Pasadena Art Museum. Hinshaw knew someone there and made a call and it helped me get included there. Tom Leavitt was the director and then Walter Hopps came on board and it was a pretty wonderful place to be, at a wonderful time. There was the Duchamp retrospective and the very first Pop Art exhibition in a museum ["New Painting of Common Objects"] and Frank Stella's first show. We hosted a party at our house during the Duchamp exhibition and Rauschenberg came and had too much to drink and fell, or maybe jumped, into our koi pond in his suit, which was velvet, and I had to dry it with a hair dryer.

RK
Was Hopps a formative person in your life?

BTS
Yes, but really more as a friend. The museum itself was such an accessible place. When they did the Pop Art show in particular, the West Coast Pop artists all hung around and I got to know them and become friends—Ruscha and Joe Goode and Robert Dowd, those guys. I had a chance to talk art. And I learned that I could hold my own with them. That I'd had a great education. I didn't have to prove anything, at least as far as talking went.

RK
Were you beginning to make art?

BTS
Well, I had started doing some writing that was very intense. I remember one time in particular at a beach house we had in Laguna. And I started writing furiously, a kind of re-interpretation of the Adam and Eve myth, which I felt that everyone had always gotten wrong and that I had a new perspective on. We were driving home and Allen started talking to me and I said, "Don't talk, please, because something is writing itself in my mind." And we got home and I rushed in and started writing. I was in a state, and I'm sure he thought I was crazy. It was a fairy tale about an enchanted princess who had an evil mother. It was a myth about my life, and writing it was a true spiritual awakening. What I understood after looking back at it was that it was me giving structure to my family as a fairy-tale or a myth, and in some sense, it led to a very deep forgiveness of my family. The writing was important. After that, instead of having to wonder what I would paint, all of these ideas just kept flooding through my head and I responded with art.

RK
The *Black Glass Paintings* then came along in 1965 and you considered them to be among your first mature pieces.

BTS
Right, they were paintings that were really mirrors. But they made you think they were paintings, made you approach them as paintings, because the frames signified "painting." They were black, or primarily black, surfaces under 3/8-inch glass, reflecting you and your surroundings, forcing you to be aware of yourself and the world out here, outside the paintings. I had my first studio in Eagle Rock then and after I made the paintings I decided to go back to school, to Chouinard [now CalArts], because I really thought the paintings were something that no one had quite done before, that they were quite hot. I believed in them so much that I began to get worried that I was self-deceived and that I needed to find out. Walter Hopps told me that no one had really done anything quite like them except maybe Pistoletto, who was working with mirrors in a different way. Of course, much later, in the 1980s and afterward, Gerhard Richter made his monochrome mirror paintings.

RK
Was this also around the time that you began experimenting with the Xerox machine? Can you talk about how that came to be?

BTS
It began because I had gone to the great Gemini print shop [Gemini G.E.L. in Los Angeles] to see if I could make a print with them. I wasn't going there to learn how to make a print but actually to do one. And they said, "Well, it's customary for artists whom we work with to have gallery representation." Basically, I wasn't well enough known for them. And they added, "Besides, we're busy working with Josef Albers right now." They were brushing me off, and I was so angry, and I thought, "What they do is passé anyway. I'm going to figure out what the printmaking technology of our time is." I'd read about Xerox machines. And it turned out that Xerox technology was unique and completely new. And so I just called the company and leased one with some money I'd gotten after my father's death. And I put it in the dining room.

RK
What did your family think about it?

BTS
I think the kids just thought, "Oh, that's Mom's thing. A weird grown-up thing." I knew, because I'd had training in printing, that what I was doing was technologically innovative, that it was right for its time. But really what also happened was that I became obsessed with the machine, with putting my face on it and my body on it, which I'd have to do when no one was home, getting up and sitting on it. Everything it did was so immediate, you could just embody your ideas with no delay at all. I had a poetic analogy in my mind that it was like a salt cellar at the bottom of the sea cranking out salt, and it won't stop. The salt is endless. It sort of frightened me. I told Allen, "I don't know how to make this stop. What'll I do?" And he said, "Just call them up and tell them to come get the machine." That's what I finally had to do. And what was happening in the middle of all of

this was that my marriage was coming apart. That eventually happened, and we divorced in 1968. I ended up losing custody of the children and it was the most painful time in my life, almost unbearable.

RK

Did making art seem like a refuge in those years, or maybe a way to think through or express that grief?

BTS

I don't know, but it was all I had. The artists I knew were like my family. I was living in my house all by myself for a while. And then I went to study at UC Irvine and became part of the group of artists who formed F-Space Gallery in Santa Ana, including Chris Burden and Nancy Buchanan.

RK

How did F-Space come about?

BTS

It was an industrial space that a group of us, about six of us, rented because some of the things we were doing, that we wanted to do, our performances, were things we just knew we couldn't do on campus because of the extremity and the content of some of them, nudity and things like that. At F-Space in 1972 I did *Nude Frieze* [a performance and installation in which naked participants were briefly suspended from walls with reinforced duct tape and Smith, sitting atop a high stool, directed the action] and that same year *The Fisherman IS the Fish* [a performance in which Smith's naked, painted, body served as a kind of projection screen]. And Chris did *Shoot* there the year before.

RK

I have to ask what it was like to have been part of the audience for that.

BTS

The word "audience" isn't really correct for those kinds of performances. It's more like witnesses. You have a feeling of responsibility when you're at certain performances, especially one like that. I recorded the sound and took pictures that evening. There were about seven or eight of us present and we all knew about it ahead of time and Chris told us we could decide whether we wanted to be there or not. It was scheduled to start at 7 p.m. and at about 7:20 we locked the door so no one else could come in. And suddenly I'm realizing that he could really be hurt or killed. But not a single person there asked him to stop, because that was just not the right thing to do. It felt kind of like we held his life in our hands, the connection was so real. The bullet was supposed to just graze him but it got more of the arm and went through muscle. And then we realized that no one had brought a first-aid kit and Alfred Lutjeans had one in his car and ran out and got it.

RK

It's always seemed to me that *Feed Me*, in the realm

of body-focused performance work in those years, was fully as radical as *Shoot*, maybe more so because you did it alone and it wasn't filmed or recorded. And in the same way that Burden controlled the parameters of what was inflicted upon his body, you were in control in that room, in a way that most people didn't really understand. How did the idea for the piece come about?

BTS

Part of it came from my anger about how I was being treated in those years by men. Everywhere I went, if I traveled by myself, I was always being followed, hit on, hustled, harassed. And it made me furious that I felt that I had to tamp down my personal energy as a woman and dress differently, in a way that made me feel like a nun, just to have some peace. I was fed up. And when I had the chance to be part of a program at the Museum of Conceptual Art in San Francisco, the circumstances were perfect. The room I could use was, after all, the women's room. It was intimate and small. What I was trying to do in there was in part to say, "The way people treat me, it's like the only thing that I'm good for is a screw, a fuck." And there are so many other ways that I wanted to be able to interact with another person, to have a connection. And so I had things in the room that reflected the various ways you can interact with someone, nurturing things—wine and cheese and other food. There were body oils and books and you could make coffee or play a record, play music. My voice on the tape loop saying, "Feed me," could be taken as a request or a command.

RK

Were you ever scared or intimidated by the men, or the women, who came in?

BTS

I wasn't at all. I was completely centered when I did it and I knew that I could do it, that I wanted to go through with it. I wasn't controlling the visitors, because of course they could say or do whatever they wanted. They could even get negative or aggressive. But I was guiding, in a certain way, by what was available in the room and by my behavior, what was going to happen. After it was over, I was completely spent, exhausted for days. But I felt that through the piece I had somehow regained parts of myself I thought I had lost for good, or some parts that I maybe never had to begin with. I had claimed my own territory. I knew it was a very good piece, an important piece. So much of my work is about validating the physical body in real space and real time. That's what the *Black Glass Paintings* were about, that's what the Xerox works were about and so much that came after—that we live in a physical world, in addition to the mental, which we overemphasize. And what happens to us bodily often means more than we can comprehend.

"After *Feed Me* was over, I was completely spent, exhausted for days. But I felt that through the piece I had somehow regained parts of myself I thought I had lost for good, or some parts that I maybe never had to begin with." —Smith

Barbara T. Smith, *Pink*, 1965,
Xerox prints, 39 × 27 in. (100 × 70
cm). Photo: Fredrik Nilsen Studio.
Courtesy the artist and The Box,
Los Angeles

By Bob Nickas

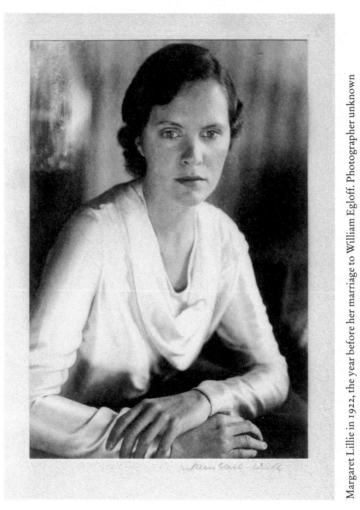

A selection of previously unpublished
psychological drawings by Margaret Egloff,
American student of Carl Jung,
Zurich, 1931

Portrait of the Artist

Margaret Egloff, untitled work (Zurich, May 15, 1931), watercolor and pencil on paper, 18 × 13 1/4 in. (45.7 × 33.6 cm)

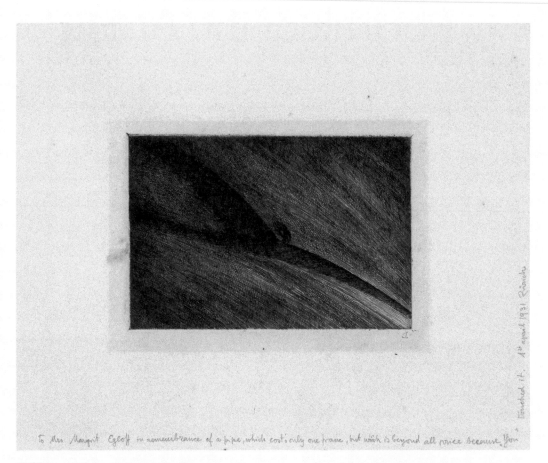

Carl Jung, untitled work (Zurich, April 1, 1931), etching on paper, 9 3/4 × 12 1/4 in. (24.7 × 31.1 cm).
The dedication reads, "To Mrs. Margrit [*sic*] Egloff in remembrance of a pipe, which cost only one franc,
but which is beyond all price because 'you' touched it."

Margaret Egloff, untitled work (Arosa, Switzerland, June 7–8, 1931), watercolor,
colored pencil, pencil, and pen on paper, 13 1/4 × 18 in. (33.6 × 45.7 cm)

Margaret Egloff, untitled work (Zurich, February 1931), watercolor and
pencil on paper, 13 1/4 × 18 in. (33.6 × 45.7 cm)

In our time, the pursuit of previously untold stories in art parallels the practice of archaeology, a sifting of the past, an excavation—as of pottery fragments—that allows us to piece together images and objects incrementally. Connections to others already known or similarly discovered may be revealed. In this there is the possibility of creating a larger view, adding pieces to a puzzle always tantalizingly incomplete. The archaeological process can also be related to delving into the unconscious, or, more widely, in the Jungian sense, the collective unconscious—which may be thought of as the foundation of an entire culture, since symbolic images are recurrent, archetypal and shared across time; in a word, ancestral. To paraphrase the founder of analytical psychology, we have always produced the symbols by which we may be redeemed. When Jung looked back on his life in *Memories, Dreams, Reflections*, a memoir published in German in 1962, the year after his death, he wrote, "I was intensely interested in everything Egyptian and Babylonian, and would have liked best to be an archaeologist."

The unearthing before us in these pages takes us back some ninety years, to seminars held by Jung at the Psychology Club Zurich, and to art, including his own, which only recently became known, by way of a 2009 facsimile edition of *The Red Book: Liber Novus*, the volume of text and images that he compiled between 1915 and 1930. The paintings and drawings made by Jung himself, as well as those of his patients and students, were never destined for gallery walls.* Rather, they functioned as a tool for accessing what Jung termed "active imagination," the exploration of the inner self by way of the unconscious. And yet the paintings and drawings that comprise the picture archive of the Jung Institute have ultimately come to seem like works of art—just as the illustrations, lettering, calligraphy and mandalas that form the visual pulse of the *Red Book* make it no less than an illuminated manuscript of the 20th century—even if their creators, Jung first and foremost, neither saw themselves as nor wanted to be identified as artists.

In 1930, a twenty-seven-year-old woman, Margaret Egloff, accompanied by her two children, a boy, five, and a girl, six, left a marriage on the verge of collapse and traveled from Boston to Zurich to study with Jung.† Her intention was to become a psychiatrist, as well as to put needed distance between herself and divorce, which in that era was more strongly held against women, mothers in particular. It's important to note that she was a student of Jung's, not one of his patients. The picture archive of the Jung Institute contains around 4,500 drawings and paintings by his patients from the years 1919 to 1955, and an additional 6,500 from the patients of Jolande Jacobi, his student and colleague, made between the 1940s and the 1970s. The fact that Egloff held onto the watercolors and drawings she created while studying with Jung—"in the context of what must have been an emotional rollercoaster in 1931," as her grandson notes—seems to be a clear indication that they were resonant for her, deeply so, although she never spoke about them during her life.

From late 1930 through 1931, Egloff was in Switzerland, attending Jung's "Visions" seminars. She was introduced to the art therapy he advocated, for which patients were encouraged to paint and draw in order to bridge the unconscious and conscious mind. Art provided an unfiltered visible image that could be analyzed and discussed. The direct triangulation between patient, analyst and image—a dream rendered—offered a focused perimeter that the elasticity of language, itself a symbolic world, was not bound by. We are, after all, more honest with ourselves in dreams. Even if we can't make sense of them or remember them clearly, we don't easily discount or explain away what we have "seen," unable to engage in self-deception as we are in waking life. A drawing can serve as a memory trace, a recording that is as close as we ever get to taking a photograph inside our heads.

Image-making was of significant importance to Jung himself, as his *Red Book* would reveal. The copious notes and illustrations comprising the book had been concluded in 1930, shortly before Egloff began her training. She would recall her attitude toward Jung as "worshipful." A drawing of hers described as a "canticle"—a church hymn or chant—comes immediately to mind. It features a bearded man seated atop a mountain, his arms and legs folded, Buddha-like; certainly someone of knowledge. To the left is a golden sun, to the right a crescent moon and a star. A serpentine path leads up the mountain, at the bottom of which a young girl is about to ascend. (The image of a bearded man appears in the *Red Book*, and also in wood carvings and a limestone sculpture made by Jung in 1918/20.) An etching that Jung gave to his young student, dated April 1, 1931, shown opposite, bears the dedication "To Mrs. Margrit Egloff in remembrance of a pipe, which cost only one franc, but which is beyond all price because 'you' touched it," attesting to the great affection that he had for her in turn. This was an exhilarating, liberating period in Egloff's life but also a difficult one, as Jung was likely aware. The etching features an elongated black bird with its wings spread from one corner to another, east to west, as it were, against a dark sky through which it determinedly soars. It's impossible not to imagine this as representing the young woman's flight, particularly since her divorce began with a middle-of-the-night trip from Boston to New York, from where she and her children would continue on to Europe. Although the Great Depression had begun and the first stirrings of Nazism were being felt in Germany, Egloff describes Switzerland in her notes as having "the atmosphere of Shangri-la, or the Magic Mountain. It was high up and mysterious and somehow magical or mystical, otherworldly."

The drawings, watercolors mostly, that Egloff made during this time reflect that heightened milieu, no doubt buoyed by her freedom from an emotionally troubled relationship and her anticipation of studies that would eventually lead her back to America to pursue a medical degree and become a psychiatrist. Having made her escape, she sought independence. In one of her watercolors, we see a woman from behind, wearing a long white gown, peering over an indeterminate black space, not a wall exactly, toward

Margaret Egloff, *Portrait of the Artist and Children* (Zurich, February 1931), pencil, colored pencil or crayon on paper, 9.5 × 13 1/4 in. (24.1 × 33.6 cm)

Margaret Egloff, *Portrait of the Artist as ATLAS* (Zurich, February 1931), colored pencil or crayon on paper, 9.5 × 13 1/4 in. (24.1 × 33.6 cm)

Margaret Egloff, *The Canticle of the Sun* (Zurich, July 6, 1931), watercolor on paper, 18 × 14 in. (45.7 × 35.5 cm)

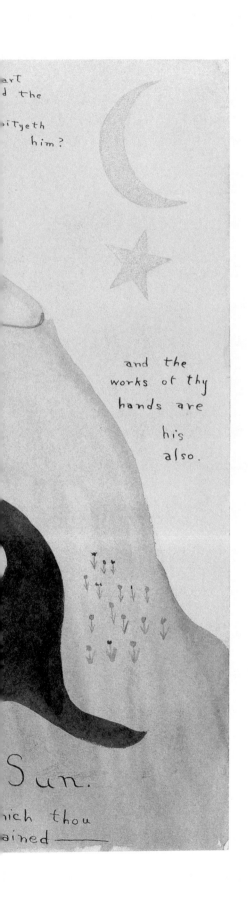

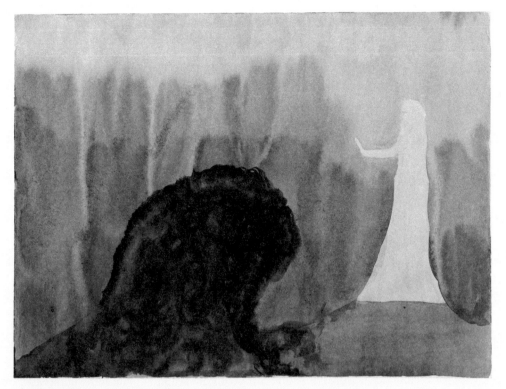

Margaret Egloff, untitled work (Zurich, June 16, 1931), watercolor and pencil on paper, 13 1/4 × 18 in. (33.6 × 45.7 cm)

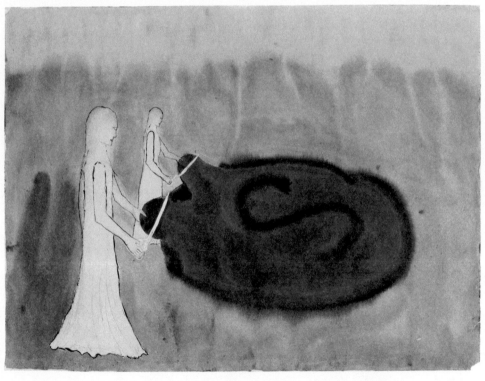

Margaret Egloff, untitled work (Zurich, June 16, 1931), watercolor, pencil and pen on paper, 13 1/4 × 18 in. (33.6 × 45.7 cm)

rolling green hills and a bright sky. In another, a nearly transparent woman, also gowned, holds back with the palm of her hand an ominous dark form that seems about to rise up against her. An especially beguiling image, clearly made during the same "session," as we can see from the similar figures and overall brown wash, features two women, nearly apparitions, sisters or maybe twins, who wield large scissors as they cut into an ectoplasmic form in which a formidable S-shaped snake undulates. Among forty-some works on paper, only one is purely nonrepresentational: a black rhombus leaning to the right, held in place by a slender, inverted green L. Though made in 1931, it has the feel of a Blinky Palermo gouache from the early 1970s, and corresponds to Swiss geometric abstraction from the 1980s. One of Egloff's seemingly simplest watercolors may be one of the more complex, with a large gray wave about to break into a white wave, creating a wide elliptical vortex at the center. Two very small forms to the right might be figures imperiled, about to be swallowed within.

Egloff also created a number of vibrant mandalas, not unlike those we associate with Jung's in the *Red Book*. A few of these works on paper were made with metallic gold color, suggesting, also by way of the imagery, alchemical/Tantric connections. Two, obviously from the same session, place elongated melon shapes on jet-black grounds, each featuring

Margaret Egloff, untitled work (Zurich, May 5, 1931), gold paint, watercolor on paper, 13 1/4 × 17.5 in. (33.6 × 44.4 cm)

Margaret Egloff, untitled work (Lugano, April 5, 1931), gold paint, watercolor, pencil on paper, 9.5 × 13 1/4 in. (24.1 × 33.6 cm)

stick figures. One, with the figures sketched in pencil to the right of the centered image, appears preparatory. The figures are drawn as if they are stepping forward, walking, striding, and dashing ahead. In the image that must have followed, they form four orderly lines, two at the top, two below, walking from right to left. Gold was used in a drawing dated February 1931, a double image. To the left is a gold treelike structure, each branch bending upward and outward with an arrow at the end. Under the "tree," deciding upon her direction, stands a gray, shrouded woman. To the right an aerial view of a path leads to a fork in the road. The path is completely filled in with small golden arrows, some proceeding ahead, other turning to the right-hand curve. The works with metallic color, this last in particular, raise the age-old question: Does one follow others along an expected route, or decide on a path for oneself?

One of the most beautiful of Egloff's images has at its center an eight-pointed star, a symbol of fertility and life, also meant to ward off evil. For Buddhists—and Jung, who studied their philosophy, understood that, as he said, "the goal in psychotherapy is exactly the same as in Buddhism"— the eight-spoked wheel represents a means of escape from suffering, for which one must first break free of attachments. Egloff's mandala has four pale blue birds, arched wings spread, flying off from the eight-pointed star, with small, banded rings behind them. Four other creatures have already left the circle, although they seem to be swimming away. (In a pencil drawing identified as *Portrait of the Artist and Children*, Egloff represented herself as a seal perched on a rock above the sea. In another playful image, she is a seal with the world balanced on the tip of her nose: *Portrait of the Artist as ATLAS*.)

None of these works were ever framed or displayed, remaining for decades in a cardboard portfolio which Egloff brought back with her to the States. Recalling Jung's method in notes dated September 20, 1979, nearly fifty years after studying with him, she recalled:

The material under discussion that year was the . . . journal of an American woman, well-educated and intellectual. She had recorded a long series of dreams, hypnogogic fantasies and images. Her material was a lively example of "Active Imagination." She had illustrated it with pen and pencil, water colors, and crayon. Jung himself often drew symbols and diagrams on the board.

His method was to use each theme, sequence or symbol as a springboard from which to launch into an exposition of his theories, speculation and vast erudition. He ranged over present day social and political matters, as well as historical and mythological material. He covered philosophy, psychology, medicine, economics, and folk lore. . . .

This method of instruction he later came to call "amplification." It is central to the technique of Jungian therapy today, as it was then. One purpose of this method is to offer the patient a way to stand back a little from his problems and see them as a little less personal, projected onto a screen, more universal and more

Margaret Egloff, untitled work (Zurich, October 26, 1931), watercolor and pen on paper, 14 × 18 in. (35.5 × 45.7 cm)

human. Ideas about the stream and continuity of human life flowed through all of his teaching.

Egloff may have been engaged and captivated by Jungian training, considering in his seminars the traumas and troubles of others, but she was still a young woman with two small children, in a vulnerable position. We may see her as a student of Jung's who, in a sense, was compelled to confront herself. In this circumstance, she was not alone. Shortly before beginning her studies in Zurich, she took her children to the Alpine resort of Gstaad for the holidays. There, in December 1930, she met another single parent, accompanied by a daughter who was a few years older than hers. The man was temporarily separated from his wife, who was then in a sanitarium near Lausanne being treated for schizophrenia. He and Egloff connected through a mutual interest in psychology, possibly also through their shared circumstances and solitude. The man was F. Scott Fitzgerald. In the biography *Fool for Love* (1983), Scott Donaldson examines Fitzgerald by way of the women who occupied central and at times difficult positions in his life, particularly his mother, with whom he had an anxious relationship into adulthood, and his wife Zelda, whose breakdown would come to haunt their marriage and upon whom the character of Daisy Buchanan in *The Great Gatsby* (1925) was based.

Donaldson writes that after Egloff and Fitzgerald's initial encounter "there were frequent meetings during the next six months when they spent long hours talking about literature and psychology and she came to know him 'very intimately.' The two of them also took trips together to the Italian lakes and to France." Donaldson makes note of a significant dream Fitzgerald had had, which he transcribed and shared with Egloff, who helped him navigate it. In the dream he had been embarrassed by his mother, whose ambitions for him were inseparable from his social insecurities. He stumbles into a party to which he had not been invited, an arena for his feelings of inferiority and fear of rejection, which endured even amid his great success. Egloff referred to it as his "Big Dream." Donaldson concludes his account of Fitzgerald and Egloff with a scene the author himself might have written: "Then they went their separate ways, Margaret to remarry, and met only once more, surreptitiously, in the Washington train station in the mid-1930s."

When we consider the brief relationship between Fitzgerald and Egloff, how they had been brought together in a moment fraught for each of them, against the backdrop of her divorce and rebirth with Jung, one of the epigrams included in his *The Crack-Up* (1936) resounds: "Switzerland is a country where very few things begin, but many things end." Egloff would later burn the letters Fitzgerald wrote to her, but she held onto these drawings, as well as to Jung's etching, with its touching dedication, for the rest of her life. Switzerland was to be, for her, the moment in time where everything began again.

* For my commentary on Jung's artwork, I am indebted to Ulrich Hoerni's essay "Images From the Unconscious: An Introduction to the Visual Works of C. G. Jung," in *The Art of C. G. Jung* (New York: W. W. Norton, 2019).

† I am grateful to her grandson, Frank Egloff, for his insights into this period, drawn from the recollections of his father.

In 2017, the artist Paul McCarthy embarked on a new body of work that brought many of the themes he has explored relentlessly for more than four decades—existential anguish, delirium, cruelty, eroticism, oppression and fundamental corporeal existence—to a fever pitch.

Taking as its starting point the controversial 1974 Liliana Cavani film *The Night Porter*, the project reimagined the movie's setting and plot, a sadomasochistic relationship between a former Nazi concentration camp officer and one of his prisoners, relocating the story to contemporary Los Angeles. Taking the form of filmed and live performance, photographs, sculptural sets, drawing, painting and writing, *NV / Night Vater* is suffused with 21st-century considerations of pop culture and corporatized mass media and their complicity in—or tacit cooperation with—the rise of fascistic forces within American culture.

Still from *The Night Porter,* 1974, directed by Liliana Cavani. Charlotte Rampling and Dirk Bogarde. ScreenProd/Photononstop/Alamy Stock

McCarthy, a dean of the Los Angeles art world, has long functioned within the city as something of a shadow Hollywood, using his studio to turn the fantasy-making machinery of the movie industry and Disney inside out, eerily and viscerally. The idea of re-imagining *The Night Porter* first came about in Berlin in 2015, when McCarthy and his son Damon, then at work on a production of a scene from a previous body of work, *Rebel Dabble Babble*, met the German actress Lilith Stangenberg. It was the first time that the McCarthys had worked with Stangenberg, and what followed was a close collaboration that led to *NV* and gradually to a

related, more open-ended series of works that have come to be known as *A&E*—all-purpose abbreviations for Adolf [Hitler] and Eva [Braun], Adam and Eve, and arts and entertainment, protean versions of which McCarthy and Stangenberg have embodied in highly emotional and physically demanding performance films.

NV was shot over a thirty-day period in 2019. The first stage of *A&E* was shot over the course of twenty days in 2020 and the second stage of the project began filming during the fall of 2022. McCarthy has conceived of the two projects, *NV* and *A&E*, as a diptych, each comprised of a series of episodes. In November of 2021, McCarthy and Stangenberg enacted a related video-recorded performance in Bergen, Norway, at the KODE Museum; its title, *A&E Dead End Hole*, derived from the performance's setting in a basement of one of the museum's buildings, a storage space that doubles as an active bomb shelter. McCarthy describes *NV* and *A&E* as a "series of cycles that continually turn in on themselves, with no end in sight."

The most recent iterations of both *NV* and *A&E* returned McCarthy, seventy-seven, to a place where he had not been since the early 1980s: performing live as an artist before an audience, a cornerstone of his early, boundary-pushing career. Over five evenings in late August at the SchauSpielHaus in Hamburg, McCarthy and Stangenberg performed scenes from *A&E* on a stage equipped with moving cameras and large screens so that the audience viewed the live action in a disorienting, prismatically fractured manner. In early September at the Volkstheater in Vienna—the city in which Cavani set and filmed *The Night Porter*—the two followed with four similarly staged evenings of *NV* variations, McCarthy playing versions of Max, originally portrayed in the movie by Dirk Bogarde, and Stangenberg playing Lucia, Charlotte Rampling's death-haunted character.

In the following autofictional essay, Gary Indiana's first foray into writing about the work of McCarthy, he takes up elements from both *NV* and *The Night Porter*—a foundational film for him as it is for McCarthy and Stangenberg—and fuses the parts into a disturbing, hallucinatory rumination on power, desire, degradation and death, a darkening cloud that stretches all the way from Stephansplatz to the Hollywood sign. —*Randy Kennedy*

NIGHT FALLS OVER DISNEYLAND

An homage by Gary Indiana to Paul McCarthy's *NV / Night Vater*

We were shooting a scene of The Night Porter *in Vienna, outside the Karl-Marx-Hof workers' flats, where the revolution took place. I had to cross the street and exit into a car. And I said to Charlotte [Rampling], "I'm shit-scared." I was looking very beautiful in my Nazi uniform, quite splendid—it's built for that, you know, to strike reverence and fear into you. I went and sat in this little bar in somebody's raincoat and kept my cap off. They told me, "We've got you a room in one of the flats where you can hide and no one will see you. The old lady's very old and very stupid. She doesn't realize what's going on. She'll hide you, we'll give a signal, and you take off the thing at the door and come downstairs and make the exit." My God. I got into the flat. She was probably eighty and perfectly sweet. There was a canary in a cage, pictures on the wall of chalets and of her daughter and her son-in-law. I had to get rid of the mac and put the cap on and pull on my black gloves to wait for the signal. And she went on her knees and touched my boots and said to my interpreter: "It's the good days again." It's true! She asked if she could kiss my hand. What do I do? I gave her my hand and saluted and went down feeling ill. There was an enormous crowd—you couldn't hide the fact we were making a bloody movie—and when I came out, it was like I was Garbo or Dietrich. And they were shrieking with joy and singing the "Horst Wessel Song." I should worry. And all the kids came running after me, to hold my hand, to touch the uniform—all of them.*

—Dirk Bogarde in conversation with Gary Indiana, 1991

Vienna at blue dusk. Los Angeles at an unknown hour. Max wears the black gloves he is noted for, a long coat that could easily hide a machine gun, and carries a black umbrella open at an impeccable angle. He is a film producer and the concierge of a pricey hotel. The war ended nine years ago seventy years ago but he hasn't changed except for the guilt. He isn't sure if he actually feels guilty, or lucky. His life's a blur. He isn't introspective, just compulsive. Lucia is checking into Max's hotel with her husband. Her husband is conducting *The Magic Flute* at the Volksoper. Lucia is checking into a Marriott Hotel by herself. She's in Los Angeles for a screen test. Her luggage is blue. Her dress is red with little white Alpine flourishes along the hem.

Max in his SS uniform operates a small movie camera and moves among naked bodies standing in a drab institutional hall. Some bodies are old, others middle-aged. Lucia looks the youngest. Another Nazi out of frame interrogates the naked bodies one by one. Name, age, address, occupation, religion. Only the third or fourth body says he's Jewish. There are Lutherans and Catholics too, Socialists and perverts and what have you. All are going to die like dogs. They are impure, and killing them is wonderful entertainment. Max will die and Lucia will die but not yet. Not now, not here. Max sends a car to Lucia's hotel. He takes her to a party at the Beverly Hills Hotel. Let me introduce you to some famous people.

What is a Nazi in love? A parlor game: Lucia scurries naked back and forth in the smoky gray room that looks like an abandoned school or perhaps a shuttered sanatorium with long windows high up. Max fires his service revolver at the wall near her head. He fires again and shatters a window while Lucia cowers, trying to make her skinny body very small. Max is happy. The sound of windows shattering makes him happy. Lucia is happy if Max is happy. He won't shoot her, or maybe he will. It's exciting.

Max has won several Academy Awards. He uses them as dildos. He couldn't care less about movies. Quality is his middle name, but who uses their middle name? His prestige gets him beaucoup pussy. Beaucoup is the one French word Max pronounces perfectly. He rapes women using beaucoup drugs and intimidation. He rapes men as well, but it's not as rewarding. His bathrobe is famous. It opens and closes upon a great mystery, Max thinks. Lucia doesn't resist him. He's a fascinating pig and she needs a job. Besides, if she doesn't do what he wants he'll kill her, and not just spiritually. This is Hollywood. Lucia thinks she's falling in love. First you have to fuck these friends of mine, Max informs her. This is Dead End Hole, my intimacy coordinator. Max films Lucia and Dead End Hole while they wrestle in shit. The party guests gather to watch.

Max's old comrades don't feel guilty. They've tried to, but the old ways are too stimulating. They're men, they want to feel like men. Strong. Pitiless. Invincible. Prissy, but in the manly Prussian manner. They are, after all, the race that gave the world Beethoven and pretzels. They know the Reich will rise again if they can wipe out all the witnesses. Lucia is a witness. A thorny problem for Max because he adores her. Max has promised to put her in movies but the only part she'll get is the one she's playing now, between his uniformed legs, with Dead End Hole slathering her with peanut butter and mayonnaise.

Other fluids may be involved. Often Max can't get it up unless he's raping someone. Even then, it's touch and go. Lucia is pleased when Max is impotent. It arouses her maternal instinct. He punches her in the face. He knocks over the furniture. The hotel was designed by Otto Wagner. Many of the rooms have Nazis in them. One is the Countess, an old bag Max pimps for. He sends the bell boy up to fuck her. The bell boy smells, but so does the Countess. Lucia's husband reads her his reviews in the Austrian press. Do you realize, he says, that I am a genius? Listen to this: I was pleasantly thrilled by this young maestro's deft command of the orchestra. Oh shut the fuck up, Lucia says. We've got to get out of here. I've got to get out of here.

Don't be ridiculous, Max tells her. We can't get out of here. It's an A-list party. There's no way out. These people you're about to fuck or suck in some fashion are known all over the universe. Their faces are on billboards. We can't leave until you've done all of them. My reputation depends on it. Then we'll go to my apartment where the other Nazis can't get you. We can stay there and get wasted and roll around in broken glass and have food delivered from the Nazi grocery store down the block. I'll chain you up, just in case. Oh Max, Lucia sighs, put your fingers in my mouth.

Hollywood is amazing, Lucia says. I've never felt so alive or so dead. I have only been here a few hours and I've fucked almost everybody. If you're enjoying yourself, Max says, puking on her dress in the limousine, you're really missing the point. Fucking is business. I am Hollywood, he adds, wiping vomit off his chin. Therefore I am amazing. I'm also Walt Disney. I move in and out of character, same as you. If you do what I say I will take you to Disneyland.

The Nazis meet in the hotel conference room to discuss Max's dossier. Your case is simple, they tell him. You're obviously insane. You can get away with anything if you're insane, particularly here in Austria. I know a guy who kept his daughter locked up in the basement for twenty years for breeding purposes. He's already out on parole as an insane person. Besides, there are no witnesses. But there might be one witness. Look at this photo of Charlotte Rampling. Could it be she? Mario might know something. He's got his nose in everything. Who the hell is Mario? That Italian who runs a pizza joint down by the river. He survived because he made a wonderful vegetarian lasagna for the Führer. He's an actor named Ugo Cardea pretending to be Mario.

Will we fuck in Disneyland? Eat hot dogs? Lucia asks. Of course, Max replies, on the ride that goes up the Matterhorn. Or the Pirates of the Caribbean. Any ride with a tunnel.

Max enjoys an Austrian lunch with Mario, white wine and coffee and a large sugared donut. A little stale cake of marzipan. He suggests a fishing outing where they can talk things over. Maybe we can catch a trout, or a similar fish. I know what you did to survive, Max tells Mario. You're such a blabbermouth but I forgive you. Not as bad as you, Mario retorts. People will do a lot to survive. Anyway, all I did was cook lasagna and shit in Hitler's mouth. Oh god no I'm not suggesting you're like me, Max says. You're too puny to be as bad as me. I never made lasagna for Hitler. Look at my beautiful gloves, Mario. An Italian like you can't wear such elegant gloves. He pushes Mario overboard and holds his head underwater. A dying trout flops around at Max's feet. The memory brings a smile but a minute later, he's tormented. Why do I keep killing people, Max asks himself. I guess I really am incorrigible.

You can only sleep your way to the middle in this town, Max tells Lucia as they leave the party, but it's better than nothing. I feel like a Disney character, Lucia tells him. Some Disney characters have long careers, Max muses, Annette Funicello, for example, and Goofy. And you yourself look like a Disney character, with that swastika, Lucia says. Don't answer the door, she tells her husband. If you open the door bad memories will waft into our room. Don't be absurd, her husband says. Memories don't waft, they seethe and subside. I know how you suffered in the war but they haven't brought all the papers yet with my reviews in them. You always love hearing about my genius.

The car arrives at Max's Brentwood apartment, an exact replica of his apartment in Vienna. The same nosy crone and her dachshund are living across the hall. A retired location scout, she often shits outside Max's door, and sure enough there's a long oily human turd on the welcome mat, along with a hard, smaller one from the dog. Max scoops up all the feces in his gloves and smears them in a swastika on the old lady's door. Don't mind the shit, he tells Lucia, wiping his gloves on her dress as they enter his place. It's an old Vienna custom, shitting on the neighbor's doorstep. They say it originated with the Germans, but who can say? It's American as apple pie, really.

The old bag at the hotel, the Countess, whatever she is, an actor named Isa Miranda, Countess Stein, is all dolled up like a senile prostitute, waiting for Max to pour her champagne. This hotel is crawling with addicts and whores. What's troubling you lately, she wants to know. You're losing your panache. Your face is sagging. You should put

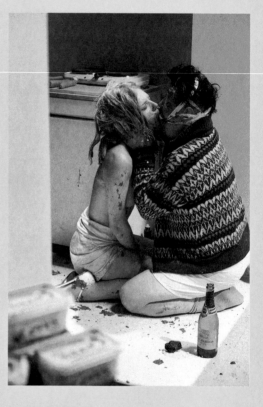
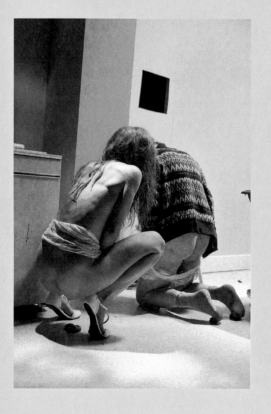
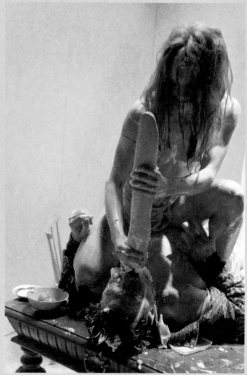

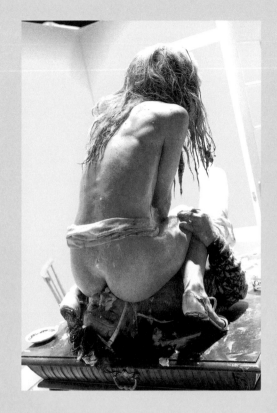
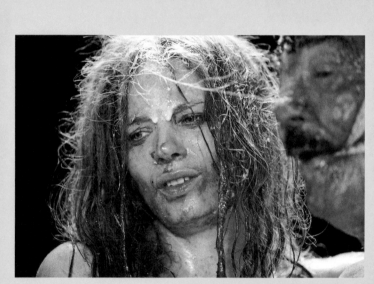
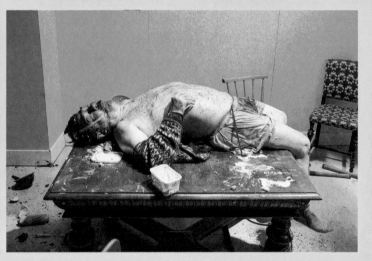
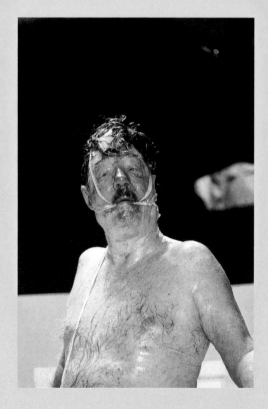
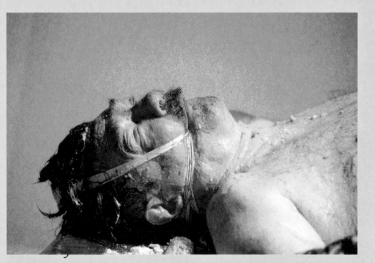

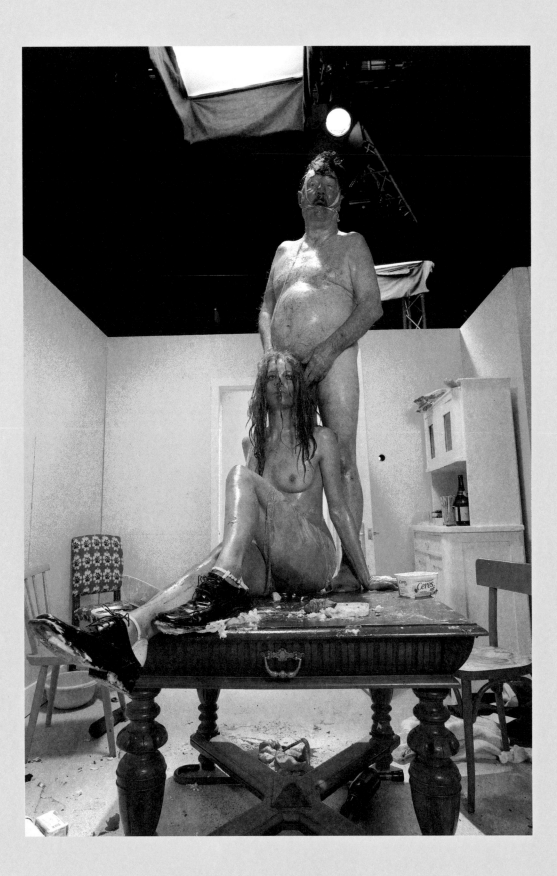

your frownies on before you go to bed. That fag dancer in the suite upstairs said you didn't shoot him up with his sedative last night. He so wanted to dance and prance like an imbecile for you. It used to make you come. Oh Countess, Max tells her, I'm tired of poking his ass with sedatives. I'm tired of all these Nazis hanging around this flop-house. Does the charm of the Third Reich never wear off for you people? Fascism never loses its charm, Max, says the Countess. The uniforms change, the symbols change, the countries change, but it's always the same yummy goulash underneath. Eat some, why don't you? You're already full of it.

You really are over the edge, Max tells the Countess. Do you realize this place was built by Otto Wagner? A very famous architect? And it isn't even a hotel, and never was? It's just a film set, and you're an actor and I'm an actor, pretending. You have no imagination, Max, the Countess says. When I close my eyes, I see the Führer again in Heldenplatz, waving to the crowds. Or Cecil B. DeMille waving to Gloria Swanson. Oh never mind about the Führer and Gloria Swanson, Max says. I'm in love. I've found her again. My little girl. I'm taking her to Hollywood. You mean? The one from? Yes, her. Remember her? Love stories don't go on forever, the Countess advises, you'd better turn her in to the Nazis, Max, or it could go very bad for you. It would be therapeutic for you to kill her. I won't kill her, Max says, because she's my little girl and our love is biblical.

You mean like Adam and Eve? Well, that too, Adam and Eve, Hagbard and Signy, Siegfried and Roy, if you like, but I'm thinking more of myself as King Herod in a giv-ing mood. You would make a good Herodias, bejeweled and implacable. On a throne, totally gaga. Watching your daughter discard her veils. You've read Oscar Wilde, you know how it ends.

Max's apartment has numerous body parts scattered around in puddles of blood on the furniture. The bathtub is full of rotting intestines. Dozens of starlets have been slaughtered here, hundreds of contracts signed in caca. Max is on the phone, shouting at the manager of the local Whole Foods. What do you mean they delivered the order, he screams. We're starving to death! Where are my cucumbers? Where are my radishes? The ham? The schnitzel, for God's sake?

You did look like a king in the old days, the Countess sighs, with your death's-head insignia and your withering little smirk, but now, now you resemble a church mouse. Hiding away in a crappy five-star hotel that's only a movie set in Cinecittà, like a timid little mouse. I am a mouse, Max says, I'm a mouse and that's how I want things, only to be a mouse in a house with my little girl Salome. In the camp, you know, after she sang a beautiful Nazi song, I made her a present of a severed head, of someone who annoyed her. In a box, with a bit of wrapping paper. If that's not biblical, Max says, I don't know what is.

You should eat your meal, Lucia tells Max. There isn't any food left, Max says.

The light is dying in Vienna. The sky above the Hollywood sign has a thread of orange under the darkening blue. Lucia has lost twenty pounds. A porcelain doll, slathered with scraps of stale garbage from the refrigerator. The electricity has been cut off by the Nazis. Max puts on his uniform. Lucia wears the dress she arrived in. Oh fuck it, they decide, and stagger out of the apartment, out of the building, into the lethal twilight. Night falls over Disneyland.

Preceding images from rehearsals (pp. 80–81) and from the second of four nights (pp. 82–84) of *NV / Night Vater / Vienna*, Volkstheater, Vienna, September 4, 2022. Directed by Paul McCarthy and Damon McCarthy. Photos: Alex Stevens. © Paul McCarthy. Courtesy the artist and Hauser & Wirth

An exhibition by Paul McCarthy featuring the film *Painter* (1995) and a selection of paintings and other works is on view through December 23, 2022, at Hauser & Wirth New York.

In 1967, when Vito Acconci and Bernadette Mayer launched the radical periodical *0 to 9*—printing its issues hurriedly overnight on a borrowed mimeograph machine in a New Jersey legal office—the idea was to make a magazine not simply about art or concerned with reproducing works of art but a magazine that was in itself, in an almost Kantian sense, art.

"I questioned the fact that when you see a word, you look through the word to subject matter, to content," Acconci recalled in a 2012 interview. "I wanted the matter of the word, the matter of the page." Conceptually, almost spatially, he added, a blank page is "the middle of nowhere"—a far more interesting place for art to materialize during those turbulent years than in a white-cube gallery or museum.

Not long before, separately, Dan Graham had begun his own explorations of magazine page as art locus, in pieces like *Figurative*, a cash register or calculator slip of numbers, i.e., figures, with no context other than the deadpan title, conceived in 1965 and eventually, improbably, published in 1968 in *Harper's Bazaar*, between ads for Tampax and torpedo bras. "I wanted to put a hole in the system of magazines," said Graham, who saw that system not only as an ideal, subversive distribution method but also as a cultural form practically begging to be hacked for art's sake.

For more than two decades now, the Mexican artist Stefan Brüggemann, who lives and works in Mexico City and London, has anchored his painting, sculpture and video work in forms of mass communication—magazines, newspapers, posters, graffiti, advertising copy, movie scripts, social media language—as a way of pursuing what he once

HI-SPEED (

A WO
STEFAN BR

Photos: Daniel Schäfer

described as the endless, impossible task of "trying to edit the world."

Over the past four years, Brüggemann has been developing a series of works called *Hi-Speed Contrast*—paintings that riff on ideas of reproduction and scale. They are based on photographic details of surfaces that are digitally enlarged and augmented to the point of illegibility. These abstracted images then become the ground for overlaid words and phrases that appear to have been scraped from the web by faulty artificial intelligence—at first glance meaningful but ultimately as unmoored and senseless as Graham's figures. Afterward, Brüggemann has the images and words printed on aluminum and spray-paints the surface chaotically and expressively, then photographs and manipulates the images again, creating works in which multiple layers of media and form accumulate.

For this issue of *Ursula*, Brüggemann carries the paintings yet another step by bringing them onto magazine pages, where, cropped and page-numbered, they will exist as stand-alone iterations of the works in thousands of copies circulating through mailboxes and newsstands around the world. After this "filtering" through a magazine, he plans to reprint the renderings on paper back onto aluminum, translating them once again to create new images of images, copies of ever more baroque copies, with no end point in mind for the works' ouroboric layers, which Brüggemann sees fundamentally as pages laid one atop other.

"My format for life is based on pages," he says. "Every time I work I make a big series of what I call notes. These are always pages. . . . It's always very difficult to separate the notes from the work, so the notes often become the work, and yet at the same time, the work can never be finished."

CONTRAST
RK BY
ÜGGEMANN

Stefan Brüggemann welcomes readers to make their own interventions to these works by tearing out the following pages, adding to them and mailing them to Stefan Brüggemann, c/o *Ursula*, Hauser & Wirth, 542 West 22nd Street, New York, NY, 10011.

ABSTRAC
TIVE
TENDENCI
ES

ALL
OW
ACT
ION

ELUSIV
E
CONTE
XT

FEA
R
CONT
EXT

INSTAN
T
FREE

RAPI
S D
D
D MOST
E XPRESSIV
RE S
ORANTI
OxO

+ SELF-
DENIAL

EXPRESSIV
E

SELF.
DENIAL
IMMERSIN
E
NA

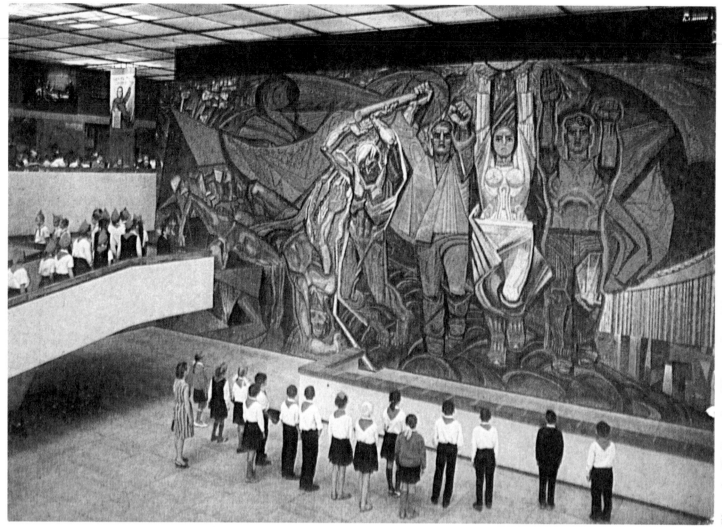

The Guard of
the Ukrainian "Sixtiers"

On Soviet monumental
art and the life and legacy
of Alla Horska (1929–1970)

By Lizaveta German

Sometimes it takes destruction for something to be remembered. History teaches us this; it also demonstrates that someone is often first a martyr before becoming a hero in the eyes of subsequent generations. Art history is no exception. The devastating fate of a masterpiece of monumental art—a half-destroyed mosaic depicting what used to be a huge bird fighting the wind—mirrors the tragic life of its creator, Ukrainian artist and political activist Alla Horska. In July, news and social media spread a horrible image of colorful leftover smalti reflecting the bright southern sun of Mariupol, an industrial city on the coast of the Sea of Azov that was heavily bombed in the preceding months and is currently occupied by Russian troops. The title of this 1967 piece speaks for itself—*Kestrel*, or *Boryviter* in Ukrainian; etymologically, "the one who fights the wind." (The mosaic is also known as *Bird of Hellas*, in reference to the town's Greek origins.) Horska, metaphorically speaking, was the one who fought the wind. First and foremost, she fought the boundaries of the ambiguous time she was destined to live through. And her fight came at a price: Along with some other visual artists of the generation known as the Sixtiers, Horska went so far as to give her life for her beliefs and anti-Soviet activities.

If one had to describe the Ukrainian Sixtiers through one personality, Horska would be a perfect candidate. Her practice and her life decisions embody the spirit of this important cultural

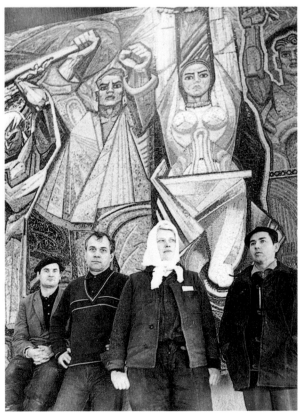

Volodymyr Smyrnov, Viktor Zaretskyi, Alla Horska and Viktor Shatalin in front of the mosaic *Banner of Victory/Relay Race*. Young Guard Museum, Krasnodon, Ukraine, winter 1969–70. Photographer unknown. Courtesy Ukrainian Unofficial Archive

epoch of postwar Ukraine, with all its contradictions and dualities. Timewise, this period loosely spans from the late 1950s, when the so-called Khrushchev Thaw initiated certain new freedoms in Soviet public and cultural life, to the early 1970s, when everything once again came under severe state restrictions.

Horska was brought up in a family that was firmly part of the Soviet establishment. The explicit pro-Ukrainian views she espoused in her mature years and her fearless political activism were quite radical, not only in view of her training as a Soviet artist informed by the social-realist canon and propaganda-informed themes, but also among her close friends who spoke freely only in the narrowest circle of like-minded peers, wittily described as "Kyiv anchorites" by art historian and critic Borys Lobanovskyi.

Horska was in no way an underground artist—on the contrary, she was extremely active in taking government commissions and participating in state-organized group shows (there were, however, essentially no other kind of public exhibitions in the USSR). Nevertheless, she tried to hack this system and make use of its advantages: in 1963 she cofounded the Suchasnyk Creative Youth Club, supervised by the Soviet youth organization Komsomol. But she soon became bitterly disappointed about the enterprise, which turned out to be nothing but a comfortable bubble of "controlled creative freedom," as rigid as the Union of Artists, the main organ behind the whole art system of the USSR.

First and foremost, Horska's 1960s spirit revealed itself in the truly multidisciplinary nature of her artistic practice, which ranged from stage design to painting to monumental public art, including stained glass and mosaics. The last are the main focus of this essay.

Horska was born in 1929 in Yalta, Crimea, to Olena Bezsmertna and Oleksandr Horskyi, who held several important jobs in the Soviet film industry. Her father qualified as nomenklatura, with a number of privileges befitting his rank. In 1943, he became head of the Kyiv Feature Film Studio (today's Oleksandr Dovzhenko National Film Studio), and the family moved to Kyiv, recently liberated from the Wehrmacht.

In Kyiv, Alla flourished as an artistically gifted teenager and took what was at the time a fairly common career path. She first enrolled at the Taras Shevchenko State Art School, and then continued her training at Kyiv State Art Institute. During her studies, she fell under the influence of Volodymyr Bondarenko (1906–1980). He himself was a former student of Fedir Krychevskyi (1897–1947), whose works today form the core of the 20th-century collection of the National Art Museum of Ukraine. Bondarenko encouraged a

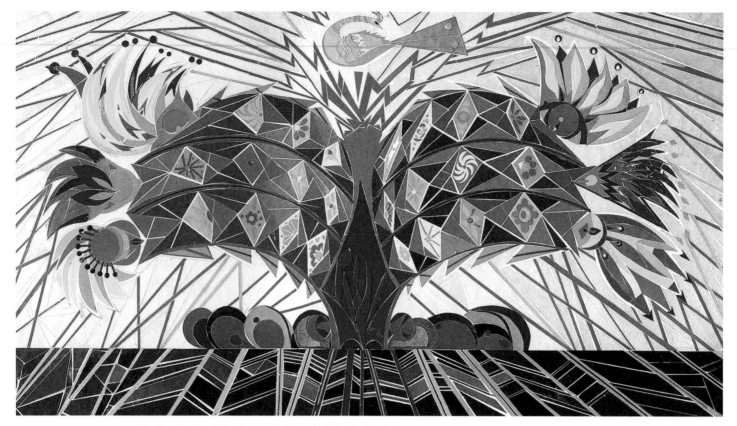

Alla Horska, sketch for the mosaic *Tree of Life* for the Ukraina restaurant in Mariupol, Ukraine, 1967. Tempera [?] on paper. Courtesy Ukrainian Unofficial Archive and Olena Zeretska

certain awakening of Ukrainian identity in his students, described by Horska's friend Halyna Zubchenko as "the first seeds of self-dignity." Horska's family was Russian-speaking, as was most of the artistic community of Kyiv in this period. This detail is important to mention, since in her older years she deliberately started to learn Ukrainian and speak it on a daily basis, a political gesture in itself. Under the friendly influence of the literature stars of the 1960s—Ivan Svitlychnyi, Yevhen Sverstiuk, and Vasyl Symonenko among them—Horska mastered the language to perfection, as a number of stylistically sophisticated letters to her friends show. One of her dearest pen pals was artist Opanas Zalyvakha, imprisoned between 1965 and 1970 in a hard-labor camp in Mordovia for anti-Soviet agitation and propaganda.

Right through the early 1960s, her biography was a polished example of a successful Soviet artist's career. Her diploma work at the Kyiv State Art Institute was a painting titled *Pioneer Control* (1952) and aligned with the social-realist canon; it was exhibited at All-Union exhibitions and reproduced in mass-produced leaflets. After graduation, Horska and her husband, artist Viktor Zaretskyi, went traveling around Donbas, in eastern Ukraine, where they both worked on paintings and sketches of labor scenes and the severe landscape of this coal-mining region. These kinds of artistic trips, funded by factories or local councils, were common in the postwar decades, when the state apparatus was obsessed with re-establishing the power not only of Soviet industry but also of its art.

In 1959, Horska became a member of the Union of Artists. This gave her even more opportunities for exhibitions and state commissions such as monumental mosaics, using perhaps the most ambitious and spectacular artistic medium of the Soviet 1960s at large. She was also active in the aforementioned Suchasnyk Creative Youth Club. This informal, cross-disciplinary institution organized exhibitions, concerts, readings, and various other events around the shared interests of its members.

In one respect, this period marked the culmination of Horska's happily Soviet professional path, since Suchasnyk was a Komsomol-controlled enterprise that made the liberalization of culture visible and won the loyalty of artists—a typical phenomenon of the Khrushchev Thaw. At the same time, however, it marked the beginning of a major anti-Soviet twist in Horska's life. The aspirations and content of the club's activities rather quickly went beyond the limits of the permitted liberties. The club's core members were passionately focused on the rediscovery of Ukrainian folk culture and the legacy of the local avant-garde, which had both been repressed in the 1930s under Stalin's regime. With poetry readings, historian-led expeditions to towns and villages across the country, and experimental theatrical productions of previously banned plays, the most important of the club's endeavors were aimed at nothing less than reestablishment

of a collective historical memory and national identity beyond the official Soviet narrative.

This Ukrainization vector had a profound impact on Horska on many levels. As well as learning the Ukrainian language from scratch, Horska was fascinated by the splendid colors and ornamentation of traditional Ukrainian aesthetics, as her sketches for monumental mosaics and actual works made with tiles and smalti prove. Stylized floral motifs and geometric patterns in projects she co-authored (in 1967 alone, the aforementioned *Kestrel* and a companion piece, *Tree of Life*, for Mariupol's Ukraina restaurant; and mosaics and interior murals for Kyiv's Mill restaurant) clearly stood out from most of the monumental work of the decade: She and her colleagues were clearly above-average producers.

Artistically and technically challenging, the art of monumental mosaics was well paid and, in terms of chosen artistic language, less supervised than painting: The dimensions of these works and their construction from small glass tiles allowed for formal experiments with color and shape that would otherwise have been considered too abstract. Artists were often directly invited and paid by big factories or local authorities who were headhunting for the best of the best. Horska was just the type of artist they were looking for. It would, however, be mistaken to think her devotion to monumentalism was merely a tool for making money with her craft. Monumental art, along with book illustrations in the huge printing industry of the USSR, was accessible to the masses, and in light of Horska's political activism, we can assume that she deliberately chose this medium to be able to "speak" through it publicly. It thus became the place where the contradictions in her practice revealed themselves most fully.

Over the course of the 1960s, as Horska's method and formal decisions evolved, the subject of her art changed dramatically. A profound curiosity in the officially disavowed side of Ukrainian culture culminated in the big stained-glass piece *Shevchenko. Mother* she co-authored with Halyna Sevruk and Opanas Zalyvakha in 1964 for the central lobby of Kyiv's National State University. Taras Shevchenko, a 19th-century poet and artist and a key figure in modern Ukraine's history, was welcomed into the Soviet pantheon of acknowledged local heroes as a fighter for equality and freedom from serfdom for his people. Nevertheless, what mattered for Soviet officials in charge of public art commissions was the "correct" construal of his political agenda. Horska's interpretation of Shevchenko's legacy reflected the poet's opposition not just to any oppressors but specifically to Russian ones. And this nuance was not in

line with the policy of casting Russia as the "big brother" among Soviet nations.

Shevchenko. Mother was accepted at the initial stages of production, but was subsequently accused of being too "anachronistic" in the way it depicted Shevchenko and the protagonists of his poems. It was deinstalled and promptly destroyed right after it was completed. The team of artists, Horska included, were expelled from the Union of Artists (though they were readmitted a year later). But if the artistic misconduct of Horska and her circle could be swallowed by the authorities with relatively minor rebukes, their political activism would have much more serious consequences.

In 1962, Suchasnyk's leader Les Tanyuk, poet Vasyl Symonenko and Horska addressed the Kyiv City Council in a bid to spur the publication of information about the previously secret mass shootings carried out by NKVD troops in 1937–41 in Bykivna near Kyiv. Their proposal was rejected and led only to increasing tensions. Eventually, in 1964, the Creative Youth Club was closed and many of its members were punished in various ways. Symonenko was brutally beaten by police officers on the street

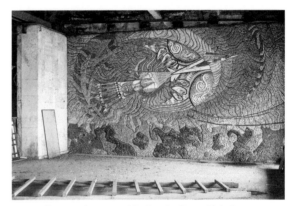

Kestrel (*Boryviter*), 1967, by Alla Horska, Borys Plaksii, Hryhorii Pryshedko, Viktor Zaretskyi and Halyna Zubchenko, assisted by Vasyl Parakhin and Nadiia Svitlychna. Smalti, slag glass ceramic, ceramic tiles, aluminum. Aristocrat restaurant (formerly Ukraina), Mariupol, Ukraine, 2015. Photo: Yevgen Nikiforov

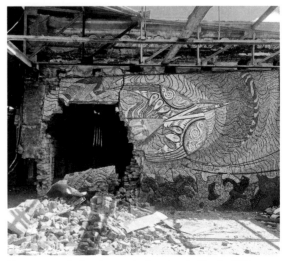

The same work after damage by Russian shelling in 2022. Photo: Ivan Stanislavskiy (Facebook)

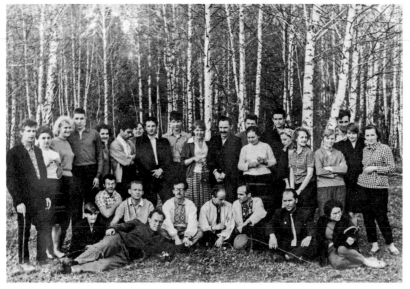

Members of the Suchasnyk Creative Youth Club in a birch grove on the outskirts of Kyiv, May 3, 1963. Photographer unknown. Courtesy Ukrainian Unofficial Archive

and died from the complications of trauma the following year. At this point, Horska was subject to constant surveillance.

This balancing of undisclosed political protest and the almost nonstop production of state-commissioned projects became only more strained in the late 1960s, during the final years of Horska's life and practice. In a single year, she signed a letter against the injustice of political trials (known as the "Letter of 139" or the "Kyiv Letter") and did sketches for one of her last—and largest, most ambitious—collaborative monumental works, *Banner of Victory*, for a museum in Krasnodon in eastern Ukraine. It was 1968: Four years after the removal of Khrushchev from the USSR leadership, Soviet troops and tanks entered the Czechoslovak Socialist Republic in order to stop the reforms initiated by the local government (as part of what was known as the Prague

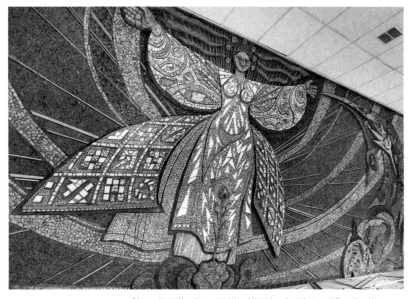

Blooming Ukraine, 1967, by Alla Horska, Hryhorii Pryshedko, Viktor Zaretskyi and Halyna Zubchenko. Mosaic. Former Kyiv deli, Mariupol, Ukraine, ca. 2015. Photo: Yevgen Nikiforov

Spring). Across the globe, 1968 inscribed itself as one of the most turbulent years of the 20th century. For Ukraine, it marked the end of an era of relative freedom, which was replaced by the new wave of political toughness aimed primarily at suppressing newly established dissident movements. Horska was again excluded from the Union of Artists, but kept working on the Krasnodon project in 1969–70, protected by the museum's chief architect, Volodymyr Smirnov.

In November 1970, Horska was found killed in the cellar of her father-in-law's house, and he himself was found dead at a railway path nearby. The whole scene was disguised to make it look as if he had killed Horska and committed suicide afterward. Though there has been no proper investigation of her death to date, it is widely believed that the KGB was responsible. Her funeral was openly attended by a broad circle of artists and activists, and so itself turned into a pro-Ukrainian mass gathering.

Banner of Victory was also known by the title *Relay Race*. It was designed for a new museum dedicated to the Young Guard, an underground organization in Krasnodon set up to fight Nazi occupiers during World War II. The heroism and martyrdom of (in fact) teenage partisans had immediately become celebrated by Soviet ideology, though the story of their activities was mostly based on Aleksandr Fadeev's novel *The Young Guard* (1946) and its 1948 film adaptation, rather than on documentary materials. The mosaic in Krasnodon shows the main episodes of Young Guard apocrypha: the illegal hoisting of red flags around town to celebrate the twenty-fifth anniversary of the October Revolution, and the execution of its members.

The plot of Horska's mosaic can be interpreted on a number of levels. On a basic level, it tells a typical, propaganda-like story of the heroic sacrifice of Soviet guerrilla fighters. We see a multitude of flags, clustered together to form one borderless red piece of cloth. This total flag is unified in the hand of a central male figure, as if he had been handed the flagpole by the twisted figure to the left. The latter is about to fall to a frightening void in the bottom left corner, as the bodies of killed partisans were allegedly thrown into a coal-mine tunnel. Shiny smalti are assembled to give a supernatural effect: Much like biblical characters in old Byzantine mosaics, the Soviet youngsters are illuminated through golden shapes. They look unreal, these saints of the Soviet pantheon.

The alternative title for the piece, *Relay Race*, opens up an extended interpretation of its plot. The girl and young men are seen not as guards of the war years, but as their descendants: none other than the Sixtiers. Brought up on similar heroic stories, soaked in Soviet

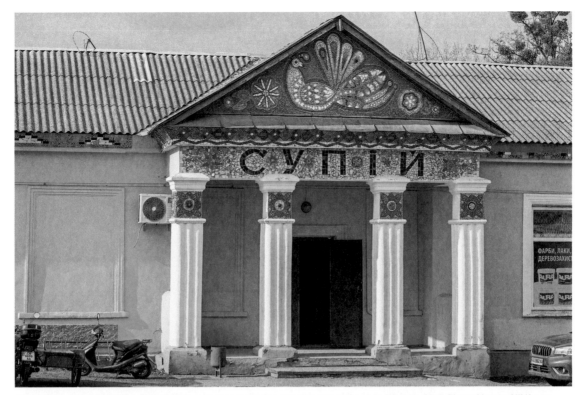

Alla Horska, Viktor Zaretsky, *Bird,* 1970. Smalti, slag glass. Supiy restaurant, Helmyaziv, Ukraine, 2019. Photo: Yevgen Nikiforov

patriotic spirit, they were expected to "pick up the victory flag" from their father figures and rebuild the ruined country: on construction sites and also on the cultural front. Horska was a perfect embodiment of this stratum: Herself the daughter of top-ranking figure in Soviet cinema (which was a generously funded industry responsible for bringing legends like that of the Young Guard to millions of viewers), she was supposed to bring these myths into the trendy contemporary medium of mosaic.

But in the end, it is not Horska's background but her life choices that give us perhaps the most true explanation of the plot. The young guards of the dissident movement strived to overcome the Soviet legacy of lies and propaganda. The total red flag is not actually raised above their heads but likely to be left behind. The new generation—three central figures who visually hold up the museum's roof like so many Atlases—step forward and turn their gazes away from the falling figures to the left, figures of the past, who are absorbed into the oblivion of history. The youth of the 1960s was supposed to be the generation to build communism, as Khruschev proclaimed. Instead, it was the generation that started to undermine it, filled with a complete disillusionment with its false values and the ruling party's hypocrisy. And Horska, the "heart and soul of the Ukrainian 1960s," as film critic and memoirist Roman Korogoskyi designated her, was the one to create a convincing monument to her rebellious circle's legacy.

There's a documentary photograph of the co-authors in front of the finished mosaic. Horska stands in the middle, right beneath her white-clad

heroine evoking Delacroix's *Liberty Leading the People* (1830) (one of Horska's sketches actually depicts a female figure with bare breasts, but nudity could never make its way into Soviet public art). Was it a hint about the actual protagonists of the piece? Or a direct, cool-headed message to those able to decipher it? Horska knew it was a dangerous game to play. She knew the piece could be destroyed after it was finished, as her Shevchenko stained-glass piece had been back in 1964. (There is a rumor that the Krasnodon mosaic was only saved because Volodymyr Shcherbytsky, the head of the Ukrainian government at the time, happened to see it and expressed his appreciation.) Did she know her life was under even a bigger threat? Perhaps. She was killed the same year the museum of Young Guard opened its doors, with the mosaic welcoming guests in the lobby.

The giant guards are still in Krasnodon; so far they have avoided the destiny of Mariupol's destroyed *Kestrel*. But they have fallen victim of the ongoing Russian-Ukrainian war in their own way: Since 2014, the town has been a part of the temporarily occupied territory of the self-proclaimed Luhansk People's Republic. Horska's works survived the hostile regime that put an end to her life and practice. Her legacy has not dissolved in that murky oblivion she assembled from blue, gray and red smalto pieces. Instead, her name, fixed in golden and white baked-glass tiles, stands as a symbol of resilience and resistance—and she has become a touchstone for the outstanding artistic quality of the still internationally underestimated monumental art school of Kyiv.

Robert M. Rubin, collector of vintage screenplays,
in conversation with filmmakers Josh Safdie and Ronald Bronstein

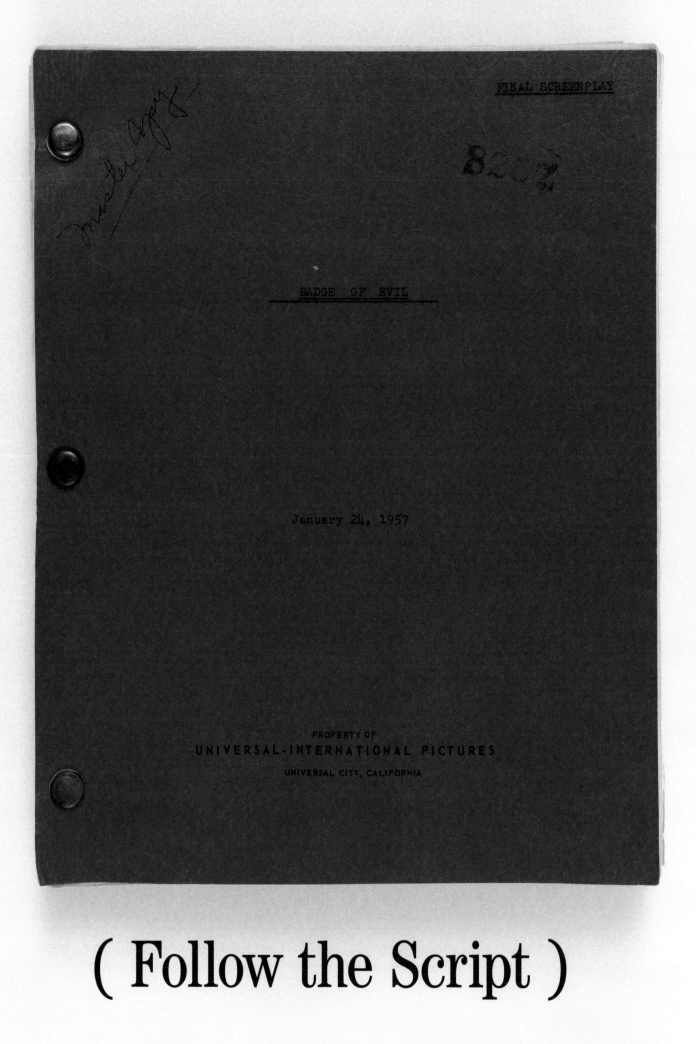

FINAL SCREENPLAY

8207

BADGE OF EVIL

January 24, 1957

PROPERTY OF
UNIVERSAL-INTERNATIONAL PICTURES
UNIVERSAL CITY, CALIFORNIA

(Follow the Script)

RANDY KENNEDY
Thanks to you all for making time for this. I feel pretty lucky to be sitting in on this cinema obsessives' self-help group. I'll get things going. I've gotten to know Bob a little, and he's talked to me about his screenplay collection. I thought it would be a great fit for this column, which concerns the collecting obsession—not so much blue-chip art collecting as the kind pursued in more esoteric circles, by people who use collecting as a way to know a subject or a genre or an era inside out. So I asked Bob to choose five scripts out of his collection out of—what, hundreds, maybe thousands?

ROBERT M. RUBIN
Thousands, yes.

RK Which span from the silent era, almost the beginning of the movies, up until the 1980s?

RR I don't really have an end point set. For example, I have some more recent David Lynch material, like *Lost Highway* (1997), because I have Barry Gifford's archives. But because Godard said that film is a 19th-century problem that was resolved in the 20th century, I guess I should probably just forget the 21st century and leave that to guys like Josh and Benny [Safdie] and Ronnie.

JOSH SAFDIE
It's funny. As screenwriters, directors and producers, we barely print our own scripts anymore. I'd say 99.9 percent of scripts are now shared as a PDFs and read on screens. They just don't exist anymore as documents, as objects. So the kind of collecting Bob does is probably going to be relegated mostly to the 20th century by default.

RK What was the first script you bought, Bob, and why did you gravitate to this kind of material, which is different in a lot of ways from rare-book collecting?

RR I've always been something of a book collector. When I was a young newspaper reporter in Red Bank, New Jersey, I used to spend my off hours at a used-book depot. It wasn't really a store but more like a warehouse. They had a huge trove of books, which they sold by the yard for decorative purposes. I would spend hours combing through boxes looking for interesting first editions, picking up A. J. Liebling and Joseph Mitchell and Jim Thompson paperbacks, that kind of stuff, back in the '70s. Then when I met Richard Prince, I got a little bit more interested in the next level of collecting. The problem is that books are really expensive, plus I didn't want to get in Richard's way. For example, when Richard bought Milton Berle's entire joke file at auction for $65,000, I bought Berle's bar mitzvah Torah, inscribed to him by his mother, for a few hundred dollars.

JS Same auction?

RR Same auction. Yeah. I was like a pilot fish. One day about fifteen years ago I saw a script for *Blade Runner* (1982) in an entertainment memorabilia catalogue. I'm a big Philip K. Dick fan. So I bought it. As I became more familiar with the market, I became interested in the idea that there were multiple writers and multiple versions of screenplays, unlike books. The guy who sold me the *Blade Runner* specialized in scripts, and I started to see what was out there. There's a lot, which is important. It's like you're standing on the riverbank and watching stuff float by. You want to be able to grab something pretty regularly. I mean, it's no fun to save up to buy a painting once every three years. Right? I realize now that my three primary collecting thrusts corresponded to my three personal ages of cinema. One, being the age that I am, pushing seventy, I grew up watching a lot of cowboy shit on television, so Westerns are part of my DNA. The second phase was film noir, which I discovered in prep school, really, through reading Raymond Chandler and James M. Cain. And then the third phase is New Hollywood. I graduated from college in 1974, so I was there running the film society during the high period of New Hollywood. I also have a sprinkling of auteur focuses—Preston Sturges in depth, Anthony Mann in depth. Some of that is accidental, based on what's available. I also have a lot of Hitchcock, and good Hitchcock is hard to find. He was very controlling of his process material.

JS Would you define auteurism as the work of a writer/director, or can it be solely a writer or a director, or . . . ?

RR By director. My bible was Andrew Sarris's *The American Cinema: Directors and Directions, 1929–1968*. In fact, Sarris taught a class I took in college. But I should also mention that I'll take any script, produced or unproduced, by somebody who has standing as a writer in the literary realm.

JS That's interesting. I get it. We're producing a script by the novelist Ottessa Moshfegh, and she's a great writer but to my knowledge she's never written a script before. Yet her writing is cinematic. It's an interesting process to watch.

RONALD BRONSTEIN
The original principles of auteurism have been terribly misconstrued, turned into a kind of one-man-band ego idea of a writer-director combination. It's sent lots of otherwise gifted artists down an unbecoming path.

RR I think my collection—which is really a collection of reconstructed archives of the films I'm interested in—will do a lot to swing the pendulum away from the director-as-auteur idea because these documents allow you to look at a particular writer from film to film before the writing is filtered through a director's vision. So I agree with you: It's perfectly clear that the auteur theory swung way too far in favor of the director. I think the original intent of the auteur theory was to demonstrate that there were people working within the studio system, in what seemed to be cookie-cutter, hacklike circumstances, who put a personal touch on the movies they made within that system. And over time, that became perverted into the idea that the director of the movie is the author of the movie. We had that stupid kerfuffle between Pauline Kael and Sarris over *Citizen Kane* (1941). As the guy who owns every conceivable variant of that script, I'll tell you it's perfectly clear that Herman Mankiewicz wrote the story and spun a great yarn, and Welles was the one who turned it into a great movie.

RB The problem arises when gifted directors feel pressure as artists to become writers, when it just isn't their strong suit. It's the rare case when someone can do both. The skill of being able to imprint your psychic fingerprints onto a movie, translating a

London After Midnight (1927) / *Freaks* (1932)

Screenplay for *London After Midnight*, 1927, directed by Tod Browning. Photo: Thomas S. Barratt. Courtesy Robert M. Rubin

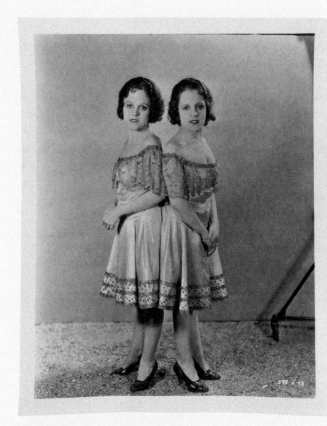

Conjoined twins Daisy and Violet Hilton on the set of *Freaks*, 1932, directed by Tod Browning. Courtesy Robert M. Rubin

London After Midnight is a legendary lost film from 1927 starring Lon Chaney. Fully a quarter of all silent films ever made are completely lost, but this one tops every list of the most important. The last known print was destroyed in an MGM studio vault fire in 1967. It was "reconstructed" twenty years ago using the script, extant stills and some Ken Burns-y camera movements. In 2014, a poster for the film sold for $478,000, making it the most expensive movie poster ever sold at auction. But this "vault copy" of the script is real process material, a relic of the movie as it existed in Tod Browning's mind before it was committed to film. The poster is just advertising for something already in the can.

One of the primary archival interests of scripts is their use in the excavation of the content of lost footage, swept from the proverbial cutting room floor. The guts of Orson Welles's *The Magnificent Ambersons* (1942) and Erich von Stroheim's *Greed* (1924), to name two of the more famous examples of disemboweled 20th-century films, are known to us only through script versions. Then there are the characters who never made it into various movies, despite being written into them and occasionally even being filmed: Charlotte Rampling's mysterious hitchhiker character in *Vanishing Point* (1971) comes to mind, although Rampling was eventually reinserted into the film for its second life, after it achieved cult status and somebody noticed. (Her character had survived in the British version, like a spy in a sleeper cell.) In 2013, the Polish artist Agnieszka Kurant made a short film titled *Cutaways* in which Rampling, Abe Vigoda and Dick Miller play the characters they portrayed (before being excised) in *Vanishing Point*, *The Conversation* and *Pulp Fiction*, respectively. Describing the phenomenon her work explores, Kurant uses the term "exformation"— coined by a Danish science writer, Tor Nørretranders, to refer to explicitly discarded information. It's a perfect word for these scripts and set photos: the stuff that fell off the back of the truck on the way to making a movie.

Lost films are an entirely different level of lostness. *London After Midnight* has engendered decades of rumors about prints languishing in abandoned South American or former Communist bloc warehouses. In 2012, it even spawned a Spanish novel, *Londres después de medianoche*, by Augusto Cruz García-Mora, in which the legendary California science-fiction editor Forrest J. Ackerman, who saw the movie at the age of eleven and never got over it, dispatches the narrator in search of the holy grail, a print.

I love how the text on this copy of the script is slowly fading and will, like the film, eventually be lost.

Browning would go on to make *Freaks* and, of course, *Dracula* (1931). I own a considerable number of set photographs and production stills from his personal collection, which was sold at auction a few years ago. The casual set photographs of *Freaks* are remarkable. The numbered stills were shot for publicity purposes, including several two-shots of the director himself with various actors from the film. There are also many unnumbered images of Browning enjoying communal lunches on the lot with the cast, or otherwise hanging out. These pictures are extremely touching. Browning clearly respected and bonded with the entire ensemble—no ableism or discrimination on that set. (Andrew Sarris described *Freaks* as "one of the most compassionate films ever made.")

Set photographs are a useful complement to the scripts and add a level of visual interest you don't get with a screen grab. Because they were shot with proper still cameras, they offer much higher resolution than images taken from film negatives. Some were used for methodical documentation of sets, for continuity purposes—ensuring the same look from take to take—and others, taken for future marketing purposes, depict posed action. These are essentially tableaux vivants staged right after the actual filming. They are about the archaeology of small differences. —*RR*

script into images, is a great skill in itself. That's what auteur theory was originally devised to analyze and decode. The translation itself was the personal part, not the screenplay.

RR The analogy is that you can talk about the Bulls and Michael Jordan, but you can't forget Scottie Pippen. But we live in a winner-take-all society, so the idea of a collective work of art runs counter to the way Americans process culture. Right?

RB Josh and I have a very contentious and almost hostile relationship with the writing process in general. Because we're both avid readers, we have tremendous and abiding respect for the sanctity of the static word on the page. But when you're approaching writing for film, you cannot shake the awareness that what you're writing is not static, that it is fundamentally transitional, intermediary. As a result, you lose respect for what you're writing. I mean, Josh brought up PDFs. In the past, people were committing words to paper in an entirely physical sense, literally imprinting ink onto paper with keys attached to little hammers. The way we work now just underscores outright how capricious and permutable the script is.

JS A script is not a text. It's a tool . . . like an actual tool—like napkin directions. It's like driving back before GPS and smartphones. You write the directions down on a piece of paper, a receipt, or whatever. When you get to your destination, you throw them out the window. A script is no different, really. *Good Time* (2017) was the first time we ever even had a script supervisor.

RB We tried for years to avoid script formatting entirely.

JS For *Uncut Gems* (2019), our script supervisor was really just a kind of stenographer for additional dialogue that came along as we were working. If you look at her scripts, they're likely much more chaotic than the film itself … She's just trying to keep up with the way that we're constantly changing the dialogue in real time. I've heard editors who keep the script supervisor's notes on hand when working. When I heard that, I was confused. We never refer back to our script or a supervisor's script in postproduction.

Every step of the way we're writing and rewriting until eventually there's no space left. Ronnie and I write together. Benny and Ronnie edit together. So in our process, Benny becomes a writer, too. He's editing and sculpting dialogue, dialogue that might have been written or improvised.

RB Bringing this back to Bob's collection, take his script for a silent movie like *London After Midnight*. Because the movie is lost, by default the script becomes the movie, or the only thing that's left to stand in for it.

JS I'd never read a script for a silent film before I saw Bob's. It sounds silly but it never dawned upon me that such scripts exist. But of course they do.

RK Do all of you know filmmakers, fellow filmmakers, for whom the script really is a kind of bible from which actors are not supposed to deviate?

JS Oh, yes. Our script supervisor on *Gems* works with Noah Baumbach, and she said they would often do like sixty takes and that Noah remains incredibly loyal to the word. Apparently, he'd say: "You didn't say this word" or "You said that word but it isn't in the script." I think that sort of dedication, take after take, can become an almost psychedelic experience for some actors—and directors! I imagine filmmakers like Aaron Sorkin and the like are very married to the page. That's their way. I read the script for Paul Thomas Anderson's *Licorice Pizza* (2021), and of course it's very written, but it felt more like notes for himself and the actors. You're seeing how he's going to direct it. It felt like he was keeping it alive. When we wrote this script *Get On My Shoulders*, which I guess ended up mutating into *Daddy Longlegs* (2009), we were so . . . Bob, I should give you one of the copies of that script.

RR I'll take it.

JS I had written the script when I was like twenty-one, finished editing when I was twenty-two. We tried to make it but couldn't get the money. I wrote all the dialogue and tried my hardest to make it feel as improvised as possible on the page. But we just couldn't get it pro-

duced. A by-product of the failure to get that script produced was a fear that if we tried to make the movie on the page, the movie would die there. So in an effort to keep a film alive, we started to write our scripts in prose. Like it's alluding to an eventual process of adaptation. It was quite liberating because you can feel the margins. It feels more open to change. It's collaborative in that way. Ronnie can attest to that.

RB Our aesthetic sprung out of this central axiom that a movie was written while it unspooled in the camera. And therefore, we didn't want to write too much before the camera was rolling, to protect and ensure immediacy. With *Daddy Longlegs*, everything was written as prose. Returning to *London After Midnight* for a second, it seems to me that there's a whole section of your collection that falls into the category of material that recovers important content and ideas that never made it into a film, or else no longer exists in the form of a film at all. The only thing we have to go by is the written word.

JS Yeah, it seems like your interest in scripts lies in the omission.

RR Well, it's true that the least interesting scripts in my collection are final shooting scripts that were faithfully followed by the director. There's very little to be gleaned from them archivally. The weirdest script I own is one for *Don't Look Back* (1967), which clearly didn't predate the movie. It was something that D. A. Pennebaker's office had to have typed up afterward, probably to try to persuade a distributor to take the film on. Back then, you couldn't just email a potential exhibitor some clips. Making and sending prints on spec was way too expensive. In the weird department, there was also a script once floating around for *Contempt* (1963). Godard was of course famous as a guy who had no scripts. Right? This one came up for auction in France and sold for some ridiculous amount of money, nearly $200,000, because nobody had ever seen a Godard script before. But it was perfectly clear that the script was simply written after the fact to get a producer off his back. The definition of an archive is something that creates meaning by its aggregation of elements. This is a

Touch of Evil (1958)

As scripts go, master copies are great ones to have. They are "Frankenstein" scripts, cobbled together with scraps and edits from many different hands, raising tentative possibilities.

At some point, someone—usually the script supervisor—blends it all together into a final shooting script, but I suspect that this copy, given Welles's working methods, is more like a real-time working copy of a shooting script than a document that's final in any simple sense of the word. I'm reminded of the byzantine edits and cut-and-pastes I've seen on Balzac's printer's proofs, in which he's frantically editing right up until the thing goes to press. It's an interesting analogy: master-copy screenplays as the filmic equivalent of an annotated printer's proof. Except that one ends up as frozen text and the other is dynamic, meant to midwife a coherent series of moving images.

Like most other Welles films, *Touch of Evil*—which until very late in the process was titled *Badge of Evil*, after its 1956 source novel, by Whit Masterson—had a checkered postproduction history. Welles was kicked off the project once filming was complete. The released version was typical studio butchery, although it has been gradually recut and restored over the years to something closer to Welles's original intentions. You need a road map to navigate all the different versions out there. The scripts help. —*RR*

Detail of the shooting schedule for *Touch of Evil* (working title *Badge of Evil*), 1958, showing the notation for the movie's famous opening-sequence tracking shot. Photo: Thomas S. Barratt. Courtesy Robert M. Rubin

Dr. Strangelove, or: How I Learned to Stop Worrying and Love the Bomb (1964)

Screenwriter Terry Southern had a hand in a number of cultural touchstones besides this one, including the foundational New Hollywood smash *Easy Rider* (1969).

Southern was clearly instrumental in helping Stanley Kubrick transform a nuclear thriller (*Red Alert* [1958], by Peter George) into a black comedy. Weegee was on the team as set photographer. His photographs memorialized the script's original pie-fight ending, otherwise lost to history. This brings us to a whole other subgenre of collecting: production stills by well-known photographers: Mary Ellen Mark (*The Missouri Breaks* [1976]) and Dennis Hopper (*Rio Bravo* [1959]) come to mind.

Here Southern is having fun with the characters' names. You can see how he plundered the list of presidential aides for the Air Force chief's now-unforgettable name, Buck Turgidson, memorably portrayed by George C. Scott. A big improvement over Buck Shmuck, if you ask me. I should also note that the "sawblade" brads binding this script indicate that this movie was a British production. The Brits used these brads instead of the standard American round brass ones. That's the bibliophilic angle of collecting this stuff: how it was reproduced, bound, and distributed, not to mention the question of who typed and collated the "rainbow" scripts—so called because of the many different-colored revision pages (each color indicating a different revision date) bound together. They are, after all, some kind of manuscripts, even if they are also just process material along the way to something else. —*RR*

Left: Title page of Terry Southern's hand-corrected screenplay for *Dr. Strangelove*, 1964, directed by Stanley Kubrick. Photo: Thomas S. Barratt. Courtesy Robert M. Rubin

Above: A Weegee set photograph of the pie fight originally planned for the ending of *Dr. Strangelove*, 1964. Photo: Weegee (Arthur Fellig)/International Center of Photography/Getty Images

collection of archives that I think will keep film people busy for generations. I'm putting the raw material together and then putting it out there. I'm not relying on a director or actor or whoever to spin self-serving anecdotes or say what happened. I'm finding the goods that, as I like to say, fell off the back of the truck on the way to the screen. "Exformation," as the artist Agnieszka Kurant calls it.

RK One of the most interesting things to me is to see the late changes in scripts that seem almost offhand, a word change, for example, but what is said then becomes canonical, one of the most remembered lines in the film. You can't imagine them another way. In your collection, for example, *Touch of Evil* (1958) still being called *Badge of Evil* right up to the end. Or in Terry Southern's copy of *Dr. Strangelove* (1964), he switches the name of General Buck Schmuck to General Buck Turgidson, one of the all-time great military movie names.

RR In the master copy for *The Searchers* (1956), the last words are: "Ride away?" with a question mark. Of course the ending shot of John Wayne not riding away but just walking through the darkened doorway into the big Western landscape is now burned into our brains. I think that what's also interesting is to read movie scripts that were never produced by great writers who have had other movies produced.

RB Yeah, there's a David Lynch script called *Ronnie Rocket*, which somehow fell into my hands when I was maybe sixteen. I could not believe that there was somebody who, in my mind, was a household name, a titan, who couldn't get a movie made. It was shocking to me. Little did I know!

JS I found the *Vanishing Point* (1971) script fascinating. You watch a movie like that, of course you can feel the existentialism and the influence of Beats, but to see an "in memoriam," I couldn't believe that. Inscribed to Dean Moriarty.

RB An in memoriam on a script implies that the writer thinks this intermediary document has some sort of permanent value to it, like a book, a novel.

RR I think it was a reflex for the writer, Guillermo Cabrera Infante, who, by the

way, I only knew because I used to be an avid cigar smoker and had read a book he wrote in the '80s called *Holy Smoke*, which was like a bible of mine. And then later on, I found to my astonishment that this was the same dude who wrote *Vanishing Point* under the pen name Guillermo Cain. And I read *Three Trapped Tigers*, which is his wacko magical realist novel. When I first saw *Vanishing Point*, I thought it was just a fun road movie, and now that I know about the script and Cabrera Infante as a novelist and critic, it has a whole different resonance for me.

JS Scripts nowadays—and I don't know when this started—have this capitalistic pressure for "commercial" appeal. I don't know if it's a by-product of commercial directors becoming big successes in Hollywood or if the studios have become more concerned with marketing, but you no longer just see scripts on their own. They always seem to be accompanied by a "deck." It's become an assumption: You write the script and then you have to make a deck. Something that's supposed to walk people visually through what the thing is. It's silly, totally silly. But it's a staple now. I guess it's the evolution of "this meets that." So today, it would almost be weird to see a script without an introduction. Now, I'm not reading a thousand scripts, and the ones that do find their way to our company might be more inclined to be "creative," but it feels pervasive. This top-sheet for the *Vanishing Point* script, albeit with much purer and more artistic intention, feels decades ahead of its time.

RR Which is, in a sense, just an update of the "treatment." Scripts started out more as blueprints than as polished texts because studio movies were green-lighted in Hollywood on the basis of the treatment. I have a copy of a William Faulkner treatment for *Gunga Din* (1938), which I think he was drunk when he wrote.

RB What does the treatment look like? How is it structured?

RR It's basically summary of the plot, saying, "Here's the story," and then there are some sarcastic asides.

JS Done with the assumption that the folks

reading it don't have the time to read the whole thing.

RR Exactly. And then Faulkner gets asked to write a "dialogued treatment," which is the next step. And he's like, "Oh, something might happen here." Faulkner's script for John Ford's *Drums Along the Mohawk* (1939)—a movie for which he received no screenwriting credit—is actually a document that you can read in the larger context of Faulkner studies and see him working out things in the script that later come out in the novels, about the rape of the land and other things, just transposed from the Hudson Valley to Yoknapatawpha County. So it's interesting to think about what so-called hack work meant for some writers and directors. Faulkner scholars are beginning to read his drafts for movies that weren't credited to him or didn't make it to the screen at all. In those years, by the time the script was written, they knew they were already going to make the movie. The script could materialize pretty far along in that process. Then *Easy Rider* (1969) came along and blew everything up. Suddenly Hollywood didn't know what the hell to do. There were all these people running around with their visionary spec scripts trying to get their movie made.

JS On the subject of hack work, you know, David Lynch directed commercials. Which were him slumming it, in a sense, but of course no true artist ever slums. Someone just sent me his promo for Michael Jackson's "Dangerous" (1991). And it's scary. It's actually very scary. Scary in the exact same way that all good Lynch stuff is. Go and watch his fragrance commercials. They feel very personal … like he's thinking of the way perfume seduces him. They're so romantic but also so artificial. You don't see that struggle in a lot of other big filmmakers' commercial work. He was working on what he wanted to do when he took those jobs.

RR In 1988, he shot an Yves Saint Laurent perfume commercial in the Maison de Verre.

JS Oh my god, really?

RR You can find it online. It's very Lynchian. There's no mistaking who made it.

Vanishing Point (1971)

A very arty script for a movie that ended up on the bottom half of Southern drive-in double bills, *Vanishing Point* was written by the Cuban experimental novelist Guillermo Cabrera Infante (1929–2005) as Guillermo Cain, a pseudonym chosen in tribute to the great noir novelist James M. Cain. This was Cabrera Infante's only screenplay. It's a great example of a script that's written to evoke and sell a concept for a movie, not a practical blueprint for something already greenlighted. Its opening page has a dedication to Dean Moriarty, the character from *On the Road* based on Neal Cassady. Cassady had just died in 1968, around the time that Cabrera Infante probably started the script. I've seen very few dedications in screenplays (Walter Hill dedicating his screenplay for Sam Peckinpah's *The Getaway* [1972] to Raoul Walsh, director of *High Sierra* [1941], is one). Kowalski's wired hippie is the spawn of Moriarty, but given *Vanishing Point*'s downmarket distribution, that literary reference remained strictly inside baseball.

The foreword is also noteworthy, especially where he uses the word "samples" in discussing music, long before samples were a thing, and talks about using existing songs, rather than a purpose-written soundtrack, as aural counterpoint in dramatic films—something we take for granted in the movies today, post-Scorsese and Tarantino. Speaking of Tarantino, his film *Death Proof* (2007)—my personal favorite among his films—is an homage to this movie and its emblematic white Dodge Challenger. I had a shirt made with the image of its license plate "OA5599, COLORADO 1970," on one sleeve, and that from the Mustang from *Bullitt* (1968), "CALIFORNIA JJZ 109," on the other. I also own a breathless 45-rpm radio promo spot for *Vanishing Point*—I notched a trove of these out of a North Carolina radio station that had them going back to the '70s. There were promo spots for cheerleader and nurse exploitation films as well. Normally, I don't go for postproduction or promotional material, but these babies were just too hard to pass up. —*RR*

Cover of the screenplay for *Vanishing Point*, 1971, directed by Richard C. Sarafian.
Photo: Thomas S. Barratt. Courtesy Robert M. Rubin

Gift of the Ages (1993, unrealized)

A material remnant of a born-digital but lost screenplay for a short film never made, *Gift of the Ages*, the story of a boy's tumultuous thirteenth birthday, was sent to Larry Clark by Harmony Korine before they collaborated on *Kids* (1995). Harmony told me he wanted to prove to Clark that he could actually write a movie. The floppy disk or whatever paleo-digital support on which the original document was saved was lost in a house fire. Harmony, like most artists, is a pack rat. He saves everything, but he couldn't save this; the printout he sent to Clark is the only physical copy in existence. One day it should be reunited with his archive, wherever that lands.

I bought the script from Larry Clark. It's an interesting bookend to *London After Midnight*. Its "lost"-ness is of a different century (well, not quite). Paul Schrader and Paul Rubens (Pee Wee Herman) are among those who have reached out to me after hearing that I have stuff of theirs that they don't. Given the ephemerality of this material, it's not surprising that some of it goes AWOL as a movie gets made. I happened to know Harmony already and surprised him with this one. The copyright is his, of course, but the artifact is—at least for the moment—mine. —*RR*

Drawing by Harmony Korine on the cover of the folder for his first screenplay, *Gift of the Ages*, 1993 (unrealized), which he sent to Larry Clark. Photo: Thomas S. Barratt. Courtesy Harmony Korine and Robert M. Rubin

RK | I have a sort of a process question, about scriptwriting, for Josh and Ronnie. I did a talk with Jim Jarmusch about a year and a half ago, and he was talking about how, at least in the really early movies, the scripts came out of fragments of things he collected and wrote down that kind of cohered in the filming: pieces of dialogue that he had; ideas for scenes and characters and settings. Do you both collect string in that way, in daily life, that makes it into final dialogue or action?

RB | Like a list of orphaned ideas, waiting to find foster care?

JS | Well, maybe just snatches of dialogue that occur to you or an idea for something a character could do. Things that don't really have any home when they come to your mind and then they end up falling into a scene in a movie you're making.

RB | We do it all the time, but they only find their way in organically. It almost never works when you cram them in with blunt force.

JS | [*Holding up a notebook page.*] This is a potential scene with dialogue in it. It has not yet made its way into a movie, but it could. I think you'd be hard-pressed to find any writer or writer/director who doesn't overhear something on the street and write it down on a pretty consistent basis.

RB | It's not really our approach, though, to take disparate bits and try to string them together. We work very hard to create a conceptual, theoretical clothesline. Wait, Josh is shaking his head a little.

JS | [*Laughing.*] The truth is that we will find ourselves receiving texts from one another all the time saying, "This just happened to me. File it. We have to put it in a movie somewhere."

RB | Ok, yes, that's the truth. But it goes into a kind of waiting room. You understand? It goes into a foyer and it sits and it waits, like the waiting room at jury duty, where you might not be called in at all.

JS | Ronnie and I have a script that we'll never make. It's only a collection of ideas. It's the two-liter-soda-and-candy-side of our process. It's called *Pizza Me*. It's just a collection of...

RB | It's exclusively those orphaned ideas that we bat back and forth, strung together with no context.

JS | It's a collection of the most surreal, ridiculous tangents that spin off relevant ideas. It's really a way not to write. If someone were to actually make *Pizza Me*, it would be the most insane thing ever.

RB | Even the title, *Pizza Me*, is a misappropriation of "You want a piece of me?"

RK | Oh, I thought it was, maybe, somebody walks into a pizza joint and says, "Pizza me!"

RB | [*Laughing.*] No, because there would be a logic to that!

RK | In your collecting, Bob, I know you said you don't have any chronological limitations and you have three overarching themes. But are there any rules you follow?

RR | One thing I do is rate things along a conceptual continuum between the archival and the artifactual. So, for example, I have John Wayne's working copy of *The Searchers*. It's 100 percent artifactual because there's none of his handwriting on it. It's a final shooting script, basically what you see on the screen. The Duke is very methodical; he folds over every page of his script when the scene is done. But that has no archival value. It's an artifact. It's like Steve McQueen's Tag Heuer wristwatch, right? You can buy any number of great vintage examples of that watch for $5,000. Or you can buy the one he owned and wore for a couple million at auction. That's the artifact. Against that, you have scripts that have no collectible value, but they have information that adds to the value of the archive. I tend to be more on the archival side, although I'm not averse to having some cool artifacts. I just bought Sally Struthers's working copy of the episode of *All in the Family* that Sammy Davis Jr. appears in (1972). It's great but it's essentially artifactual. I'm a huge Sammy Davis Jr. fan, and I grew up with Archie Bunker. As far as collecting rules go, you know, as with any kind of collecting, the more you buy, the more you pay on time and don't dick people around, the more they come to you with better and better stuff. So the entire picker ecosystem for entertainment memorabilia knows that my guy has a guy, and that it's cash on the barrelhead. No stress, right?

RK | You're getting the best drugs.

RB | Is your collection the biggest of its kind?

RR | It's the biggest of its kind because it's probably the only one, or one of the few of its kind, that's thematic. The other collections tend to be acquisitions by libraries and institutions that focus on particular directors or writers. The Harry Ransom Center in Texas has the David O. Selznick archive and the De Niro archive, the Lilly Library at Indiana University has Welles and Ford

RB | Do you have a private collector nemesis?

RR | Well, the other day I was bidding for Ben Johnson's working copy of *The Wild Bunch* (1969). I have all kinds of *Wild Bunch* material. I have three or four different scripts and I have set photographs. I even have Peckinpah's early TV Western scripts. That's how much of a Peckinpah completist I am. But I wanted Ben Johnson's working copy. I thought I'd have to pay three, four, five thousand for it, maybe six or seven. I dropped out at fourteen because I realized this other bidder really, really wanted it. I'm dying to know who that could be and what his angle is. I'm starting to get pipped at the post on stuff that surprises me. Everybody has always wanted material from *The Godfather*, *Apocalypse Now*, Casablanca, *Gone with the Wind*, *The Wizard of Oz* and the like. But a premium of ten grand over the market value of a generic *Wild Bunch* shooting script because it was Ben's? I don't get it. A so-called lined copy of *The Elephant Man*, used by the film editor to put together the movie, just went for $32,000 over a high estimate of $5,000. More people are starting to get into the game.

JS | Someone once told me the smartest thing you can do is invest in the 20th century. I asked what that meant and he said, "Buy the physical proof that the 20th century existed." Because who knows what comes next.

RR | It's pretty good advice. I've been working at it for years now.

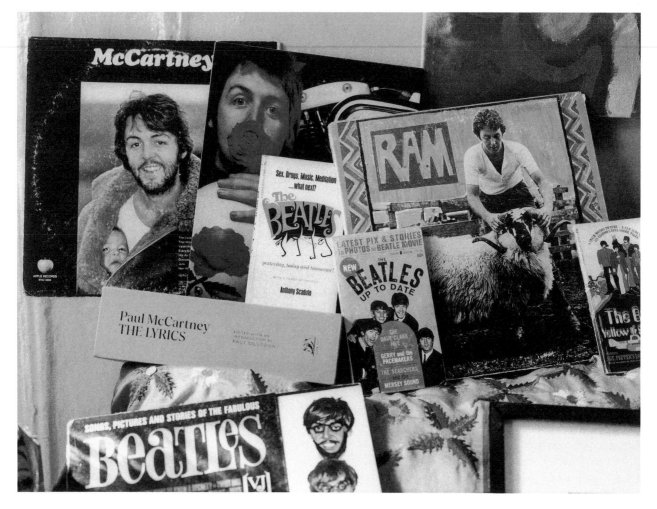

THE ARTIST'S LIBRARY By Sarah Blakley-Cartwright

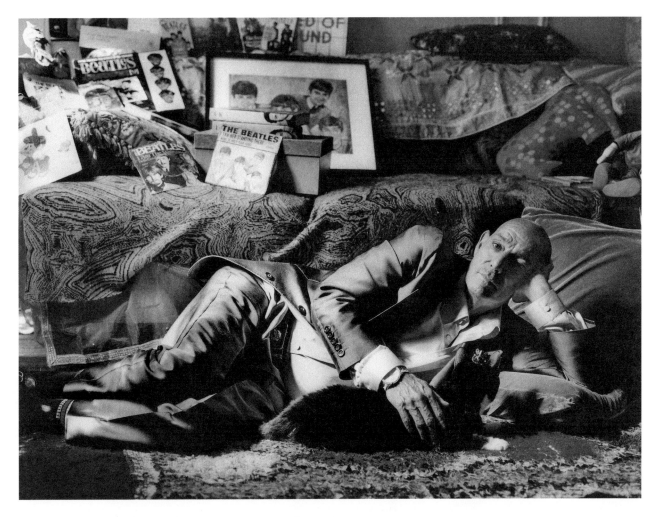

Tabboo! on Paul McCartney's *The Lyrics*

Tabboo!, *Pyramid Poster Drawing*, 1987. Pen on gelatin silver print by Jack Pierson, 11 × 14 in. (27.94 × 35.56 cm). Courtesy Gordon Robichaux and Karma

In this installment of the recurring Ursula *series in which writer and editor Sarah Blakley-Cartwright asks artists to select a favorite book from their shelves, the New York painter and performer Stephen Tashjian, better known as Tabboo!, speaks about growing up post–peak Beatlemania, collecting Beatles ephemera, and a prized lime-green tome:* The Lyrics: 1956 to the Present, *by Paul McCartney, published in 2021, with an introduction by poet Paul Muldoon.*

Sarah Blakley-Cartwright
Tell me about your relationship to the Beatles.
Tabboo!
My mother worked at the local library, and I would take out a book from the '60s that had all the Beatles' lyrics with psychedelic illustrations. That's kind of how I got into art.
SBC
You have so much memorabilia!
T!
This is just some of it. My collection is massive: every album, every single, everything.
SBC
Tell us about this book, *The Lyrics*.

T!
They kept telling Paul he should write his biography and he didn't want to, so he said, "Why don't we just talk about my lyrics and they will tell the story of my life?" This book then came out last fall, when my sister died of Covid. I was sort of out of it; it was sort of dark. And that's one thing about the Beatles' music: When I was a kid, I wasn't the happiest. I don't know if a lot of people are as teenagers. It was just as the Beatles were breaking up and they were marketing all the old Beatles stuff to the young kids, so I took my teenage angst and put it into the music and felt relief.
SBC
That's beautiful.
T!
A lot of Paul McCartney's songs are about love and positivity and lifting people. It's strange to me because I'm gay. I don't have a family. I'm really not that into kids. I mean, I love kids, but I have no interest in having any. A lot of Paul McCartney's music is about his family and his wives, love songs to girls and his children and living on a farm. That's all the opposite of who I am, and yet everything he does touches my heart so deeply. When [the 2021 documentary featuring] Rick Rubin's

interviews with Paul came out, they would hit a few notes from a certain song and I would burst into tears.
SBC
What was the experience of reading this book like, without the melodies?
T!
When certain songs came up, it meant so much because I have listened to the Beatles' music and Paul McCartney and Wings music, I would say, for 70 percent of my life. Lately, I don't listen to much music.
SBC
Why not?
T!
I might be getting old. I still have thousands of records. I think music from your youth is comforting. It has really helped me. A lot of Paul's songs, like "Let It Be" or "The Long and Winding Road" are melancholy and hopeful and beautiful—sort of spiritual.
SBC
The Beatles each had their public personas, which they got typecast into. George was the quiet one, Ringo the funny one, John the creative one and Paul the more straight-laced guy, doing the soppy pop songs.
T!
That was marketing. I remember reading that once they made their money, they wanted to back out. Like, "Ok, we are all multimillionaires, that's enough. I don't want to do another interview, I don't even want to make another record, who cares." But Paul was like, "We need to get into the studio." And he did that, and he's still doing that. He's eighty years old and just released another record. He never stopped.
SBC
How do you think Paul drew upon his image?
T!
By the time I got into the Beatles, he was kind of an idol. He had a shag, a mullet, patchwork clothes with platform shoes. Even the early-early Beatles, they had this gay manager, Brian Epstein, who said, "You need a haircut, you need to wash your hair, you need Pierre Cardin suits. We're going to do to you what the guys in Motown are doing to those inner-city kids." The Supremes were showing up in Miss America beaded gowns on *Ed Sullivan*. It just makes it so much more interesting.
SBC
All that exuberance and extravaganza.
T!
My friend [Charlie Porter] wrote a book called *What Artists Wear*, and when he met me he was like, "Oh my God!" Strangely, the art world is oftentimes more dull than

Previous spread and right: Tabboo! with Beatles memorabilia in his apartment, East Village, New York, 2022. Photos: Angalis Field

you think it's going to be. And even the music world can be dull. So when someone comes and shows up and gives people some bling, everyone loves it, they turn their heads. That's half the thing with people like Madonna or Beyoncé. Their songs are incredible, but they also show up in the most incredible outfits. The same is true of Lady Gaga, Frank Sinatra and Elvis.

SBC

In the book, Paul talks about the pageantry of the *Sgt. Pepper* era as a kind of game that freed them up and gave them a new anonymity, in an odd way, because they could be someone else.

T!

That was also during the Carnaby Street '60s thing, which was incredible. If you could go back, that's where to go: London in the '60s, woo! I went a couple of years ago and it was not that at all. But you know, time marches on.

SBC

Paul was looking backward, too. He talks about how "Honey Pie," for instance, was written in the '60s but it's a throwback to the 1920s and '30s.

T!

That was another thing I always loved about him. In the Beatles, even in Wings, even now, he always had that vaudeville, London, music-hall kind of sound. Elton John would, and Queen would, too: I guess it's a British thing.

SBC

Was some of the ephemera in this book worth waiting for?

T!

Most of the pictures I've seen, because I've seen everything a hundred thousand times since I was twelve, you know, and now I'm sixty-three. I came to the Beatles, as far as really liking them, through Yoko. At the same library I used to go to, they had the *Wedding Album*, which was like an avant-garde scrapbook of John and Yoko's wedding. With recordings and a photo strip and pictures of their wedding cake. It was very Fluxus. And then I got into John and then I realized, "Wait, that's the Beatles!"

SBC

You might be the first person to discover the Beatles through Yoko.

T!

Wings was contemporary for me, but the Beatles stuff was older. It was like I was researching ancient Egypt. I started in 1970, when I had some babysitting money, and I bought a record that had a sheet that showed you every album they ever released, every single they ever released, every single that they worked on with anybody else. And I would go

through it and check it off, one by one by one. There was so much to buy and learn. There was so much marketing for *Yellow Submarine*. Look, I have a *Yellow Submarine* alarm clock.

SBC

And lunch box!

T!

I have lobby cards. I have *Yellow Submarine* stationery. I have all the Apple Records 45s hung along a wall. As a collector-hoarder, I really got into them big time. My mother used to bring the neighbors over: "Look at what Stephen did with his room!"

SBC

Is there a McCartney song you've been listening to more than others?

T!

"Calico Skies" is really beautiful. He

wrote it for Linda when she was dying of cancer. And he sings it to her on camera, and he can't look at her because he knows she's going to be dead. That's a beautiful new one. Also "Here, There and Everywhere." The harmonies are beautiful.

SBC

Paul is so disciplined. But whenever anybody said, "You guys are working too hard," he'd reply, "No, we're playing too hard."

T!

And he obviously doesn't need to make another penny.

SBC

He does it for the love.

T!

And for the love of the audience.

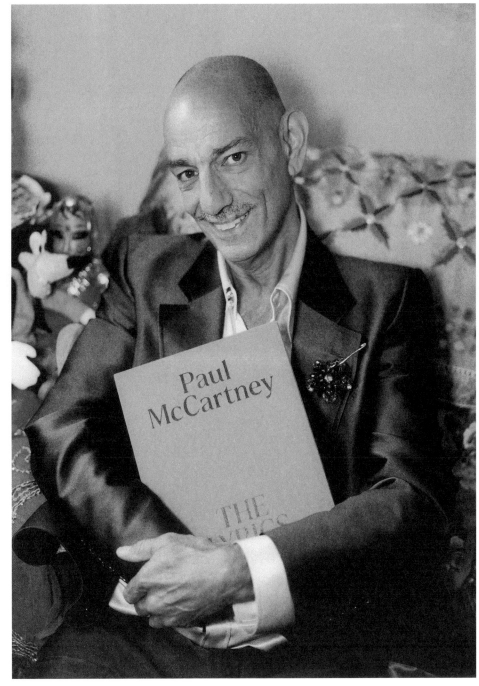

An Expanded Eye

Jacqueline Burckhardt and Bice Curiger with forty-nine copies of *Parkett*, Zurich, 1997. Photo: Daniel Schmid. From Jacqueline Burckhardt, *La mia commedia dell'arte*. Courtesy Jacqueline Burckhardt and Edition Patrick Frey

Notes and reflections inspired by Dora Imhof's
C is for Curator: Bice Curiger – A Life in Art and
Jacqueline Burckhardt's *La mia commedia dell'arte*

By Daniel Baumann

Until around twenty-five years ago, the art world was preoccupied with finding an audience for contemporary art, selling it and defending it from attacks; there were different camps and ideologies and an overarching agenda of expanding the idea of art and making convincing arguments for certain well-defined positions.

Around the turn of the millennium, the situation gradually but fundamentally changed. Arguments lost significance, replaced by prices, by the act of paying. Among the multifarious consequences of this shift was a transfer of power from the established tastemakers and gatekeepers—which is to say, critics, curators, museum people and artists—to gallerists, collectors and auction houses. A loss of significance often leads to self-examination, so it was no coincidence that an interest in the history of art began giving way to an interest in the history of exhibitions, a field where artists, curators, museums, historians and critics—not collectors, art fairs and auction houses—held sway. A key publication in this regard was Mary Anne Staniszewski's 1998 book *The Power of Display*, which my friends and I discussed enthusiastically. As the blurb has it, "Art historians, traditionally, have implicitly accepted the autonomy of the artwork and ignored what Mary Anne Staniszewski calls 'the power of display.' . . . Staniszewski treats installations as creations that manifest values, ideologies, politics and of course aesthetics." A year before, Catherine David's Documenta 10 had shown the way forward in this shift, cross-examining Documenta itself as a Western, male-dominated exhibition that fetishized the object and various forms of showing off. She opened the format of the exhibition to the world and to global ways of thinking, and she was heavily criticized for it. But her innovations set into motion the "political" biennial-type exhibition as we know it, establishing the parameters for every Documenta since, creating a genre that has now in turn itself begun to smack of academicism and mannerism.

A further form of self-examination and self-affirmation has recently taken place, with increasing frequency, via biographies and autobiographies of critics and curators. While the former concentrate on collections of writings, the latter tend to present the stations of curatorial curricula vitae more or less with the curator at the center. No publication took this farther—deservedly—than that devoted to the Swiss curator Harald Szeemann: the doorstopper devoted to the entirety of his career, weighing in at some ten pounds (4.5 kg), published posthumously in 2007: *Harald Szeemann— with by through because towards despite: Catalogue of All Exhibitions, 1957–2005*. I guess we can, with bated breath or a frustrated sigh, look forward to similarly comprehensive biographies of Kasper König, Rudi Fuchs, Jan Hoet, Manfred Schneckenburger, Pontus Hultén, Jean-Christophe Ammann, Okwui Enwezor et al. Some might already have made the shelves without my realizing it, but this year brought the biographies of both Bice Curiger (curator and cofounder of the art magazine *Parkett*) and Jacqueline Burckhardt (art conservator and likewise cofounder of *Parkett*). My first thought was, "Is this really necessary?"

But of course I wanted to get my hands on the books: *C is for Curator: Bice Curiger – A Life in Art* by Dora Imhof (Verlag der Buchhandlung Walther und Franz König) and Jacqueline Burckhardt's *La mia commedia dell'arte* (Edition Patrick Frey).

Curiger was and is one of the most successful and influential women curators of her generation. Too few people understand, for instance, the importance of the new approach to writing about art that Curiger ventured into as a very young critic—a collection of these writings has yet to be published. More familiar is the story that, together with Burckhardt and Dieter von Graffenried, she invented a new type of art magazine (*Parkett*) and that, beginning in the mid-1970s, she experimented with, even established, the essay-exhibition as a new approach and format for showing art.

Parkett is to my mind Curiger's chef d'oeuvre. It was more than printed matter; it was an exhibition in paperback form that celebrated the printed volume as kunsthalle, museum, collection and gallery. It was accompanied by a program of editions that raised the bar for what a periodical could be. The magazine's celebrated run came to an end in 2017 after more than a hundred issues. It began in 1984; I was seventeen and I can still remember how I opened the thick, booklike first issue in my father's office and before reading anything else coming upon the dedication. I was incredibly surprised: It was not to Benjamin or Derrida, as was then de rigueur, but to the legendary Swiss cyclist Hugo Koblet, who won the Tour de France in 1951 and died tragically at the age of thirty-nine, in 1964. This was a statement I understood; it spoke to me and chimed with my attitude toward life at the time, shaped by a boundless interest in sports and music, art and kitsch, fashion, taste, everything. Hierarchies no longer meant anything; everything was suddenly possible and important; everything was up for renegotiation. As the German journalist and cultural critic Diedrich Diederichsen put it in his 1985 book *Sexbeat*: "1982 was a thoroughly good year. The project of setting up a new

kind of pop music by historicizing and relativizing all elements of music showed most stunning results in the form of [English pop band] ABC and others. Nobody believed any more in authentic expression. All elements were referential, alluding to the history of pop culture, nothing was innocent anymore, everything so extremely self-aware, intellectual, campy—and nonetheless beautiful and enthralling." This is what *Parkett* stood for (Diederichsen was for a while a regular contributor), and for the first time ever it was possible to read thoughtful, well-argued writing about a new generation of artists in nonacademic German. *Parkett* made contemporary art meaningful, accessible and sexy. Many people have forgotten that, well into the 1990s, it was difficult to find essays or catalogues about contemporary artists. With oodles of enthusiasm, *Parkett* filled this important gap and more. Soon, the magazine was credited for its sharp radar for up-and-coming artists. It established itself as a highly regarded—if at the same time jealously mistrusted—trendsetter, meaning that curators, gallerists and collectors turned to it for orientation and those whose names appeared within its pages began to count as established figures or even future greats.

A decisive role was played by the "*Parkett* collaborations." The idea was that each issue would be created in dialogue with an artist, who would work on the magazine together with its staff. This proximity to artists was the constant, the motor and the mark of quality of Curiger's

work, and to this day the attitude informs every exchange with her. Although *Parkett* had a big influence on the Euro-American art world, by the early 2000s it had gradually lost its clout, which happens eventually even to great magazines and which was, as is often the case, a result of changing realities on the ground. First, it was by then no longer an exception for even younger artists to have catalogues and substantial bodies of writing devoted to their work. Second, the rise of the internet meant information was suddenly available quickly, globally and at no cost. Third, the art world was becoming global while *Parkett* retained its primary interest in the dialogue between Western Europe and the United States. Or, as Burckhardt tells her interlocutor Juri Steiner in *La mia commedia dell'arte*: "In retrospect the art world at the time was extremely Western in its mentality, and, as you say, the earth was still flat for us. . . . In a world that has become round, we would need to know a great many more languages and cultural and political contexts in order to sufficiently understand—let alone have an informed opinion about—the art of other cultures."

Nothing arises out of thin air, and *Parkett* was no exception. It had its roots in Curiger's training as a journalist, ethnographer, art historian, activist and curator. As *C is for Curator* makes clear, she had already put her feelers out far and wide as a very young woman—for example, in an early visit to New York. She wrote for magazines and newspapers in a nonacademic, slightly tongue-in-cheek proto-pop language,

View of *"Zeichen und Wunder"* (Signs and Wonders), Kunsthaus Zurich, 1995. From left: Fischli/Weiss, *The Question Pot*, 1984; Niko Pirosmani, *Stag, The Actress Margarita*, and *Giraffe* (all n.d.); Lily van der Stokker, *Dear Mammy*, 1995. Photo: Mancia/Bodmer – FBM studio. Courtesy Franziska & Bruno Mancia

and co-organized the legendary, scene-defining exhibitions *"Frauen sehen Frauen"* (Women See Women)—put together in 1975 by a feminist collective to which Curiger belonged—and *"Saus und Braus"* ("Living It Up," approximately) in 1980. She was also part of the dancers' collectives Frauen-Jet-Gruppe (Women Jet Group) and Frauenrakete (Women Rocket), which brought to the stage various combinations of amateurism, feminism, desire, critique, dance, performance art and parody. This unabashed mishmash of seemingly contradictory positions and visions was part of Zurich's self-reinvention at the time. It was provocative and productive, broke down barriers and was bolstered by the stylish sense of humor that continues to run through all of Curiger's work. She did not act alone in this but was part of a bigger scene that included Burckhardt and artists such as Peter Fischli, Dieter Meier, Sigmar Polke, Klaudia Schifferle and David Weiss, as well as future gallerist Susan Wyss and fashion designer Sissi Zöbeli.

The two exhibitions that launched Curiger's curatorial trajectory already espoused her essayistic approach, which was still fairly novel, and a nimble-footedness that was antithetical to the sluggishness and conservatism of Switzerland at the time. In contrast to the thematic exhibition, which is constrained by a clearly defined frame (geography, chronology), the essay-exhibition can develop much more freely. Szeemann was the pioneering forerunner in the development of the form, giving the genre its first canonical show in 1969 with "Live in Your Head: When Attitudes Become Form" at the Kunsthalle Bern—an exhibition whose title could stand for each and every essay-exhibition. The advantage of the format was and is at least twofold: It allows contemporary art—art which cannot yet be seen with historical distance—to be situated in a framework of reception without overly constraining how it is to be read. This preserves the autonomy of the work while still evincing a curatorial hand. In addition, the hope—a generational one—was that the new approach would break the power of obsolete and canonized narratives by countering them with subjectivity and self-empowerment. During the 1990s, Curiger achieved mastery of this dynamic as curator-at-large of the Kunsthaus Zürich. I and my fellow young curators made pilgrimages to her exhibitions and discussed them, critically of course, afterward. These shows included the 1994 group show with Sophie Calle, Sylvie Fleury, Raymond Pettibon and others titled *"Endstation Sehnsucht"* (A Streetcar Named Desire); "Birth of the Cool," a survey of American painting from Georgia O'Keeffe to Christopher Wool (1997); *"Freie Sicht aufs Mittelmeer"* (Free View Onto the Mediterranean, 1998), which focused on young Swiss artists; and "The Expanded Eye," a panoramic show in 2006 whose English subtitle was "Stalking the Unseen." For me personally, the exhibition *"Zeichen und Wunder"* (Signs and Wonders, 1995) stands out. It was the first time I had ever encountered the work of the Georgian artist Niko Pirosmani, and Curiger's accomplishment in bringing this then completely unknown, incredibly interesting painter to Europe can hardly be overstated.

The entrance to the Städtische Kunstkammer zum Strauhof in Zurich in 1980, with a poster designed by Peter Fischli and Klaudia Schifferle for the exhibition *"Saus und Braus"* ("Living It Up," approximately) and an installation of wooden logs by Hannes R. Bossert. From *C is for Curator: Bice Curiger – A Life in Art*, by Dora Imhof. Courtesy Bice Curiger and Verlag der Buchhandlung Walther und Franz König

The essay-exhibition today belongs to the fixed repertoire of curatorial work, almost without exception. It populates museums, galleries, biennials, project spaces and, in recent years, even auction houses, and there seems to be no idea or cloud of associations too abstruse to be honored by an exhibition. That this is so points to the limitations of the format, namely its latent arbitrariness and how easily its manifestations can slide into irrelevance, but above all the fact that a hundred thousand associations don't write history anew. In love with our sudden inspirations, we neglected—despite a slew of great ideas and subversive perspectives—to construct engaging new narratives that transcend individual, subjective experience. One reason was our blindness to many truly important subjects, a myopia that doesn't feel great in retrospect. The intensity with which race, gender, class and climate have, in the past few years, become major themes in the art world was, in hindsight, wholly to be expected, and it was such vital subjects as these that surfaced too rarely among the essay-exhibitions. A new generation is demanding that history be rewritten; that rewriting is already happening. I suppose it had to be this way: We did not become who our parents warned us about. Instead, we became the Establishment.

Translated by Alexander Scrimgeour

HAUSER & WIRTH PUBLISHERS

Jack Whitten: Cosmic Soul

Text by Richard Shiff

Now Available

www.hauserwirth.com/publishers

New and forthcoming books

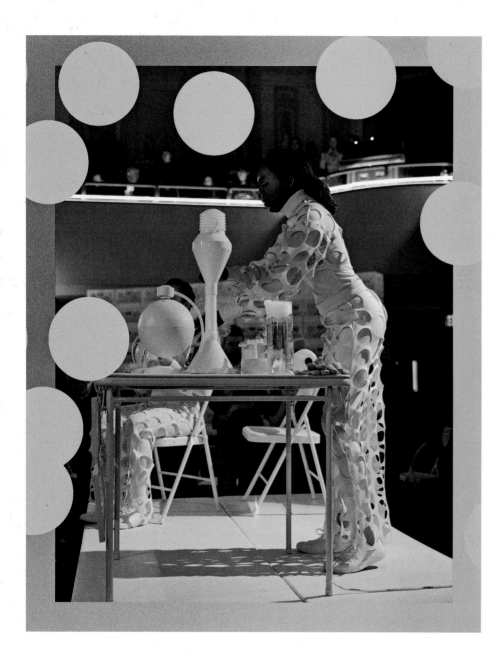

Alex Da Corte: Chicken, edited by Alex Da Corte, Karen Kelly and Barbara Schroeder (Dancing Foxes Press)

In 1962, the Young Men's/Young Women's Hebrew Association on Broad Street in Philadelphia nearly became the highly unlikely site of the first institutional Pop art show in America, before Pop had even fully taken hold as the movement's name. Billy Klüver, the Bell Labs engineer and self-taught art savant, organized "ART 1963/A New Vocabulary," gathering the work of wildly experimental friends like Rauschenberg, Rosenquist, Lichtenstein, Dine and Marisol. Then, less than a month before it opened that October, the wily

Walter Hopps beat them to the punch on the West Coast, opening his own Pop show, "New Painting of Common Objects," at the Pasadena Museum of Art. Philadelphia's consolation prize more than made up for the loss: One of Allan Kaprow's most memorable Happenings, *Chicken*—a gallinaceous free-for-all that he described as a "a comic-tragedy about ourselves, full of the utterly ridiculous"—closed the exhibition on its final night.

In February 2020, as the pandemic was howling in across the globe, the Philadelphia artist Alex Da Corte took to the stage in the same building to reimagine Kaprow's Happening for a new generation, dialing down the original's violence against chickens (in fact, chickens were now absent

entirely), dialing up a more vividly colored, clublike queer vibe and substituting the ovoid metaphor of the moon for the domesticated layer of eggs. This beautiful new book, made in close collaboration with Da Corte, feels less like a documentation of that night than a surrogate for it, a sparkly moon rock for all those not lucky enough to have joined him for the lunar excursion.
—*Randy Kennedy*

László Krasznahorkai, *Spadework for a Palace*, translated by John Batki (New Directions)

Last weekend I stumbled out of a party somewhere lower and westerly in Manhattan to discover that I had lost all sense of direction. The blocks seemed to wind in on themselves like streams of conversation, until I was spat out in front of the most beautiful, secret-seeming cobblestone courtyard. Gas lamp burning, not a soul around. It was one of those New York discoveries that materialize from the landscape like a revelation. You have to be dreaming or intoxicated to receive them. This is precisely the feeling László Krasznahorkai manages to produce in his newly translated *Spadework for a Palace* (originally published in Hungarian in 2018). It's narrated by a middle-aged librarian who happens to be called "mr herman melville"—a man who is made dreamy by his passions, and for whom "reality is no obstacle." His fantasy is to build a perfect library, what he

terms "the Permanently Closed Library," a hermetically sealed collection of knowledge. The book, not so much a story as a confession, is comprised of a single sentence—one that carries you forward with the inevitable unfolding of a crooked, midnight street, leading you, almost speechless, into a stunning clearing of thought. This is a manifestly New York book—a labyrinthine ode to Lebbeus Woods and Herman Melville, to New York's geography, oddities and insanity, inflected with *Bartleby, the Scrivener* and even a touch of Borges. Read it in one delirious sitting, at the pace of a long, aimless stroll. —*India Ennenga*

Cover image: *Solohouse*, 1988–89. Courtesy the Estate of Lebbeus Woods

And Warren Niesłuchowski Was There: Ontological Nomad, Guest, Host, Ghost,
edited by Sina Najafi and Joanna Warsza
(Cabinet Books/Museum of Modern Art in Warsaw)

Born in 1946 in a displaced persons camp outside Munich, Jerzy—later George or "Jeż"—Niesłuchowski ended up in America before deserting the army to avoid being sent to Vietnam. Then he headed to Paris, where his adventures included joining the protest-oriented Bread and Puppet Theater en route to Iran. When he returned to the United States, it was with a passport gifted him by a Brit named Warren, whose first name he adopted. In the 1990s, he held down some art-world jobs—as Alanna Heiss's unreliable assistant at a fledgling PS1

and as an editor with Routledge—before essentially ceasing to engage in regular work and only occasionally having a hand in various projects. In an ever more literal sense as the years went on, the global art world became the place where Warren lived.

This book—officially published not long after his death in 2019 but arriving at its U.S. distributor a few years late—focuses on what its editors call "The Homeless Years," from 2003 on, during which he lived as a kind of Bartleby while also fulfilling the art world's implicit injunction to sociality: the circuit of openings, dinners, drinks. His "search for adoption by an imaginary family"—and his affection for Auden, Rilke, as well as for wordplay ("Poe-Land," "categorical *apéritif*," "phoneless in Gaza")—is evident here in emails to friends such as artist Joan Jonas, Chloe Piene, Barry Schwabsky, Adam Szymczyk and Michael Taussig. The book also includes a selection of his writings, among them an essay ostensibly about Tony Oursler but mostly about Blake, Aristotle, Hellenistic modernism, the advent of writing, and other seemingly disparate topics.

Artist Simon Leung—who made a number of works focusing on Warren's life that are also documented in these pages—was, he says, anxious of "idealizing" his subject. This book, too, is a hagiography of Warren as a *Lebenskünstler*—and an homage to an art world that long offered a home for people who didn't want to fit in, or couldn't. —*Alexander Scrimgeour*

Cover image: Warren Niesłuchowski arriving at artist Chloe Piene's home, New York, 2018. Photo: Chloe Piene

Cover image: Stills from Trinh T. Minh-ha, *Forgetting Vietnam*, 2015. © Moongift Films. Courtesy the artist and Primary Information

Trinh T. Minh-ha,
The Twofold Commitment
(Primary Information)

Trinh T. Minh-ha's work routs conventional categories—it's a matrix, as defined by its silences and omissions as by its inclusions. This is as true of her films as of her philosophy, her feminist work and her postcolonial critique. She is informed by her childhood in Vietnam and adulthood in the United States, her years in West Africa and Japan, and her study of ethnomusicology as well as French literature. So it's no surprise that *The Twofold Commitment* is a work of duality in both content and form: half is the lyrical screenplay for her film *Forgetting Vietnam*, and the rest a selection of wide-ranging conversations. Building from one of the founding myths of Vietnam—that two dragons entwined and fell to a watery resting place, becoming one in the country they created—the book is a work of splitting and rejoining. Published on the fiftieth anniversary of America's withdrawal from the Vietnam War, it responds to a moment of historical division with a metaphorical cleaving: between text and image, screenplay and interview, fiction and philosophy, showing that in separation there is also sameness. As Trinh explains in one of the included conversations, "the question of change or sameness is a little bit . . . like stillness and movement. If we think of them as opposites, then we think, for example, of stillness as something that is rather stale . . . and we think of movement as something that brings about change. . . .

For me, they are like two facets of the same coin." Like so much of her previous work, this book presents a nuanced, third path that threads oppositions. Serving as both a good introduction to Trinh's thinking and a deep dive into her creative process, *The Twofold Commitment* presents the complexities of one of the greatest living filmmakers and theorists. —*India Ennenga*

Gianni Pettena,
Tutto, tutto, tutto . . . o quasi /
Absolutely Everything . . . or Almost,
edited by Pino Brugellis,
Alberto Salvadori, Elisabetta
Trincherini (Quodlibet)

As the 1960s picked up speed, with protests against the Vietnam War and consumerism becoming a global phenomenon, a group of students in Florence became increasingly frustrated with the methods used to teach architecture. They could not relate to prewar modernist models, and they resented their faculties' detachment from contemporary social discussions. To address their concerns, they founded what would later be known as the Radical Architecture movement, which thrived for more than a decade as the leading laboratory for Italian architecture and design.

Among the students was Gianni Pettena (b. 1940), who defined himself as an "anarchitect." His neologism proposed both nonarchitecture and anarchy as ideal conditions for the development of creativity. For example, his unconventional design for a couch, called *Rumble* (1967), went beyond functionality: It was conceived not according to human scale but rather to the scale of a room, as if it was an indoor landscape, while its configuration depended on human interaction.

Pettena felt closer to art than to architecture, but he was nonetheless proud to proclaim that, unlike some Radical architects, whose projects were realized only in photomontages, he was able to build everything that he designed. In 1972, he refused to participate in "Italy: The New Domestic Landscape"—the pioneering exhibition for Italian design at the Museum of Modern Art in New York—preferring to mount a solo show of American landscape photography at John Weber Gallery. The critic John Masheck, in an *Artforum* review, called him "an architect actively on strike."

This book makes available to an international audience for the first time Pettena's prolific practice as architect, theorist and artist. It contains his published writings and documentation of his numerous projects and situates him among the most active and connected intellectuals of his field. He taught in internationally renowned universities, foresaw the prominence of Zaha Hadid and Rem Koolhaas and engaged in close dialogue with fellow architectural mavericks like Robert Smithson and Buckminster Fuller. Advocating an organic interaction between architecture and art, Pettena maintained his focus, presciently, on social and environmental awareness.
—*Maria Elena Garzoni*

Paul Lafargue,
The Right to Be Lazy
and Other Writings,
translated by Alex Andriesse
(NYRB Classics)

Groucho Marx didn't want to be a member of any club that would have him as a member. And Karl Marx (at least according to his friend Engels) didn't want to be a Marxist if it meant the version of it practiced by his knockabout son-in-law, the French-Cuban revolutionary Paul Lafargue, whose best-selling pamphlet *The Right to Be Lazy*, first published the year Marx died, has probably done

more to embed notions of labor and class struggle in popular consciousness than *The Communist Manifesto* itself. Lafargue's slightly Swiftian conceit had less to do with control of the means of production than with the belief that productivity of any kind, by anyone anywhere, is a vastly overrated virtue, modernity's most insidious bill of goods. By the 1960s, the counterculture had taken up the treatise as a guidebook, conspicuous on the plywood tables of good anarchists everywhere, as Lucy Sante writes in the introduction, holding out the promise of that glorious day when work would become "a mere condiment to flavor the tasty dish of laziness."

Lafargue's ideas about locating true fulfillment in indolence have filtered through philosophy, poetry (Philip Larkin: "Why should I let the toad work / Squat on my life?") and contemporary art (Pierre Huyghe's precocious Association of Freed Time) and seem less satirical with each gain in late-capitalist efficiency, each advance in workplace monitoring software designed to make the productivity score the defining metric of human life. This sharp new translation brings the book back into handy circulation along with its anthemic epigraph by Gotthold Ephraim Lessing, fit for the front of a tattered T-shirt: "Let us be lazy in everything / Except in loving and drinking / Except in being lazy."
—*Randy Kennedy*

Cover image: L. S. Lowry, *Going to the March* (detail), 1928

HAUSER & WIRTH PUBLISHERS

Amy Sherald
The World We Make

**With contributions by Ta-Nehisi Coates,
Kevin Quashie and Jenni Sorkin**

Now Available

www.hauserwirth.com/publishers

Leigh Ledare, *The Walk*, 2016. Glass, silicone caulk, vintage Soviet postcards, pages torn from R. D. Laing's *Knots*, soap and assorted stains. 32 panels, each measuring 12 × 9 in. (30.48 × 22.86 cm). Courtesy the artist and The Box, Los Angeles

Amapola By Alissa Bennett

I suppose it was in early 2006 that I began to understand something had changed. It wasn't anything that I could identify at first, just a series of subtle shifts that indicated that I was shuffling slowly into middle age. There was the New Year's Eve party in Bushwick to which I wore an inappropriately transparent minidress and cowboy boots. "Is that your MOM?" I heard another guest screech as I vomited alone off of the rooftop. There was an incident in a midtown Sephora when a salesgirl recommended a concealer formulated for mature complexions, and a car-service driver who put on the Temptations after I told him his music was giving me palpitations.

I spent much of that winter neglecting my Match.com profile and calling out of work sick, canceling dinner plans and avoiding my friends so I could scrutinize my appearance in a Conair Illumina tri-paneled mirror that I'd hauled around since high school. Holed up in my increasingly catastrophic room, I found myself frantically switching through each of the mirror's four settings, strobing my face with its flickering atmospheric simulations. Day, evening, office, evening, home, office, evening, day, home. I noticed that the office option made me look much worse than I ever imagined, as if my face was a pile of dirty dry cleaning left on a counter for strangers to inspect. I found some solace in the evening setting, a rosy light that called forth old and young things in equal measure. It brought peace to close my blinds and light my room with it when I applied my acid peels.

I ordered an elastic face strap from the back of a *Star* magazine that promised to lift and tighten even the most stubborn sloping jaw lines. I stuck scotch tape to my forehead. I purchased a handheld microcurrent device and a conduction gel designed to electrocute my face back into something familiar. When I bothered to show up at the hair salon where I rented a chair, I would spend much of the day staring at myself while doing a series of increasingly baroque facial exercises that I hoped would tone and tighten; it took dedication, the experts said. You cannot rewind the hands of time overnight.

Walking home one night, I listened to the sound of the metal end of one high heel clicking across the pavement, its plastic cap lost to the filth of a city that no longer felt hospitable to my sagging life. I followed a well-dressed middle-aged woman with a dowager's hump for several blocks, reluctantly leaving her only to stop in a health-food store for a cleansing green juice.

"You look great!" I yelled with sincere passion to this hunched specter in skintight black jeans and a boiled wool Comme des Garçons blazer. She glared at me for a moment before returning her gaze downward. Maybe it hurt her back to say thank you, I thought. I made my way into the store and ordered a sixteen-ounce I Dream of Greenie.

"I threw in some parsley to help you with those bags under your eyes," the ponytailed loser behind the counter told me. "It's your kidneys, you gotta clean out the kidneys." I felt my hand rise to my face and threw a $10 bill down on the counter with the kind of disgust that only the elderly can muster. "Fuck you," I hissed. "You fucking pervert!" I ran out before he could respond and gulped down all of the juice, then threw the empty plastic cup at the shop door. But as I did I wondered if he was right, if maybe all I'd been missing this whole time was something as simple as parsley.

i

Once I'd made it halfway up the stairwell of my sixth-floor walk-up, I could hear the theme song to *The Golden Girls* echoing through the hallway. It meant Ruthie was home, and I felt distaste rising like bile in my throat as I fit my key into the lock.

Ruthie was a forty-five-year-old freelance bookkeeper who spent her afternoons drinking red wine from a *Happy Days* thermos and whittled away her evenings watching reruns on Nick at Nite and Lifetime. We'd lived together on Third Street for nearly ten years, but I felt no affection for her. She was depressing and mousy, shot through with an unintentional cruel streak that I felt indicated an undiagnosed mental disorder.

Despite the fact that we were the same age, I'd always felt at least a generation of difference between Ruthie and myself. She was pallid and misshapen and her forehead was sliced through with creases that exposed the lies she told about how much she loved her "life." She looked like a gigantic leather shoe that had been worn out in the rain, and it was a terrible shock when our building's super once asked me if we were identical twins.

Ruthie had her crayons out and was defacing an adult coloring book when I came in. Her hair hung in great greasy clumps, her bangs combed down to meet overplucked eyebrows in an approximation of a 1940s pinup look. She wore a vintage robe with a large cursive "L" embroidered on the front, a relic from a year-long romance she'd had with a swing dancer who called himself Johnny-O and some-times rode a unicycle. She'd maintained a slovenly devotion to this look for years, and though there were no more boogie-woogie championship weekends in the Catskills, she seemed to remain somehow trapped in 1999, perpetually waiting for Johnny-O to roll up in his saddle shoes and scream her name.

"Every time I see a unicycle, I just have to see if it's him," she told me once as we walked to a Bed Bath & Beyond.

"You have something on your robe," I said, sitting next to her on the couch.

"Shit. 'Comforting Beef Stew,'" she said, scraping at the blob with a chipped nail. "It's in the Crockpot if you want any." Ruthie was always cooking something in her Crockpot. "Wine?" she asked, smiling, holding out her thermos.

"Ruthie," I said to her, "do you notice anything different about me?"

"Different like what?" she asked.

"I mean I've been going to this new dermatologist, and I just wanted you to look at me and tell me if you see anything that looks different."

"Well," she hedged, squinting her eyes and licking at the inflamed skin above her top lip, "you look like . . . kind of red."

I got up and stomped toward my room without looking back at her. "Good night, Ruthie. Please do your dishes tonight."

My Illumina's day setting confirmed Ruthie's observation: I was red. And as I inched closer I spotted a new pocket of fat hanging pendulously under my chin.

It's strange to chart your decline in an unchanging surface, and as I lay down on the mélange of laundry covering my bed, I began thinking about the differences between landslides and cameras, about how time ravages us all, though some things stay the same. I dreamt of Pompeii that night, of bodies turning to stone under a blanket of lava or ash or whatever it was. I dreamt of myself frozen forever, twisted into the shape of a decorative sconce, installed permanently on the wall next to Ruthie's TV.

<div align="center">• • •</div>

It was a poorly plotted plan, I suppose, an idea that bordered on farce. But it began by letting myself go. I stopped exercising and ate plates full of heavily salted frozen lasagna. I threw away my moisturizers and drank liters of ultra-high ABV beer while gazing into my Illumina, using the day setting to apply dollar-store makeup as unflatteringly as possible. It's not that I exactly wanted to be old. It's just that I was at the end of my rope, the end of an endless stream of first dates and sculpting foundational garments that had strangled my forties. I suddenly felt choked by any shoe that featured high heels or even laces, assaulted by the barbed-wire waistbands of the stretchiest of jeans. I was an exhausted person who deserved some kind of break.

I'd seen ads for Briarbrook for years before I finally began to pay attention to them, to wonder if maybe what I needed was a few months of 5 p.m. buffet dinners and penny-ante card games. Maybe I would find some kind of well-being making potholders and playing backgammon and eating vanilla pudding out of plastic cups. Briarbrook wasn't a nursing home, after all; it was a community of lively and mature people who had paid their dues and were interested in "discovering everything that life had to offer." I printed out a picture I found of some residents playing an indeterminate lawn game, and I pinned it to my mood board. In my shakiest, most geriatric-looking script I wrote: "THIS COULD BE YOU."

I purchased pastel twinsets and orthopedic shoes. I found beige-colored imitation leather purses at the Salvation Army and hitched them in the crook of my arm without irony. I learned that a thin layer of latex affixed to my face with a warm blow dryer erased the last remaining evidence of youth in my complexion, which exhaustion and poor nutrition had already done their best to eat away. It was shocking how easy it felt to release myself from the bondage of sexuality, to drift away on a sea of sentimental memories about milkmen and holiday oranges.

I told Tammy, my salesgirl at Ricky's, that the short, cropped gray wig looked fine. No, I didn't want to try on Paris Hilton's platinum fall. I did not want Angelina Jolie's sexy waves. I gasped when Tammy presented me with a Bettie Page–brand clip-on bang that reminded me so much of Ruthie that I would not have been surprised to hear it speaking in her voice.

"You'll understand when you're older," I told Tammy. "I don't need all this. I'm a confident woman . . . Do you have prosthetic noses here?"

<div align="center">• • •</div>

Eventually I came to understand that one cannot just move into a retirement home; there are application processes and Medicare numbers, social security reviews and mandatory down payments. That's when I thought about my Aunt Ellen again for the first time in years.

Seventy years old and wealthy from leading a miserly life, Aunt Ellen, a pinched and withered woman, lived alone in a single-level ranch house in Woodbridge, New Jersey. Since we were children, we had all known about the little safe in her closet, covered with tablecloths and old sweaters, packed with wads of $100 bills that grew to such a hoard that the door would no longer close, money that was truly begging for liberation.

<div align="center">iii</div>

I cooked up a pretense to get myself through her front door in early May. I told her that I'd given up my dream of hairstyling and had finally gone back to college to finish my bachelor's degree. I said that I had developed a new passion to become an oral historian and to gather the stories of the elderly.

She put out tea and canned shortbread cookies and looked me over sternly. "Forty-five and back in college? A little long in the tooth, aren't you, Erin? At your age, you're going to live in a dorm?"

"No, Aunt Ellen, I'm not going to live in a dorm. I live on Third Street in the city, remember? I live with my fiancé. His name is Robert, and we are very happy."

"I haven't heard about any of that from your mother. She's tortured thinking you're going to die alone in that cold-water flat of yours. She said she thought you were going through 'the change' and that it was turning your brain to mush."

"Will you excuse me, Aunt Ellen?" I said. "I need to use the ladies' room."

Equipped with Aunt Ellen's driver's license, her social security card and enough of her cash to last me a year, it was easy to find a place close to Briarbrook—a boxy, beige furnished rental. No one at the realtor's office batted an eye when I produced $15,000 in cash from my straw handbag.

"Old people are always doing this shit," I heard the broker, Annie, say to a colleague as she counted out the bills in another room.

"I'm old, not deaf!" I yelled out, and the words sounded sincere, almost truthful.

My new apartment in no way resembled the Avalon that Blanche and Rose and Dorothy shared on *The Golden Girls*. There was no lanai, no oversize pottery, no shell-printed settees on which to contemplate my new life. But it was clean and quiet, and I slept comfortably each night on a Craftmatic Adjustable Bed. Every morning, I rose at six-thirty and walked to a local park, where I read Mary Higgins Clark books and drank decaffeinated coffee from a Styrofoam cup while waiting for the Briarbrook residents to make their morning journey up the hill to the gorge. Lugging their collapsible easels and watercolor kits, their fishermen's caps listing in the breeze, they would bicker their way past me, complaining about humidity or the empty bottles teenagers discarded in graveyards at night. "They're pigs," they would say. "No respect." "I'd disown Stevie if he ever turned out like this." It was comforting, and I found myself nodding in agreement.

It was in the neighborhood luncheonette that I first encountered a Briarbrook resident named Martin. He had a waxy dignity about him, and I found the rubbery sag of his earlobes and the hair that grew in tufts from the tip of his nose oddly alluring.

"You're not at Briarbrook," Martin said, sitting down next to me at the counter. "We're technically not supposed to eat here, but I can't stand beefsteak Wednesdays."

"Oh, I just moved to the neighborhood," I told him. "My name is Ellen. I came here from New Jersey when my husband died."

Martin seemed to sense nothing out of the ordinary about me, and though I could tell that he liked me, my body and face seemed to inspire no special interest in him, no awkward stares or incidental touches. After some weeks of Wednesday lunches, he said he was pleased to invite me as his guest to Night of the Arts at Briarbrook.

"We've got to get you out of that house, Ellen," he said. "You can't live your life all closed up just because Robert died. We can't give up on everything just because we're old. "

I wiped away a genuine tear and fished in my purse for a Brach's hard candy. "Do you have any Xanax or whatever?" I asked.

"So will you join me for Night of the Farts?" he asked, and though this kind of humor would have repulsed me coming from a younger man, it had a certain ring of dignity when Martin said it.

"I got nothing better to do," I said coquettishly, holding out my hand for the Xanax clasped in his knotted fingers.

"Just friends, Martin," I warned him that evening when he picked me up from my apartment.

"You're too young for me, Ellen," he said, winking, before helping me into my seafoam green windbreaker and escorting me down the block. "I've been to seven Nights of the Arts, and every single one of them is more terrible than the last," he said as we walked together, my arm in the crook of his. "Stay away from Joyce Davis. Never met a meaner girl in my life."

Briarbrook was everything I'd dreamed. There were imitation Tiffany lamps and floors covered in billiard-green industrial carpeting. Cheerful staff members in pastel polo shirts held out cups of nonalcoholic punch and paper plates of Cheez-Its. There was a library full of mysteries and classics that no one under thirty now had the attention span for, overstuffed floral chairs and oak tables accented with laminated weekly schedules.

"Come this way, Madame," Martin said, leading me through a throng of jealous-looking elderly women.

"Martin!" a blonde in a forty-year-old pink satin evening suit said. "You just get better and better."

"Sure, Joyce. Thanks a lot."

"See you for cocktails in the dining room after?" she asked. "I'm sure you can bring your friend if you'd like . . ."

"Going to see the show now, Joyce," he said. As we pushed past her, I felt a surge of pride.

The recreation room was hung salon style with watercolors. Most of them featured the gorge, but there were also a number of shabbily rendered African violets and a cross-eyed-looking child who I assumed had been painted from memory.

"I want to show you something," Martin whispered, walking me over to a framed painting that rested on the ledge of a small easel.

I looked at the image, a woman in a powder-blue blouse reading a book on a park bench. It didn't matter that the wig had been rendered a little crooked or that the hands were as big as baseball mitts or that the lips smudged into a watery dribble sliding down the chin.

"It's a painting of me!" I said, my eyes dampening and my speech beginning to slur from the fifteen milligrams of OxyContin that Martin had given me before we left the house.

"It's you all right, Ellen," he said. "I call it *Amapola*. But you're only seventy. So you probably don't even remember that old song."

"You're right, Martin, never heard of it," I said. "Hey, I've got a pack of Marlboros and a six-pack of Bud Lite back at the house. What do you say we blow this place and play a game of gin?"

"You make me feel young again, Ellen," he said.

"It's Erin," I told him, hooking my arm in his and walking him toward the door, "and goddamn, do I have a story for you."

By Eddie Chambers

Looking back at the intersections of music, food, art and politics at the Africa Centre in London's Covent Garden

In the Centre

The Africa Centre, which used to occupy a substantial, multi-story building in the fashionable heart of London's West End, midway between Leicester Square and Covent Garden tube stations, has an extraordinarily important place in the history of Black creativity in Britain in the second half of the twentieth century. It was, in a manner of speaking, Africa in central London. It is astonishing that relatively little is known or remembered of its illustrious history, or of the many exhibitions of the work of Africa-born or -based practitioners—and periodically also that of Black British artists—that took place there. With the demise of the Commonwealth Institute and its two gallery spaces in the early 2000s, and with what turned out to be the long-term closure of the Africa Centre in 2013 (although a new chapter in its history has recently begun in new premises in Southwark, on the other side of the Thames), central London lost two highly significant visual art spaces in which the work of Black artists and other practitioners of color could be seen as a matter of course. A measure of the importance of this fact is that aside from the October Gallery, gallery-going audiences and the general public in central London currently have little to no access to venues in which the work of Black artists is always on display.

The Africa Centre was founded in 1961 with the aim of informing the British public

Poster for a concert by the Super Disken Allstars at the Africa Centre, London, 1994. London Metropolitan Archives, City of London LMA/4816, from the Africa Centre Collection

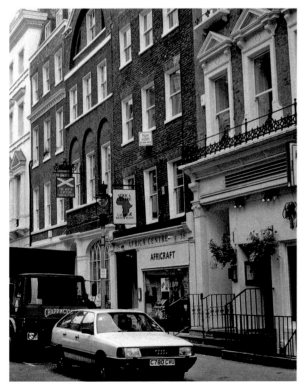

Exterior view of the Africa Centre, King Street, London, ca. 1980s. Courtesy the Africa Centre, London

about Africa. Its building on King Street—opened by Kenneth Kaunda, the first president of Zambia, in 1964, the year of that country's independence from British rule—served as a hybrid performance space, gallery and educational facility. For many in Covent Garden, this creation of Africa in central London remained hidden in plain sight, but for countless others, the Africa Centre became an important, much-loved part of their lives or their time in London. The ground floor housed a shop selling Kenyan kiondo bags, carvings from West Africa, various kinds of jewelry and the like, while upstairs a specialty bookshop sold a range of publications about Africa and/or by African and Caribbean authors. On the building's lower level was the Calabash restaurant. A report in the NAACP's magazine *The Crisis* gives a wonderful sense of what was available: "a chicken dish (cooked in coconut cream) from Zanzibar, a fish speciality from Senegal, an Algerian lamb and aubergine (eggplant) stew and other dishes from Zaire (beef with palm nut and spinach), Sierra Leone, West Africa, Uganda and Malawi." Musicians from across the continent played frequently at the Africa Centre, among them legends such as Nigerian guitar wizard Victor Uwaifo. Zimbabwean promoter and sound engineer Wala Danga organized club nights; there were also occasionally outlier events such as a 1979 concert featuring Scritti Politti,

Prag Vec and The The. A new generation would call the Africa Centre its own from the late 1980s on, when the venue became legendary for Sunday evening parties thrown by London-born DJ and producer Jazzie B with the Soul II Soul sound system; these nights led to Virgin Records signing the collective behind hits such as "Back to Life (However Do You Want Me)" in 1988.

Of the significant events that took place at the Africa Centre in the first decades of its existence, some are remembered better than others; among the former is the Destruction in Art Symposium, organized by Gustav Metzger and John Sharkey in 1966; as part of its programming, Yoko Ono performed her *Cut Piece* (1964) there. In the mid-1970s, the illustrious speakers at the Africa Centre included Chinua Achebe, who discussed his own work along with that of other African writers; and the

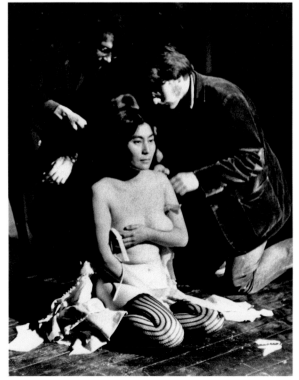

Panelists at the Destruction in Art Symposium (DIAS) at the Africa Centre, London, 1966. Photo: Tom Picton. Presented by Tom Picton's family/ Tate Archive. © The Estate of Tom Picton/Tate

Johnson Mbondo, manager of the Calabash restaurant, and others on the balcony of the Africa Centre, ca. 1980. London Metropolitan Archives, City of London LMA/4816, from the Africa Centre Collection

Yoko Ono performing *Cut Piece* at the Destruction in Art Symposium (DIAS), Africa Centre, London, 1966. Photographer unknown. Courtesy Fondazione Bonotto

Pan-African colossus, radical academic Walter Rodney—author of *How Europe Underdeveloped Africa* (1972). Such progressive programming spoke to the ways in which Africa Centre became a hub: In the words of journalist Richard Dowden, "it became The Place for African presidents, freedom fighters, writers and artists to speak and debate. You could find everything African there, from Ghanaian food to fierce debates and fantastic parties."

The Africa Centre had a clearly Africa-centric (rather than diasporic) focus, which also applied to its arts programming. A 1991 publication speaks of the desire "to include works from all parts of the continent" and describes the gallery as a space "offered primarily to African artists wishing to exhibit their work in Central London." While it is likely that more attention would be paid to diasporic artists today, the centrality of Africa was important for compelling reasons, not least the success of independence movements across the continent and the seemingly intractable consolidation of Rhodesia and South Africa as bastions of white supremacy that came to an end only with the founding of Zimbabwe in 1980 and the end of apartheid in the early 1990s.

Over many decades, the challenges Africa faced and the complexities of overcoming them, on the one hand, and the continent's frequently optimistic consciousness, on the other, were reflected in the Africa Centre's exhibitions, performances, discussions and other cultural events. The programming demonstrated that the continent of Africa was more than, and very different from, the widespread perception of a continent racked by extraordinarily violent conflicts that were either anticolonial in nature or emanated from the vying of the world's superpowers in a series of gruesome Cold War battlegrounds. The

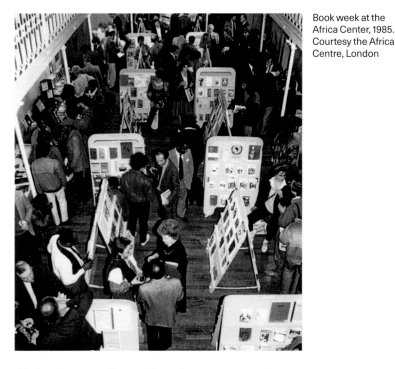

Book week at the Africa Center, 1985. Courtesy the Africa Centre, London

Africa Centre thus offered a counterpoint to the ways in which Africa was often regarded—and constructed—as a wholly dysfunctional continent racked by incomprehensible tribal and ethnic tensions and discord that rumbled on year in, year out.

As an art student in the early 1980s, I was working with a group of other young Black artists and art students keen to start showing their work at galleries beyond the towns and cities of West Midlands where we had grown up or were studying. To that end, we speculatively approached the

Africa Centre, which we had at that point never visited. When I wrote to the venue on behalf of the group, I was keen to stress what would now likely be referred to as our diasporic sensibilities. "The [accompanying] details refer to the group of young black artists whom I am representing, and not myself personally. None of us were born in Africa but we consider ourselves to be 'Pan-Africans'; by this we mean that we acknowledge Africa as being the home of our ancestors and consider ourselves to be in a form of exile, being unable, for obvious reasons, to return to Africa." Our approach was positively received, and "The Pan-Afrikan Connection: An Exhibition of Work by Young Black Artists" opened in May 1982, featuring predominantly paintings and drawings from Dominic Dawes, Claudette Johnson, Wenda Leslie, Keith Piper and myself.

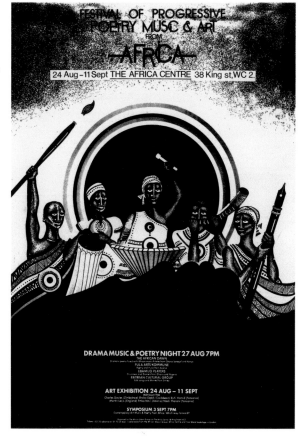

Poster for the Festival of Progressive Poetry Music & Art from Africa held at the Africa Centre in 1981. Courtesy the Africa Centre, London, and Eddie Chambers

Poster for a concert by the African Dawn at the Africa Centre, 1983. London Metropolitan Archives, City of London LMA/4816, from the Africa Centre Collection

While this may well have been the first exhibition at the Africa Centre dedicated to the work of British-born or raised Black artists (all of Caribbean parentage), it followed the previous year's Festival of Progressive Poetry, Music & Art from Africa, which resonated strongly with diasporic and Black consciousness sentiments and, perhaps unknowingly, pointed to future strands of curating and scholarship around African Art and how African

and diasporic contemporary artists would be situated, constructed and understood. From the festival's publicity:

Contemporary African art has not yet received the attention that has been increasingly fostered upon historical African art which had past realities as its point of departure. This attention has partly come about as a result of the status of such works as investible objects or, as in the case of mass produced "airport art," an attempt at an appropriation of mythical Africa.

The exhibits, on the other hand, attempt to comment/reflect/criticize the existing realities of Africa including the popular struggles of its peoples by utilizing various media including sculpture, cartoons, prints, posters and montages. In the process, some of the works continue the evolution of traditional aesthetic elements.

The music night brings together various groups and artists committed to the idea of revitalizing the richness of African culture by fusing the progressive elements of traditional forms with social commentary in order to fashion a new potent force for contributing towards the changing of contemporary reality.

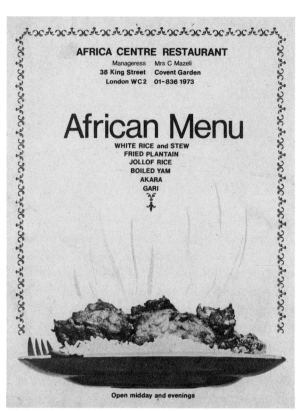

Menu from the Calabash, the Africa Centre's restaurant, date unknown. London Metropolitan Archives, City of London LMA/4816, from the Africa Centre Collection

This was a fascinating statement-cum-manifesto, replete with Marxist interpretations of and attitudes toward culture, that simultaneously referenced the vexing dominance of outdated and patronizing institutional attitudes to African art that were often essentially anthropological or ethnographic in nature.

The accompanying exhibition was an extraordinary undertaking, featuring work by Ruhi Hamid, a graphic artist of Tanzanian Pakistani background; Nadir Tharani, a painter from Tanzania; Charles Davis, a graphic artist from Zimbabwe; and South African sculptor Pitika Ntuli. The presence of Hamid and Tharani was somewhat revolutionary on account of the South Asian background of these East African artists. Furthermore, these four artists were joined by a white British painter, Martin Lovis, and Shakka Dedi, born in New York to Jamaican parents. Dedi would go on to be the founding director of the Black-Art Gallery established in 1982 in Finsbury Park, north London, a key initiative that did much to articulate understandings of Black art in the UK.

Arguably the most significant and influential group exhibition held at the Africa Centre was Lubaina Himid's "Five Black Women" in 1983, which also broke the mold of the venue's customary visual-arts repertoire. At some point, Himid, who had studied theater design at Wimbledon School of Art, joined the Africa Centre's

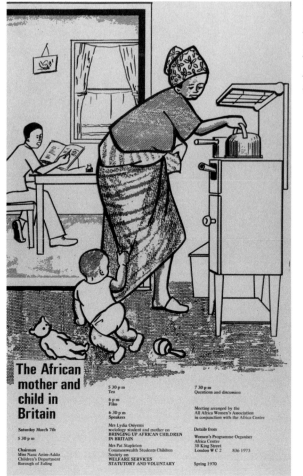

Poster for a symposium at the Africa Centre, 1970. London Metropolitan Archives, City of London LMA/4816, from the Africa Centre Collection

exibition selection committee, facilitating her organization of this important, timely and influential exhibition of her own work along with that of Sonia Boyce, Claudette Johnson, Houria Niati and Veronica Ryan. (Notably, four of these five artists have since received an honor bestowed by the Queen, while Himid herself won the Turner Prize in 2017, and Boyce was winner of the Golden Lion at the 2022 Venice Biennale.) Himid's own life-size, painted, cutout men with meter-long erections were complemented by Johnson's pastel drawings of women. Boyce made autobiographical work, also using pastels, while Ryan showed small sculptural works and Niati

Lubaina Himid, *It's All in Your Head*, 1982. Wooden cutouts, dimensions variable. Installation view, "Five Black Women," the Africa Centre, London, 1983. Courtesy the artist and Hollybush Gardens, London

reimagined colorful Delacroix paintings. As was typical of exhibitions at the Africa Centre, wall-based work was hung on the walls of a rectangular, upper-level balcony, from which one could not only look down at the multipurpose space on ground level, but, more importantly, look across at the artwork installed on the adjacent or opposite wall—"across a yawning chasm," as Himid recalled.

The Africa Centre's exhibitions did not come with catalogues as a matter of course. While this certainly makes the historian's work more difficult, Himid saw it differently, noting, some six years after the exhibition, "We recognized the show as being important but the need to have a catalogue to prove that the event occurred did not have a high priority, since we clearly and confidently expected there to be shows along these lines all the time from that moment on." The "Five Black Women" exhibition was indeed the first of several such undertakings organized by Himid. Also in London, a few months later, "Black Woman Time Now" opened at the Battersea Arts Centre, and then the altogether much better known and more substantially remembered group show "The Thin Black Line" took place at the Institute of Contemporary Arts in 1985.

The Africa Centre's precarious finances were a matter of public record and around a decade ago, partly in an effort to stabilize itself financially, the institution gave up its iconic Covent Garden location. With the move to Southwark, into a building strikingly redesigned by architecture studio Freehaus, the Africa Centre may thrive once more, albeit in a new form in which its historical focus on the visual arts has been subsumed into a broader rubric of "culture." But the legacy of the place and its exhibitions is enormous, and it will be for visionary researchers and art historians to excavate more of its remarkable history.

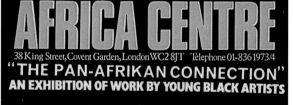

Poster for "The Pan-Afrikan Connection: An Exhibition of Work by Young Black Artists" at the Africa Centre, 1982. Courtesy the Africa Centre, London, and Eddie Chambers

Still from *Nicolas Party: Pastel*, 2022, a short film by Pablo Tapia-Plà, showing pastels during their manufacture at the Maison du Pastel in Paris, said to be the oldest pastel maker in the world, with roots going back to 1720

Nicolas Party on the importance of pastel

Nicolas Party, *Portrait with Roses*, 2019. Soft pastel on linen, 59 × 50 1/8 × 1 in. (150 × 127.2 × 2.5 cm). Photo: Adam Reich. © Nicolas Party. Courtesy the artist and Hauser & Wirth

In 2013, I bought a box of pastels, took a piece of paper and from the start, I thought: "Oh, this is it!" It was very immediate. I was working directly with my hands and fingers; it was fast. There were a lot of colors. I was, technically, pretty bad at it, but somehow I thought: "Oh, I love this medium and I'm going to work hard to try to find my own way of using it."

At first, I found myself doing only portraits. It wasn't until later that I discovered the historical connection with makeup and gender and all the playfulness around it. Pastel was very, very popular in the 18th century. It was the Rococo period and makeup was used and overused on men and women. Everybody had this white powder, red cheeks, lipstick, those little black marks, huge wigs. And the powder that was used to cover faces was the same that is used for pastel. Often it was the same manufacturers. So if you painted a portrait in pastel of someone wearing all this makeup, you would literally be painting another pastel. You were painting a painting.

Pastel is different from paint. If you mix oil paints, they get more oily and there will be always a bit of yellow in them because the oil is kind of yellowish. Acrylic is a very postwar kind of medium. Acrylic is very plasticky, and oil is very oily. They are both great for different things, but pastel has this very powdery, almost pure pigment feeling because the amount of binder that you need to make the sticks is very small, and as soon as you use it, it reverts to its powder form. What you have on the canvas is basically just the dust of more or less pure pigments. And you can't mix the color before you put it on a canvas. That's why I've done a lot of flat color backgrounds: to make use of the great quality of the pigments. That's also something that I really love.

It was only in the late 1600s that pastels started to come in a full range of colors. There's one very important figure: Venetian artist Rosalba Carriera (1673–1757). Her pastel-only portraits were in demand in every court in Europe, but she never really traveled. She went to Paris for a year once, and it started a huge pastel trend during the Rococo period in Paris. And from there, the trend boomed, more or less, all around Europe. It was the golden age of the court portrait. In the French court, at least, there was a lot of fun going on. There was a lot of theater. So there was a lot of play with makeup and with gender. Pink was very popular. I love pink.

Another fascinating aspect of this history is that pastels helped create a huge boom for women artists, many of whom were working full-time and earning a lot of money. Because pastel is made out of little sticks, you could work at home and didn't need to attend the academy. Remember that with oil painting, at the time, there were no tubes. So it took some doing to set up a studio and paint. Most of the time, artists would have been trained, either in the family business or by going to the academy, and women were not allowed to attend the academy. So for women, there was a huge opportunity—they could go and buy pastels, like I did, and go home and start.

The trend for pastels ended with the French Revolution. In a way, from that point on, it had the stereotype: "Pastel is for women. It's for painting portraits and flowers. So if you want to be a real artist, don't use pastel because it's not serious. You need to use oil and paint historical subjects." Pastel is very soft and delicate. In our cultural stereotype, it's very feminine. But I feel very attracted by the quality of the medium. Its fragility and sensuality, the softness of the surface and the mysterious powdery dust is something that feels very natural and familiar to me.

As told to Jed Moch

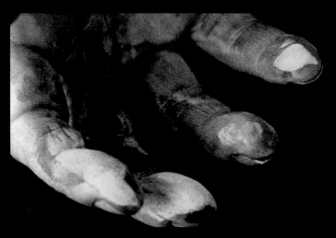

Stills from *Nicolas Party: Pastel*, 2022, a short film by Pablo Tapia-Plà,
showing the artist at work in his studio in New York and the interior
of the historic pastel manufacturer Maison du Pastel in Paris.
The film can be viewed on the *Ursula* website.

Nicolas Party, *Portrait with a Seahorse Necklace*, 2018. Soft pastel on linen, 48 × 40 in. (122 × 101.6 cm). Photo: Adam Reich. © Nicolas Party. Courtesy the artist and Hauser & Wirth

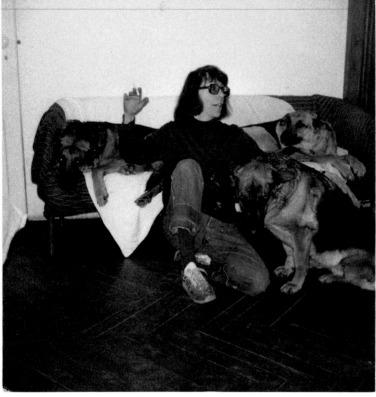

Joan Mitchell with her German shepherds Iva, Marion and Madeleine, Vétheuil, France, ca. 1982–83. Courtesy Elisabeth Kley

Joan Mitchell and Joyce Pensato, Vétheuil, France, 1983. © 2022 The Joyce Pensato Foundation

On learning from Joan Mitchell and Joyce Pensato

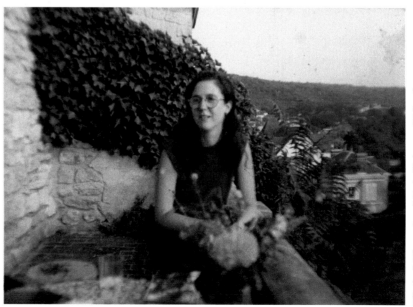

By Elisabeth Kley

If Joyce considered Joan to be her mentor, Joyce was mine. She enthralled me from the day I met her, long before I learned to understand her painting. Perhaps it was just her big heart.

In 1982, my parents went to visit Joan Mitchell in France and arranged for me to stay with her for one month. My mother's old New York City roommate, Martha Bertolette, Joan's college roommate at Smith, was the connection.

I flew to France in early July and spent a night in Paris, visiting Joan's impressive retrospective at the Musée d'Art Moderne de la Ville de Paris, which I didn't understand. The next day I arrived at her house near Vétheuil, a small village northwest of the city, on a hill overlooking the Seine. I walked up the gravel driveway, went inside and found Joan in the dining room with her three German shepherds—Iva and her daughters, Marion and Madeleine. They usually began barking as soon as the gate was opened, but they didn't make a sound. Instantly, Joan loved me. The dogs came first.

The interior was stark. A billiard table dominated the living room, with a small Mitchell triptych over the fireplace. There was a bedroom (just a bed, where Joan slept), the dining room with two sheet-covered couches for the dogs, a balcony with a view to the river and a kitchen. On the second floor, paintings by Sam Francis hung in the hallway above bookshelves stuffed with paperback mysteries. The octagonal library held more books, a television set, a small drawing by Matisse and a small painting by Kline. I slept in the main bedroom nearby, the largest, which Joan had abandoned when she broke up with her lover, the Canadian painter Jean-Paul Riopelle. Outside, a large garden held fruit trees, vegetables, flowers and the raspberries I picked and ate each day.

We settled into a routine. Afternoons, I painted landscapes outside using only white, ultramarine blue and raw sienna, to Joan's bemusement. Notes to me from Joan, written after I'd gone to bed, were left on the billiard table, scrawled on scraps of paper and score sheets, along with tubes of paint from Lefebvre-Foinet, the Paris paint store that had supplied Kandinsky, Matisse, Modigliani and Miró. "Squeeze paint!" she'd say. I didn't listen, but I cherished the paint nevertheless.

Joan usually stayed awake until dawn and got up at three in the afternoon. She claimed to be afraid of the dark and said she needed to check her paintings' colors in natural light, but I think she also wanted to sleep until cocktail time. After rising, with coffee and newspaper at a table on the slope leading up to her studio, she was dry and self-contained. Drinking began after breakfast, Campari laced with vodka. By the time I went to bed, her voice had begun to drawl and conversation could turn maudlin. But I didn't notice this until the following year.

Dinner was usually simple: a melon, chicken with tarragon, and cheese, all with red wine. Afterward, Joan would bring her gallon of Johnny Walker up to the library to watch the news. Gisèle Barreau, a brilliant young composer who was living with Joan that summer, would retire with two beers to her private room up the stairs, inside the round tower. Joan and I, and sometimes Noël [Morel] (her assistant from town), would talk until 3 a.m. in the kitchen or in her studio.

A veteran of years of psychotherapy, Joan enjoyed ferreting out all of my life's details. She analyzed letters from my mother—the oldest of five from a shabby Irish family who loved shopping and owning nice things. To Joan (still the wealthy WASP, in spite of her bohemian lifestyle) my mother was an arriviste. I had never really questioned my parents' personalities, so this was new to me. But Joan liked my cranky architect father.

Joan told stories of her friendship with Giacometti and an affair with Beckett, who was crazy about her painting. She loved color and light; adored the work of van Gogh, Matisse, Picasso, Bonnard and the Abstract Expressionists; detested the latest trends—neo-expressionism, neo-geo, Conceptualism and even Warhol. I was obsessed with Morandi. She said he was death. She described her sadistic German nurse, her deaf mother, and her father who had wanted a boy as the roots of her bifurcation into sensitive little Joan, who painted, had feelings, and dissolved into the world around her and big Joan, who was always prepared to lash out. When I pulled out my catalogue for her Paris show, she insisted that the curators had tried to make her work look terrible and that big Joan had rescued the installation. I couldn't understand why they would want to sabotage a show they had organized, but I didn't argue.

Ostensibly, I was there to take care of the dogs when Joan was away, but she rarely left the house. Since her messy 1979 breakup with Riopelle, she had avoided the town, where they had been notorious for restaurant arguments. Their open relationship endured until Riopelle began an affair right in the house with a young dog-sitter who was supposed to be uninterested in men. Joan, devastated, resumed psychotherapy, saying she felt so helpless that she was unable to cross the street. The car in the garage behind the studio was never used. Travel was mostly for exhibitions and gallery meetings. With Riopelle, she had socialized with a broad array of artists, writers and musicians, but now her world was limited to a small circle of friends. It was protected, and also stifled.

Joan's sister Sally, who lived in California, had terminal cancer. Joan had visited her in the spring and then followed her decline by telephone. The details were dire and distressing and Joan found it comforting to tell me about them. Morning notes included updates from early calls. Death was omnipresent, but music helped, especially opera. Maria Callas blasted from the studio all night, helping Joan to work through sadness. Toward the end of my month in the house, Sally died.

Joyce Pensato arrived with her best friend, Carl Plansky, a day or two before I left. Joan and Joyce had bonded at the New York Studio School, perhaps due to their love for energetically slashed paint. Joyce once stayed with Joan for an astonishing six months, and called herself a Joanie, but it was an odd friendship. Joan's mother was a poet, as were many of Joan's friends, and accurate language in her presence was crucial. Joyce was a second-generation Sicilian American who had great difficulty writing. I often helped her turn disjointed phrases into complete sentences for grant applications and recommendations. Once she saw her words clearly, she was unwavering about what she wanted to say, resisting all embellishment.

After I left that summer, life was never quite the same. I began therapy with Jaqueline Fried, who was also treating Joyce and Carl. Jaqui is the daughter of Joan's much mourned longtime therapist, Edrita Fried. (Joan painted an enormous four-panel work in her memory.) Back in New York, Carl and Joyce got me a part-time job at David Davis's art-supply store on LaGuardia Place, south of Washington Square Park, where they both worked—Joyce as a salesperson, Carl as merchandise ordering manager. The neo-expressionist painters all shopped there.

My job was ambiguous. I was supposed to be David's secretary, but I usually worked on a grandiose hundred-page catalogue printed on the in-store copy machine. Included were endless price lists for all the store's paints (one price for each size), illustrated with photographs of tubes made on the copier. Phone inquiries were handled by the staff, but sometimes David would answer, ranting about the wonderful things he sold and offering to mail the caller a catalogue. I'd make copies until the machine ran out of toner (usually before the print run was completed) and then wait for the repair person to refill it.

David always looked shabby and was sometimes known to panhandle in the park. His living arrangements were mysterious; he probably slept in the basement. When smells wafted up, Carl would announce that David was down-stairs burning a fish. If, to everyone's relief, David took a day trip out to the stretcher-strip factory, I would go to the artist-run restaurant Food for lunch and spend two hours going to galleries.

Even though my desk was inches from David's, I tried to keep my distance. Joyce, on the other hand, was forever grateful he had given her a job, mainly because she was so disorganized. Money was stuffed into pockets and unzipped handbags. Receipts were tossed into drawers. Wallets, keys, and passports were constantly being lost. Her clothes were always messy and her fingernails grimy with paint and charcoal. If anyone came to her apartment to visit, she stuffed everything into the closet. She had very little confidence in her Sicilian beauty and tweezed her heavy eyebrows relentlessly. However, like Joan, she was crystal clear about what mattered: painting, integrity and emotional truth.

After my first year of therapy, I went back to spend another month in Vétheuil. This time, having gone over my previous summer with the therapist, I changed my approach. I went to bed at midnight and refused to show Joan my paintings until just before I left. A big mistake.

Death was still an obsession for her. A cousin of Gisèle's who had died of cancer inspired Joan's *La Grande Vallée*, a series of paintings named after a spot in Brittany where Gisèle and the cousin had played. Another guest, an attractive young man from Australia, was there interviewing Joan when I arrived. Noël was history—he'd been caught stealing over the winter.

Having told the Australian about Noël in depth, Joan wanted the interviewer to see him in person, so the two of us walked to the restaurant where Noël worked. Two beers got me drunk, and I went straight to bed when we returned. The next morning I was horrified that Joan was still awake. Noël had whistled at me when we left, which I didn't notice but the Australian had told Joan, who turned the incident into a major drama. She told me I was *planer*, French for having one's head in the clouds.

I really was spaced out—but not completely. Mostly I was concerned with my awful paintings, rigidly organized images of fruit trees, still in muted colors, but on canvas rather than on board. When the time came to unveil them, Joyce had already arrived. I arranged them proudly on the porch, and Joan was (understandably, in hindsight) not impressed. The only one she liked was a small painting of the town's church. It, at least, she said, had some air between the brushstrokes.

Bitterly disappointed, I went to bed disconsolate. Joyce, probably amused, was

Joyce Pensato, *Castaway Mickey*, 2015. Enamel on canvas, 90 × 80 in. (228.6 × 203.2 cm). © 2022 The Joyce Pensato Foundation. Courtesy Petzel, New York

Joyce Pensato, *Untitled*, ca. 1980. Oil and pastel on paper, 27 3/4 × 22 1/4 in. (70.5 × 56.5 cm). © 2022 The Joyce Pensato Foundation. Courtesy Petzel, New York

Joan adored the work of van Gogh, Matisse, Picasso, Bonnard and the Abstract Expressionists; detested the latest trends — neo-expressionism, neo-geo, Conceptualism and even Warhol. I was obsessed with Morandi. She said he was death.

sympathetic when we left the next morning for a day trip to Chartres. I was tremendously relieved to get away from that claustrophobic house, and the relief was even stronger on the plane going home. That was my final visit to Vétheuil. I was not mature enough to handle Joan.

But we did keep in touch. We wrote, and when Joan was in New York, we would go to shows with Carl and Joyce. We'd meet in her hotel room, always at the Westbury, sometimes along with other artists. Often, she embarrassed us by repeating our confidences to everyone. Once she brought a poet friend to my apartment.

Joan's New York openings were exciting, first at Fourcade and then, after Xavier Fourcade died in 1987, at Robert Miller. The four-panel painting *Edrita Fried* (1981) was hung in the 1983 Whitney Biennial, also a thrill. In a Studio School lecture that year, Joan spoke with the excitement of a teenager about her enthusiasm for Abstract Expressionism, recalling her searches for de Kooning and staying up all night with Kline. During my time with her in New York, I was careful not to get too close. Joan wanted to talk about my breakup with my composer ex-boyfriend. I wanted to move on.

Somehow, I'd managed to be clueless about Joan's mouth cancer, discovered in 1984 and removed by intense radiation that left her jaw fragile and her mouth almost too dry to eat solid food. She had had two hip replacements, which made walking increasingly difficult. In 1989, she was diagnosed with early-stage esophagus cancer, and she died in 1992 from advanced lung cancer. Jaqui, the therapist, told me about her last hospitalization, but advised me not to call.

Carl and Joyce were among the first artists to live in Williamsburg. Joyce's apartment was on Devoe Street, around the corner from her unheated ballroom studio on Olive. She wasn't quite ready to use the huge space, so she painted on the balcony where the orchestra had played and stretched a badminton net across the main floor. Friends came to her apartment for poker nights, and, at a large Thanksgiving

dinner, tables stretched from the kitchen to the railroad flat's back room, her winter drawing studio.

Joyce worked her day job at the art-supply store full time until her father died in the mid-1980s, and she decided to quit to concentrate on her art. Alongside paintings by her lifelong friend Christopher Wool, her work was on view in the inaugural exhibition at Four Walls in Hoboken, New Jersey, in 1984. She was also in a group show at Monique Knowlton, a fancy SoHo gallery. Both featured powerful charcoal drawings of ghostly linear creatures, alternately built up and erased. They'd evolved from her Studio School drawings of found Batman masks, old Mickey Mouse toys and used gloves.

Her canvases, in contrast, had heavily built-up surfaces, black with subtle bits of color, resembling dried lava or soil. Layers

of paint were added and violently scraped away, often making holes. Themes of abjection were widespread in the 1980s art world, and Joyce's paintings could be seen as scatological. Her first big break, a two-person show with Rona Pondick, an up-and-coming artist who made sculptures of excrement and babies, was canceled two weeks before the opening.

Friends were disgusted by the cancellation, and studio visits were arranged. Joyce's charcoal drawings of cartoon characters always seemed to outshine her abstract paintings. The French dealer Anne de Villepoix was bored in the ballroom, for example, but jumped to attention when she saw Mickey Mouse and Donald Duck. The drawings were included in a 1992 group show at Luhring Augustine with Arnulf Rainer and Paul McCarthy and in another group show at 303 Gallery. After several

Note from Mitchell to Kley, 1982. Courtesy Elisabeth Kley

projects in France, Joyce had a 1994 solo show in Paris with de Villepoix. Joan had never been encouraging about Joyce's paintings, saying they reminded her of skin disease. Joan insisted on color and light, while Joyce was obsessed with darkness. But her loyalty to Joan never wavered. Even after Joan died, Joyce got in touch with Gisèle whenever she went to France.

If Joyce considered Joan to be her mentor, Joyce was mine. She enthralled me from the day I met her, long before I learned to understand her painting. Perhaps it was just her big heart. Though it took years for her to start to like my work, she was my therapy older sister and we spent a lot of time together. When I started making maniacal drawings of Dalí after my father's death in 1998, she finally approved, perhaps the most gratifying recognition ever. Art had to reach out and grab Joyce—she wasn't interested in anything subtle. Her favorite criticisms were "It's not enough" and "It's holding back."

We both loved costumes and photography, and throughout the late 1980s we always went to see the start of the Greenwich Village Halloween Parade, when everyone was posing and there were a lot of lights. When Joyce traveled, the copious toys that she collected and used as inspiration for her work came along with her and posed on hotel beds and restaurant chairs. She shot them in her studio, too, with dramatic lighting and shadows, on furniture covered with cascades of dripped paint.

Joyce's dogs—Max, followed by Charlie—were completely untrained and indulged. If they peed on the floor, Joyce was undisturbed. She walked them with the longest possible leash so they could proceed at their pleasure. When visitors arrived, Joyce would throw keys out the window—she hated stairs. Although she never had a problem climbing ladders for large work, she avoided all other exercise. She gained weight but didn't care, once noting at an artist's talk that her command of painting space grew along with her body. At restaurants, she picked at food, but she snacked on junk all day.

After she quit working for David Davis, she survived on infrequent art sales. When they dried up, she relied on infusions of cash from her mother and brother, enduring lots of telephone nagging in return and partially repaying them when something finally sold. Joyce and Carl had helped Joan move out of her St. Marks Place apartment and some of Joan's things were still in Joyce's studio, so she sometimes sold a Mitchell pastel. She had lots of Joan's photos as well, along with a cherished painting stool.

Elisabeth Kley, *Charles Rennie Mackintosh*, 2018. Glazed earthenware, 15 × 12 in. (38.1 × 30.5 cm). Photo: Gregory Carideo. Courtesy Canada and Gordon Robichaux

In 1995, Joyce joined the Max Protetch Gallery and had solo shows there that year and two years later, but she left when Protetch asked her to make caricatures. She didn't have a New York gallery for almost a decade, and then, as she often put it, her ship came in when Friedrich Petzel took her on in 2007, giving her five solo exhibitions in the years that followed. There were also solo shows at Lisson in London, Corbett vs. Dempsey in Chicago, Grice Bench in Los Angeles and Nanzuka in Japan; a retrospective at the Santa Monica Museum in 2013 and solo shows and projects at other museums in Fort Worth, St. Louis and Boston. After so many years of struggle, she was finally living her dream, and the last twelve years of her life were years of celebration.

Most of the time, she was glued to her studio, making the "donuts" and "meatballs"—her fabulous paintings of Mickey Mouse, Donald Duck, Batman and Homer Simpson. She often said that her works were finished when they scared her and made her laugh at the same time. Cartoon characters were her inspiration, but her work was never cartoony, a term she reserved for superficial art. She intertwined numerous layers of black and white paint to make riveting images of chaotic exultation and fury, fearlessly obliterating one version after another until she was completely satisfied.

Even when she hardly had any money,

Joyce insisted on paying for her annual restaurant birthday dinners. Now, when she emerged from her studio for openings and special occasions, elaborate parties were thrown. There were photo shoots with wigs, crazy sunglasses, golden shower caps and toy guns, wonderful food, champagne and cocktails. She treated herself to a freeze-dried palm tree for the studio, which was otherwise filled with paint-spattered toys, giant cutouts of Muhammad Ali and Elvis Presley, and endless open enamel cans holding expensive Chinese brushes suspended in congealed paint. Other luxuries included Chanel sneakers, haircuts at the Plaza, staying at the Viceroy in Santa Monica, and never taking the subway again.

Joan remained a lodestar for Joyce, as the ultimate tough woman artist, a mentor and a role model. In May 2018, Joyce and I were thrilled to attend a symposium at the Guggenheim in preparation for the Joan Mitchell retrospective that opened this past October at the Fondation Loius Vuitton in Paris after stops in San Francisco and Baltimore. Tragically, Joyce did not live to see the show and its magnificent catalogue. The frontispiece reproduces a letter from Joan to Joyce, and the book includes a wonderful essay by Joyce about Joan (produced from interviews). At least in the book, they'll be together forever, for posterity. As for me, I wish I'd understood Joan's paintings when I knew her. Now I am in awe.

Returns: Half a Century

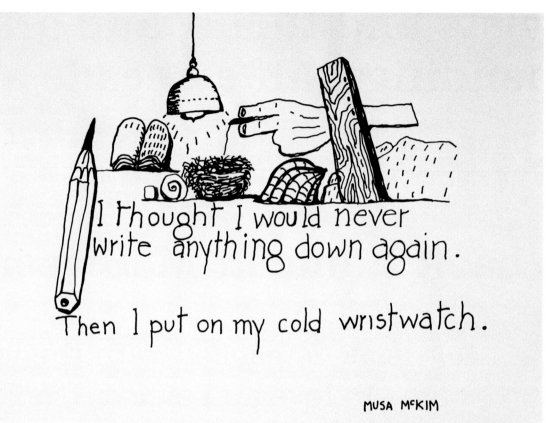

"I thought I would never write anything down again.

Then I put on my cold wristwatch.

MUSA McKIM

Philip Guston, *I Thought I Would Never*, ca. 1972–75, ink on paper, 19 ×24 in. (48.3 × 61 cm).
Illustration of a poem by Musa McKim. Photo: Robert E. Mates. © The Estate of Philip Guston.
Courtesy the Estate of Philip Guston and Hauser & Wirth

In October of 1970, just days after the critical firestorm that was ignited by Philip Guston's tumultuous return to figuration at the Marlborough Gallery in New York, Guston and his wife, the poet Musa McKim, decamped to Rome, where he began a residency at the American Academy.

The year after they came back to the United States, in 1972, Guston began a series of deeply felt drawings paired with the poems of McKim and of his friend Clark Coolidge. That same year, he drew on the Old World he had just revisited to set out in stark terms the art-historical parameters of the troubled new world of his figurative paintings.

"I wanted really to see early frescoes of Last Judgments and end-of-the-world paintings" Guston told a group of Yale summer-school students. "Particularly Romanesque paintings and Sienese fresco painters who paint huge marvelous frescoes of the damned, all the tortures in hell, and so on. Heaven is always very dull, just a lot of people lined up. Like trumpets, they're all lined up. There's not much to look at. But when they're going to hell the painter really goes to town. All kinds of marvelous stuff. That's when they really enjoyed painting. So, I feel we live in comparable times. Oh yeah, and I want to paint that."

"Philip Guston Now" is on view at the Museum of Fine Arts, Houston, until January 16, 2023, and continues at the National Gallery of Art, Washington, D.C., and Tate Modern, London.

In 2023, Hauser & Wirth Publishers will republish *Night Studio*, Musa Mayer's memoir of her father, Philip Guston.